A Beginner's Guide

SUMI-E

Learn Japanese Ink Painting from a Modern Master

Shozo Koike

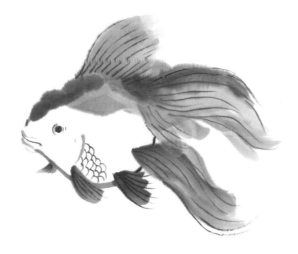

TUTTLE Publishing

Tokyo | Rutland, Vermont | Singapore

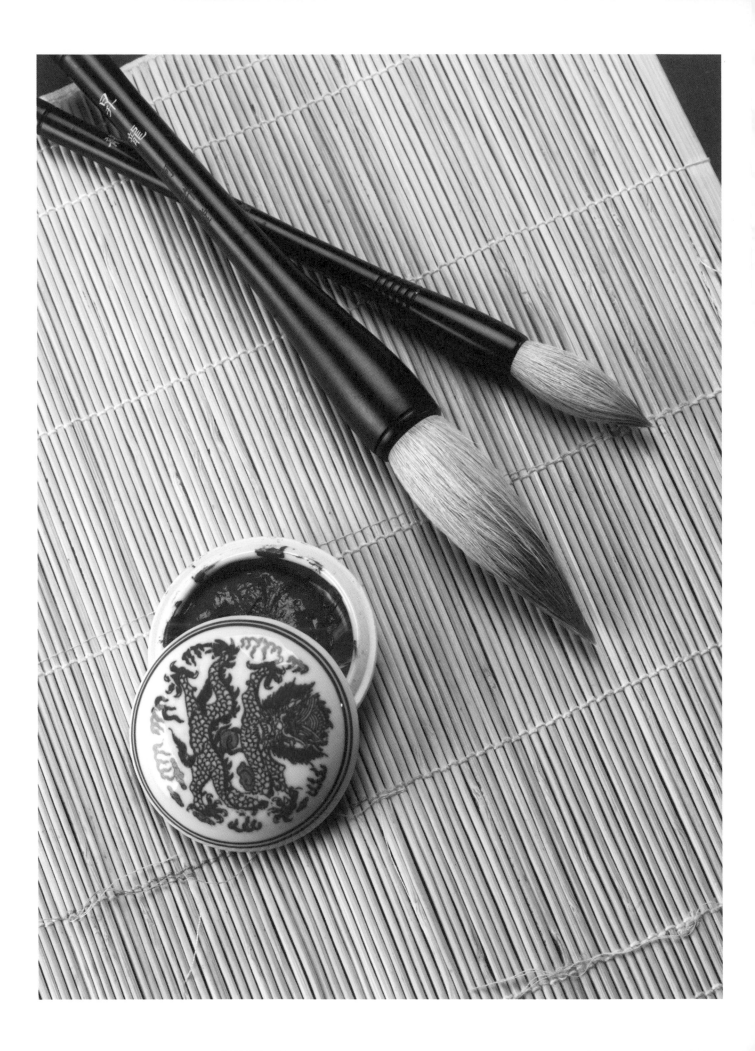

Contents

Foreword

When I was a child, I hated getting my hands stained with ink, and to this day I have memories of trying to rub it off. Now, with these same ink-stained hands, I teach Sumi-e to my pupils. What is fascinating about Sumi-e is that although its forms are drawn solely in black ink, they capture volume and depth so well that it is difficult to believe they are monochrome works.

Developed over the last several years, this is an original compilation of models for the pupils of a painting class. With the help of diagrams and photographs, the book explains how to draw nineteen Sumi-e subjects and provides information on the basic techniques of the art in easy-to-understand language.

I intend to go on doing everything I can to familiarize people with the world of Sumi-e.

—Shozo Koike

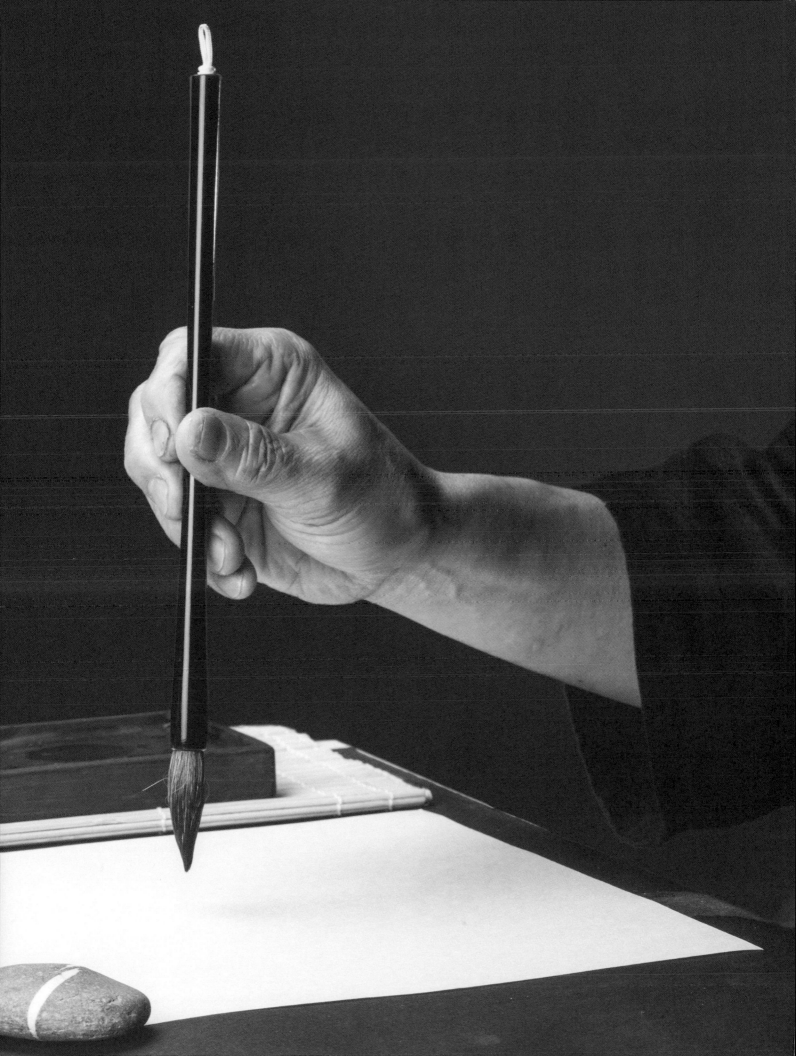

Sumi-e Ink Painting

Origins

Sumi-e is a contemplative form of Japanese ink painting using a brush and various gradations of black sumi ink on white space to capture not only the essential character or essence of an object, creature or scene in the natural world, but also its complexity and timeless beauty, in a minimum of brushstrokes. The focus of the art is on the quality of the brush lines, because it is these that encapsulate the form of the subject without the need for unnecessary detail.

As is true of most Asian art and culture, the roots of Sumi-e (*sumi* means "black ink" and *e* means "painting") are based in China. From the earliest times, Chinese scholars transcribed documents and wrote literature, including poetry, with brush and ink on paper. Calligraphic poems were sometimes enhanced with simple artwork. The earliest form of monochrome art in China was usually painted on silk, naturally sized with the glue-like substance of silkworms, and developed in detail via overlapping brushstrokes from an outline. It became a recognized art genre during the Northern Sung period (960–1126), and was known as Suiboku-ga (*sui*, water; *boku*, sumi ink; *ga*, painting). New styles and techniques of using sumi ink and brushes to produce a gradient of different tones, often in combination with pigments, were developed during subsequent Chinese dynasties. As the art spread to the Far East, first to Korea and then to Japan, the main medium became the newly available, more absorbent and more "personal" handmade paper and the technique came to favor minimal brushstrokes in sumi ink as opposed to color from pigments and excessive detail.

The Northern Sung style of painting was introduced in Japan by Zen Buddhist monks from China during the Muromachi period (1338–1573). Zen Buddhism, a school of Mahayana Buddhism that originated in China during the Tang dynasty as the Chan school, had first appeared in Japan in the Kamakura period (1185–1333). Zen emphasized vigorous self-restraint, meditation practice and insight into the nature of the mind and the nature of things. It was at this time also that many Japanese monks went to study Zen in China and came back with monochrome ink paintings. The technique was thus introduced in Japan between the late Kamakura (1288–1333) and Nanbokuchō (1336–92) periods. The flow of Zen monks between the two countries intensified during the Muromachi period when a new style of painting, already widespread in China but only later dubbed "Southern school," entered Japan. The technique and style of this new style of painting—Sumi-e—developed in the vicinity of Zen temples, and it was here that it experienced its golden age. It became highly popular throughout Japan, where it merged with local culture and brought to life a new art school with its own characteristics.

Over time, the number of brushstrokes used in this style of Japanese ink painting were reduced and also simplified, and were often combined with poetry in calligraphic form to create the type of Sumi-e style that is more popular and recognizable today.

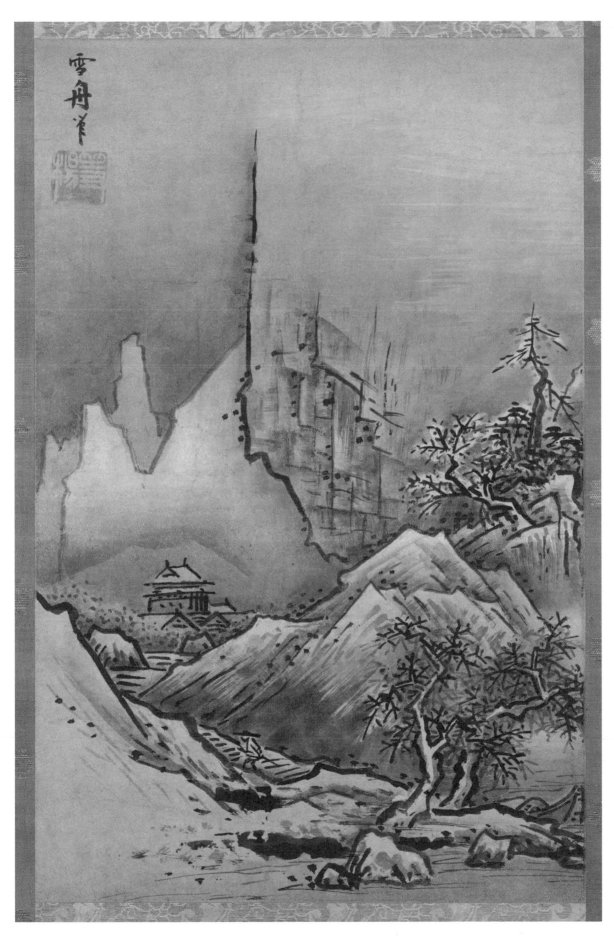

Sesshū Tōyō, *Winter Landscape*, *ca. 1470–90*
Ink on paper—18.8" x 11.9" (47.8 x 30.2 cm)—Tokyo National Museum (National Treasure)

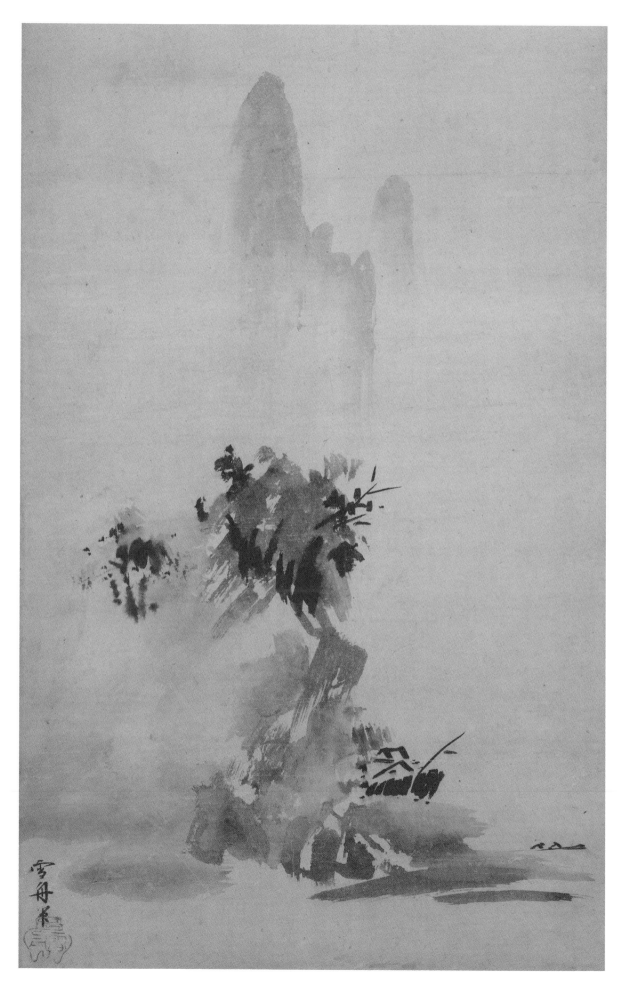

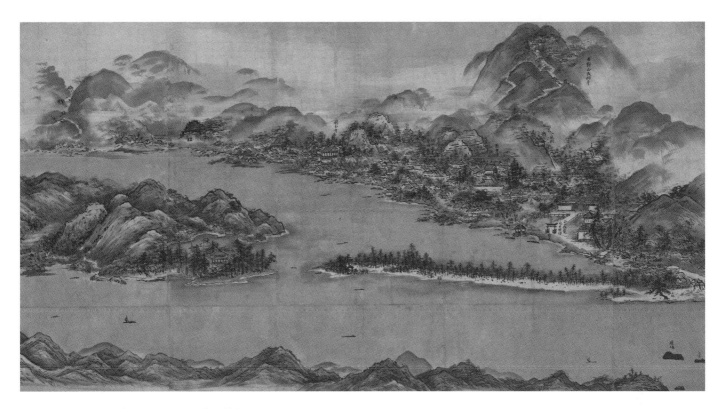

ABOVE **Sesshū Tōyō**, *Amanohashidate*, ca. 1501–06
Ink with touches of color on paper—35.2" x 66.34" (89.4 x 168.5 cm)—Kyoto National Museum (National Treasure)

Meditation and Mindfulness

Although there is no direct relationship between Zen doctrine and the origins of Sumi-e, the ancient art form of Japanese brush painting is spiritually rooted in Zen Buddhism. The aim of Sumi-e artists—to eliminate all but the essential character of their subject in a painting as well as to capture its spirit—is closely related to the pursuit of Zen Buddhism. The earliest practitioners of Japanese brush painting were highly disciplined monks who spent years devoted to the demands of Sumi-e, receiving training in the areas of concentration, reflection, clarity and simplicity, which would later influence their work. The monks also followed a rigorous schedule of meditation in preparation for painting. They would enter a deep contemplative state before preparing the ink stone, grinding the sumi ink, loading the brush with ink and releasing the brushstroke on handmade paper or silk scroll. Mastering the subtleties and shades of black in sumi ink to express nature's colors was far more difficult than painting with color, and required a much higher degree of skill.

Beginners of Sumi-e are not expected to invest the same time and effort in rigorous training and discipline as Zen monks. But cultivating a mindful approach to making Sumi-e can be a therapeutic experience, allowing you to focus on your surroundings and to be inspired and creative. It can also help you to relax, thereby reducing stress and helping to deal with the problems and difficulties of everyday life. Through mindfulness as well as careful observance of the instructions and plenty of patient practice of the requisite brushstrokes, it is possible to create beautiful Japanese-inspired monochrome ink wash paintings.

LEFT **Sesshū Tōyō**, *Hatsuboku sansui* (detail), 1495
Ink on paper—58.5" x 12.9" (148.6 x 32.7 cm)—Tokyo National Museum (National Treasure)

Mindfulness in Sumi-e painting begins with setting up your workstation, a clean, quiet space for focus and contemplation where all your tools and supplies are carefully placed, preferably on a flat table. This will be followed by the preparation of the ink and, finally, the laying down of brushstrokes, one by one, as your composition evolves. Unlike many other painting forms, the art of Sumi-e does not allow for pencil sketching in advance nor for any corrections once the ink is on paper, but with a calm mind, an awareness of your breathing, keen attention to the task at hand and constant practice, your brushstrokes will come more naturally as you capture the essential features and spirit of your subject.

Master Sumi-e Artists and Their Works

Sumi-e reached its height in the Muromachi period (1338–1573) with masters whose landscapes were uniquely Japanese. Presented below are some of the most representative artists and works of the early world of Japanese Sumi-e.

Sesshū Tōyō (1420–1506)

A Zen monk at the famous temple of Shōkokuji in Kyoto, Sesshū was the pupil of two celebrated painters of the period, Taikō Josetsu (fl. 1405–96) and Tenshō Shūbun (? –ca. 1454). Between 1467 and 1469, Sesshū joined a Japanese mission to Ming China, where he devoted himself to painting and enjoyed great success. On returning home, he remained active, painting mainly in southwestern Japan, in Yamaguchi and Oita. Despite the wars and ensuing chaos at the time, Sesshū ventured into every region of Japan, including the ancient provinces of Mino, south of the current prefecture of Gifu, and Tango, north of the present-day prefecture of Kyoto.

Sesshū's most famous work, the *Scroll of the Four Seasons*, or *Long Landscape Scroll* (*Sansui chōkan*), a painting spread across a horizontal scroll over 15 m (50 ft) long, dates to 1486.

Another of Sesshū's masterpieces is his renowned *Winter Landscape* (*Tōkei sansui*), one of a pair of painted vertical scrolls dedicated to autumn and winter landscapes ([*Shihon bokuga*] *shūtō sansuizu*), which is today in the Tokyo National Museum (page 7). Depicting the edge of the crag with solid vertical lines that vanish in the upper part of the painting, the master managed to express austerity while conveying a wonderful sense of depth. The work is distinctive for the superiority of the composition and the vigor and handling of the brushstrokes and ink. In *Autumn Landscape* (*Shukei sansui*), the second painting of the pair, the style is softer. Here, the artist represents the features of the landscape with great insight, successfully conveying both a sense of depth and the solidity of the cliff and mountain.

Another masterful painting is the famous landscape titled *Hatsuboku sansui* (page 8). A preface with a dedicatory inscription dated to the middle of the third month of the fourth year of the Meiō period (April or May 1495) appears in the upper section of the work and

was composed by Sesshū himself, who, according to the Japanese system of calculating age, was seventy-six years old at the time. Alongside it are several poems written by six monks belonging to the five most important temples in Kyoto. The work is of inestimable value thanks to its content, composition and signature calligraphy.

Sesshū's deliberately loose technique used here is known as *hatsuboku* or "splattered ink," from which the title of the painting was derived. In the dedicatory inscription, however, Sesshū uses the term *haboku* ("broken ink"), which is why the painting is also known as *Haboku sansui*, that is, the "splattered ink landscape," as it is often called in the West. In the *hatsuboku* technique, the ink is fashioned into vaguely contoured shapes of various shades of diluted ink, some lighter, some darker. Although the play of light and shadow recurs over the painting's entire surface, there is a powerful structure to the work that communicates the sense of stability and composition typical of Sesshū's style.

According to the inscribed dedication, when Josui Sōen (ca. 1489–1500), one of Sesshū's pupils in Suō, in the prefecture of Yamaguchi, returned to Sagami, in the present-day prefecture of Kanagawa, he asked the artist for this painting as proof of having studied with and learned from him the art of painting. On his way home after receiving the work with Sesshū's inscription, Sōen got six monks from Kyoto to write their poems on it.

In that same inscription, Sesshū relates that he had studied in China with the masters Li Zai (? -1431, "Rizai" in Japanese) and Zhang Yousheng (? - ?, "Cho Yusei" in Japanese), and that in Japan he had been the pupil of Josetsu and Shūbun. He thus flaunted his own abilities and at the same time traced the roots of the style to Sōen painting.

Amanohashidate, an isthmus in Miyazu Bay in the prefecture of Tango, is depicted in one of the "Three Famous Views in Japan," and serves as the title of another of Sesshū's highly celebrated works, one that offers a bird's-eye view of the bay's eastern portion (p. 9). As both the Chionji pagoda and another temple, the Nariaiji, appear together in this work, it has been possible to date it to between the tenth year of the Meiō period (1501) and the third year of the Eishō period (1506). By then, Sesshū was over eighty, and it is amazing that he was able to travel to this place and immortalize it in real life. The work's vibrantly colored ink, firm brushstrokes and magnificent composition mark the peak of Sesshū's exquisite technique.

Hasegawa Tōhaku (1539–1610)

Hasegawa Tōhaku, one of Kyoto's leading artists during the Azuchi-Momoyama period (1573–1600), was born in the province of Noto. In his youth, he was a pupil of the masters of the Kanō school, whose paintings were characterized by bold brushworks, sharp outlines and moral symbolism, but he later turned to the legacy of Sesshū and the Chinese artist Muqi Fachang (ca. 1210–75; "Mokkei" in Japanese), whose works strongly influenced his own. He

was held in high esteem by several celebrated figures of his day, such as the Japanese tea master Sen no Rikyū (1522–91) and Japanese military leader Toyotomi Hideyoshi (1537–98).

If viewed from a distance, the painting reproduced here—the left side of his famous *Pines* (below), a pair of six-paneled screens known as *Shōrinzu byōbu*—conveys the impression of a forest as the morning fog is rising, an image of a tranquil scene that generates a sense of serenity. Faintly visible beyond it is the soft outline of snow-capped mountains. If viewed up close, however, the composition is amazing in that it is made with incredibly bold brush-strokes. Here, we are looking at one of the greatest masterpieces of Japanese Sumi-e.

Notably influential in terms of content are paintings associated with Hamamatsu prefecture (in the collection of the Tokyo National Museum), whose subjects are often found in Tang dynasty-influenced Yamatoe-style paintings of the Muromachi era (1392–1573), which often show the beauty of nature, and in Hon'ami Kōetsu's (1558–1637) depictions of Miho no Matsubara (collection of the Eikawa Museum). Aside from the pine theme, a conventional Yamatoe motif, Tōhaku's originality can be recognized in his use of the type of ink painting that had been transmitted from China.

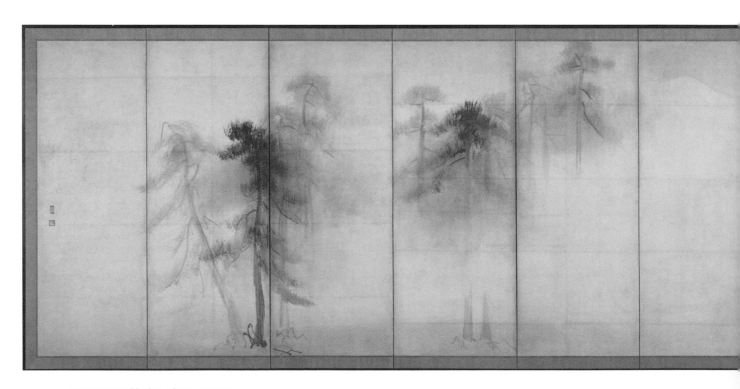

Hasegawa Tōhaku, *Pines*, ca. 1595
Ink on paper, screen with six panels, one of a pair, 61.7" x 140.2" (156.8 x 356 cm)
—Tokyo National Museum (National Treasure)

Still visible along the shore of Noto, where the artist was born and raised, is a vast pine forest much like the one in the painting. Here, a combination of tradition, the Muqi technique and Tōhaku's memory of the landscape of his homeland come together in a work of an esoteric and soul-stirring environment.

Ogata Kōrin (1658–1716)

Kōrin was born in Kyoto in 1658 as the second son of an owner of a textile store and money lender, Ogata Sōken. When Kōrin was thirty, his father died, leaving the management of the shop to his eldest son. At that time, the practice of usury was facing a crisis, but Kōrin, who had always been fond of pleasure, spent his days on amusements and ended up squandering his sizeable inheritance. Reduced to borrowing money from his younger brother, Ogata Kenzan, Kōrin finally found work as a painter and ended up becoming one of the most representative artists of the Edo era (1600–1868) as well as the founder of the Rinpa school, which specialized in decorative painted panels and took its name from him ("school of Kōrin" from [Kō-] rin and *pa* school).

Bamboo of various colors and thicknesses on a vertical axis combine with branches of sharply angled plum trees to adorn the entire surface of one of his most famous works, a double-paneled screen that depicts the delicate coexistence of bamboo and a plum tree (ink and gold leaf on paper—25.7" x 71.3" (65.2 x 181 cm), Tokyo National Museum). In this case, Kōrin's expressive technique, which is sometimes overly ornate, displays refined elegance. Quiet and reflective, the work's special quality has struck wonder in all those who have come from every corner of the world to admire it. The theme of the painting is "winter's three friends," that is, the three plants that either retain their bright colors throughout the cold season (pine and bamboo) or blossom in the winter (the Japanese plum). Their presence helps people endure the cold but also represents the virtues of the cultivated individual, namely, refinement, purity and honor. These three motifs, passed down from the Muromachi era, became immensely popular in the Edo period as decorations at joyous occasions or as symbols of virtue and beauty. They are still highly appreciated in contemporary Japan and deeply rooted in the culture of the country.

Tawaraya Sōtatsu (1570–ca. 1640)

Co-founder of the Rinpa school, which grew out of the traditional Yamatoe style, Sōtatsu ran a painters' atelier in Kyoto. As an artist of that city, he rose to a position of considerable importance. Active between the Keichō (1596–1615) and Kan'ei (1624–44) periods, he extended ornament over the entire surface of his paintings, making daring choices. One of his more intimate works, *Pond with Lotus and Water Birds* (ink on paper—46.9" x 19" (119 x 48.3 cm), National Museum of Kyoto), is painted entirely in monochrome ink and is likewise a National Treasure that embodies the peak of the artist's technical expertise.

Tools and Supplies

Sumi-e uses the same tools and supplies today as were used hundreds of years ago. The most essential—ink stick, ink stone (or grinding stone), brush and paper—are commonly called the "Four Treasures" (of the Study). During historical periods when China was ruled by emperors, as well as in other countries of the Far East, all written forms of communication, whether documents or literature, including poetry, required a brush, sumi ink and paper. Despite the later widespread introduction of pencils, ink pens and ballpoint pens, writing with a brush continues today, whether for painting or calligraphy. Every primary school pupil in China and Japan learns to use a brush for calligraphy.

Since the Ming dynasty (1368–1644) in China, other tools have been added to the "Four Treasures" for both painting and calligraphy, such as a stand on which to hold brushes; a rest for the ink stick; a water container large enough for cleaning brushes; a small spoon or water dropper for adding water to the ink stone; small dishes or a shallow compartmentalized dish for mixing sumi ink; paperweights for holding down the paper; and a small seal and pot of red seal paste for identifying the artist. These can range from simple utilitarian objects to highly ornate works of art revered by antiques collectors. Generally, painters and calligraphers influenced by Zen doctrine prefer simple, unadorned tools.

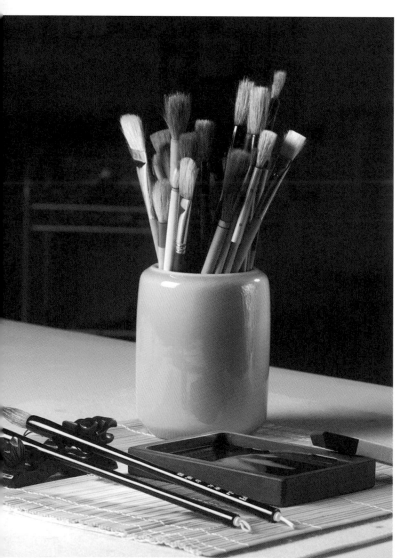

BRUSHES *Fude*

The methods and rules for using a brush, whether for painting or calligraphy, have long been established historically and traditionally. These include knowing the effect that various types of brushes have on different types of paper, how much ink a brush can hold and the effects that are created when painting narrow to broad lines as well as light to dark tones. For newcomers to Sumi-e, the brush, ink and paper can be daunting. Unlike a pencil or ballpoint pen, where the tip is moved continuously across a page, a brush is moved from right to left as well as up and down. The pressure of the thumb and fingers used for each brushstroke, in harmony with the inner *yin-yang* energy (*qi/chi* or *ki*) centered in the lower abdomen as you breathe, adds to the liveliness and spirit of a painting.

Fude brushes for Sumi-e are much like those used for calligraphy; their handles are either bamboo or wooden, while their bristles are made from a combination of the hair of goats, deer, horses, mountain sheep, martens, badgers, weasels, raccoons or wild boars, depending on use and desired effect. The bristles of brushes used for Sumi-e must be tapered to a tip.

Types of Brushes

Handmade Asian brushes for Sumi-e are much like those used for calligraphy. Their handles are either bamboo or wood, while their bristles are made from a combination of the brown, white or mixed hairs and/or whiskers of goats, deer, horses, wild boar, mountain sheep, martens, badgers, weasels, squirrels, racoons, rabbits, cats and even humans. The specific use of a brush determines the kinds of hair or whiskers used and their location within the bristles. Master craftsmen know whether to take hair from the tail, body, mane or whiskers of an animal and how to skillfully combine them. Increasingly, the hair of domestic rather than wild animals is used. A beginner should invest in a quality brush, even if more expensive. If well cared for, it will last for decades. Inexpensive mass-produced brushes made by machine will not perform to expectations. Western watercolor brushes should be avoided.

Because different brushes have different qualities, they are designed for specific tasks. For example, a large mountain horse hair brush is useful for painting large forms, while brushes made from small mammal whiskers are used to create very fine lines. Of the more than twenty brushes available for Sumi-e, the most useful one for beginners is the traditional Japanese *choryu*, which is soft, subtle and elastic, with a good sharp tip. The outer skirt of the brush is made from white sheep hair wrapped around coarser hairs. Both thin or wide lines in a wide range of shades can be drawn with this brush, and the tapered tip always returns to a straight point, a feature vital to Sumi-e. Begin by purchasing both a large and a small *choryu* brush. As you gain confidence and skill, you may want to purchase a number of other reasonably priced brushes for specific purposes, such as coloring and shading. Brushes are available from Asian art supply stores or online.

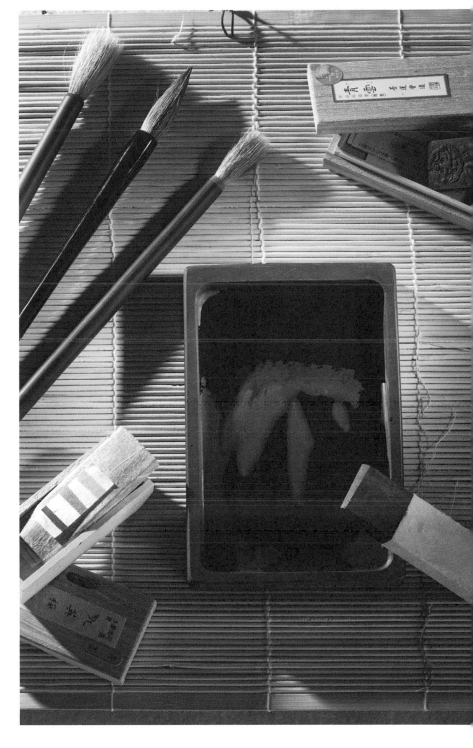

Caring for Brushes

New brushes come with the hairs starched with animal glue to hold them together. Hold the brush in your hand and first loosen the tip of the bristles by gently rotating the brush between your thumb and index finger. Move down the bristles, freeing all the hairs. Then only dip the brush in water and swish it around to wash out the starch. Repeat the process several times, removing excess water by pressing the bristles on a cloth or paper towel. Each time you use the brush, moisten it with cold water to bring the hairs back to life. After use, carefully wash out all the ink, especially at the base of the bristles, then squeeze out excess water on a cloth. Do not leave it to soak in water as the hairs will fall out.

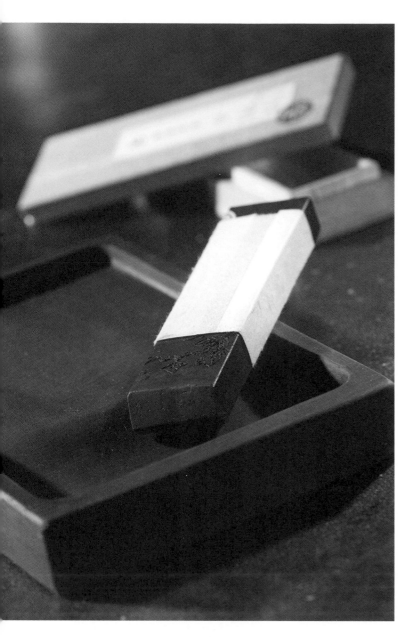

INK *Sumi* and INK STICKS *Kokeiboku*

There is a saying, "sumi ink is black and yet it is not black." Black ink, which is derived from grinding a hard, dry, rectangular or cuboid ink stick with a small quantity of water over an ink stone, can generate a whole range of colors, from silvery gray to brown or blue tones to a deep shade of black. The highest quality is a pure gray tone. In Japan today, a wide assortment of sumi ink is available in both jet-black tones (regarded as "warmer") and blue tones (regarded as "cooler"). You should experiment with various hues and use the ink best suited to what you want to create.

Over 2,000 years ago, China developed a way of making ink from soot collected from the inside of pottery kilns. These days, the carbon for sumi ink comes from three sources: burned rapeseed oil, which produces very fine soot with a deep black color; burned pine sap, which produces a transparent-like soot that ranges from light black to bluish gray; and burned industrial oil, which produces brownish tones. The carbon is combined with animal skin glue, then pressed into molds. Sometimes incense and medicinal scents are added as preservatives or for aesthetic reasons. Ink sticks often have various inscriptions and artwork incorporated into their design, while more expensive ones may have gold leaf accents.

The online video tutorial for this page may be viewed on our website:
www.tuttlepublishing.com/beginners-guide-to-sumie

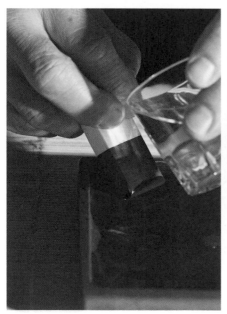
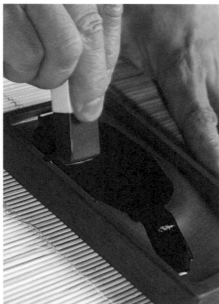
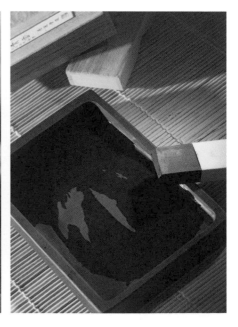

When buying an ink stick, you need to ask about the tone as well as the price. Generally, blue tones are the most expensive, brown tones the cheapest. Prepared liquid inks (*bokuju*) of varying density are also available on the market. They are cheaper and more convenient to use but do not produce a good gradation in ink tone and are thus recommended only for practicing brushstrokes.

Although traditional Sumi-e used color sparingly, nowadays color is more likely to be added to a basic black ink painting. As with black ink, colored inks are made from natural sources such as plants (for example, to obtain rouge red, indigo blue and rattan yellow) and minerals (white pearls, powdered jade, azurite blue and green malachite). They are available in concentrated liquid form in tubes or in the form of powders and dried chips.

INK STONES *Suzuri*

The ink stone, often called a grinding stone, is available in a variety of shapes—rectangular, round, oval, irregular—colors, ornamentation and price. The flat section of the stone where the ink stick is ground is regarded as the "land" or "plain." A smaller, deeper section at the far end of the stone, commonly called the "ocean" or "sea," is for holding water. Ink stones are made of slate from particular quarries and can vary in quality. If the surface is too rough, the particles of pigment from an ink stick will not completely dissolve. Before using for the first time, soak the ink stone in water for a few minutes. Before each use, make sure the grinding surface is clean.

Preparing the Ink

The earliest practitioners of Sumi-e used the time it took to grind sumi ink to mentally and physically prepare themselves for painting. They would meditate, warm up their arm, wrist and hand muscles and generally focus their thoughts on the subject of the painting to come. Depending on the quality of the ink required and the amount of water used, grinding could take anywhere from five minutes to half an hour. Beginners of Sumi-e can also use this grinding time to practice meditation and breathing to get into the right mindset.

To use the ink stone, first half fill the "ocean" end of the stone with water. Then moisten the top ("land") of the ink stone with a few drops of water. Holding the ink stick upright, move it smoothly back and forth against the surface. The movement must be regular and the pressure evenly applied. The finer the ground material, the better quality the ink. As the ink stick dissolves from the friction and the water, the sumi ink will accumulate at the base ("ocean") of the ink stone. Once the water at the top of the inkstone has evaporated, dip the end of the ink stick in the sumi at the bottom of the stone and continue rubbing until the desired density is reached. Test the shade by dipping the moistened tip of a brush into the ink and making a few strokes on scrap paper. Once you have ground enough ink, rest the ink stick on the side of the ink stone or on a paper towel. Because grinding the ink is time-consuming, you may prefer to buy concentrated liquid ink for practicing brushstrokes, although it does not work well for shading and is hard on brushes.

PAPER *Washi*

Although Asian papers are generally referred to as "rice paper" in the West, they are, in fact, handmade from a variety of natural fibers and in a variety of finishes—raw

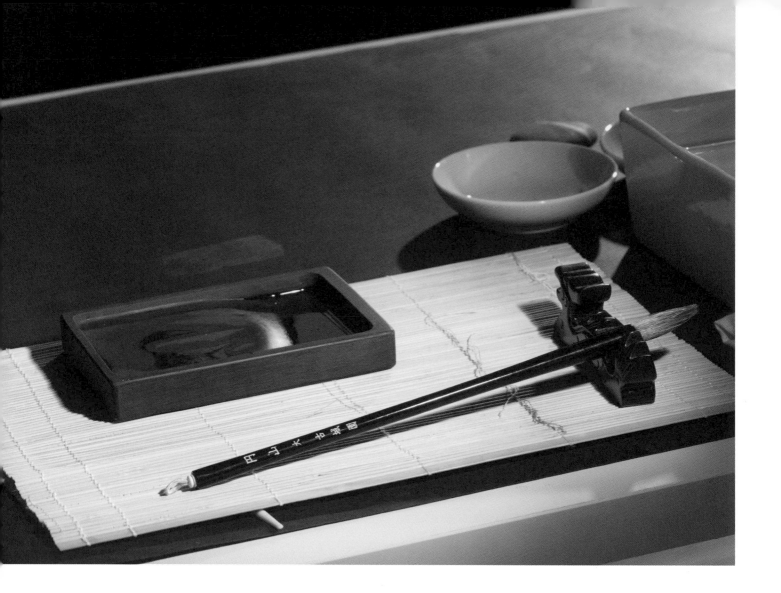

(absorbent), semi-sized and sized (non-absorbent). *Washi* is a particularly delicate Japanese paper produced from the long fibers of three plants—*kozo*, a type of mulberry, and *mitsumata* and *gampi*, two species of the *Daphne* genus. Ink will not spread out on these smooth white papers, making them ideal for Sumi-e. Popular papers from China include those made from the fibers of rice straw, bamboo and tree bark. Check Asian papers online or visit Asian art supply stores to see the large variety of papers available and their qualities. For the best results, thicker Sumi-e paper is recommended. But it is not necessary to use these expensive handmade papers at the start. Good machine-made papers are an option. Less expensive machine-made rolls of practice paper are also available. Avoid newsprint even though it is cheap, and also Western watercolor paper as you will not be able to create subtle gradations of color.

OTHER IMPLEMENTS

A **wooden brush hanger** with small hooks or pegs at the top is ideal for storing a collection of brushes as any moisture left in the brushes will drip downward.

Ceramic brush holders are a cheaper storage option and are easy to find, but care must be taken that the bristles of brushes are completely dry before placing them in the holder or they will deteriorate.

A **brush rest** on which to place a brush in the middle of a project, is useful, as is an **ink stick** rest after the stick has been blotted dry with a cloth or paper towel.

A **water dropper** (*suiteki*), much like a small teapot, is ideal for adding water, drop by drop, to the ink stone for grinding sumi ink, while a larger **water container** is a necessity for washing ink out of brushes.

A variety of **small dishes** or a **shallow compartmentalized container** are necessary for mixing sumi ink and water to create different intensities of black.

SEALS AND RED SEAL PASTE

In traditional Sumi-e, the only spot of non-black color is usually a red seal (or two) placed below the artist's signature in vertical black ink calligraphy, or on the opposite side of the painting from the signature. The seal is a unique means for the artist to identify himself and his artistic qualities or philosophy, as well as a fundamental part of the aesthetic of the painting. The position of the seal is carefully chosen to balance and enhance the subject. Shown here are the seals of the author and master artist Shozo Koike, each differing in size and design.

It is possible to carve your own seal from the end surface of a block of soapstone, a soft stone that varies in color and pattern, using a special carving knife. Both soapstone and knife are available in Asian art supply stores along with a pot of seal paste or an ink pad. You can also order a personalized seal online. Your design may be based on your initials or any motif or symbol that is significant to you. Online videos on seal carving show the methods of carving a seal that prints white lines on red, where the design is carved down into the soapstone, or a seal that prints red lines against a white background, where the design is raised and the background is cut away.

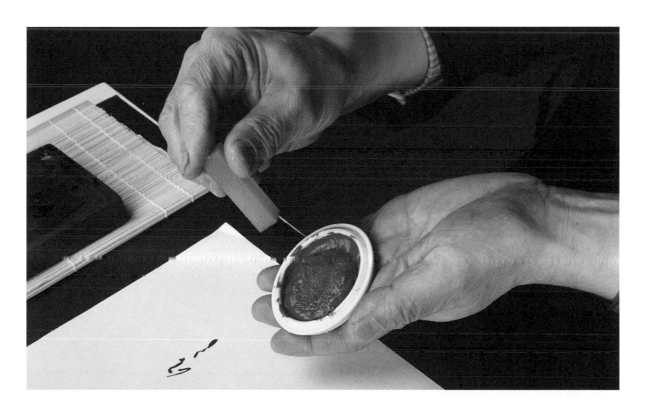

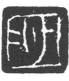

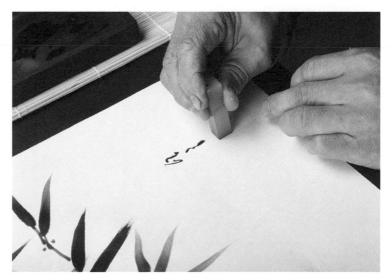

Basic Techniques

This section teaches beginners of Sumi-e 11 basic techniques in preparation for the 19 Sumi-e projects presented on pages 35–183. The first technique, *chōboku*, explains the preparation of sumi ink prior to painting. The techniques that follow show the different ways of handling the brush in order to make particular strokes and to achieve other effects suitable for the subject matter of the 19 projects. You can also refer to the free online video for each technique.

Chōboku

Concentrated or dark sumi (*nōboku*)

Medium sumi (*chūboku*)

Light sumi (*tanboku*)

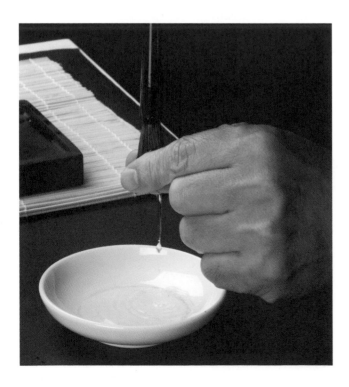

Chōboku is the technique of preparing the right tone of sumi ink on the brush before you start painting. Begin by grinding a black ink stick on the ink stone to create a small quantity of concentrated or dark sumi.

- Pour the dark sumi into a small dish.

- Hold the brush vertically, at a 90-degree angle, and dip it into clean water in a larger container.

- With your other hand, gently run the bristles between your thumb and forefinger and squeeze out excess water.

- Load a small amount of dark sumi onto the tip of the brush. Transfer this to another dish and add water to obtain a lighter sumi.

- Wash the brush in clean water and squeeze out any excess water.

- Load the brush with light sumi ink from the tip to 90 percent of the way up the bristles.

- Using the edge of the dish containing the light sumi, discharge the excess liquid into the dish and shape the tip of the brush.

- Now prepare the medium tone. Pour a small amount of dark sumi into a dish. In another dish, mix some light sumi with some dark sumi by rotating the brush and applying gentle pressure. Repeat until you have obtained the desired shade of sumi.

- Dip the brush halfway up the bristles into the medium sumi. Never immerse it fully. Finish by dipping the tip of the brush lightly in the dark sumi.

- The brush is now ready for painting.

The online video tutorial for this page may be viewed on our website:
www.tuttlepublishing.com/beginners-guide-to-sumie

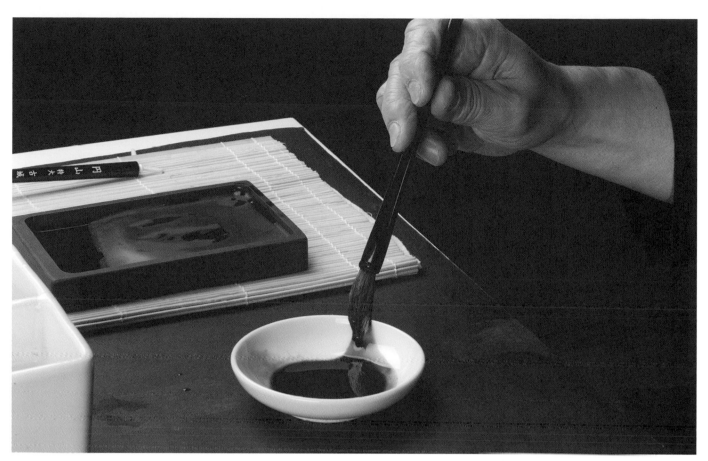

Preparation of light sumi (tanboku)

Preparation of medium sumi (chūboku)

Sokuhitsu

側筆

The principle feature of the *sokuhitsu* technique is that the brush is used from the tip or point of the bristles to the base of the heel, next to the handle. Unlike in calligraphy, where the brush is held perpendicular to the paper, at a 90-degree angle, in Sumi-e it is common to hold the brush on an incline, at a 45-degree angle, so that the bristles from the tip to the base make maximum contact with the paper. In both positions, your elbow should be horizontal and your wrist, not your whole arm, should be used in combination with your thumb and fingers to create the movement for painting different types of strokes.

- Hold the handle of the brush lightly but securely in your hand about halfway down, supported by your thumb and fingers. Depending on the effect you want to create, hold the handle either inclined, at a 45-degree angle, or vertically, at a 90-degree angle.

- Place half or more of the brush on the sheet of paper and let the brush slide, usually in a straight line, though sometimes in a zigzag. If the tone of the medium sumi ink (*chūboku*) and the movement of the brush in the *sokuhitsu* position are correct, you should be able to distinguish the variations in the sumi as it passes from light to medium to dark.

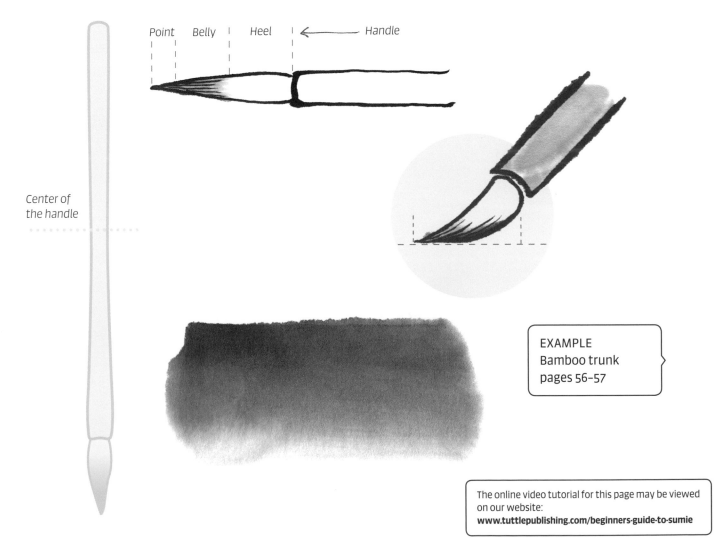

Point Belly Heel ← Handle

Center of
the handle

EXAMPLE
Bamboo trunk
pages 56–57

The online video tutorial for this page may be viewed on our website:
www.tuttlepublishing.com/beginners-guide-to-sumie

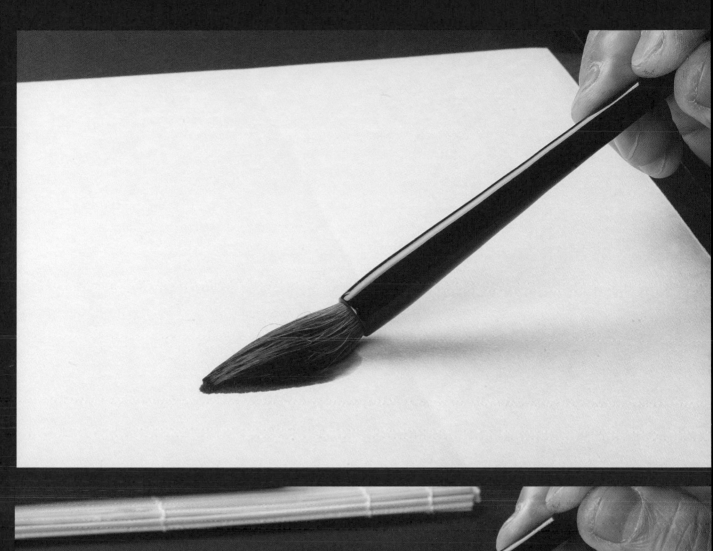

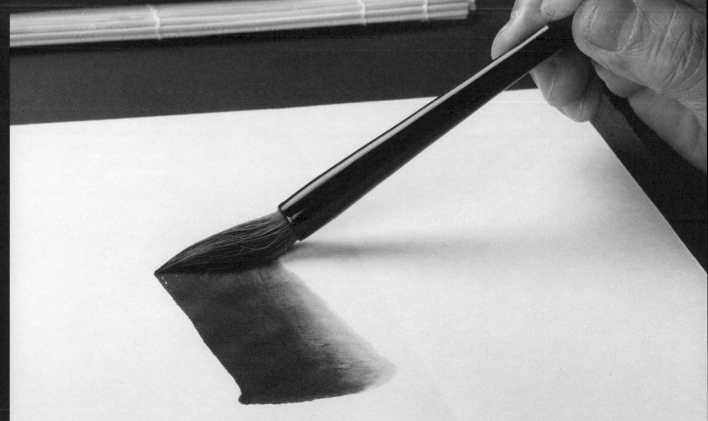

Chokuhitsu

直筆

In the *chokuhitsu* technique, the brush is used to draw points and lines directly on the paper. The brush is held perpendicular to the paper for both points and lines.

- Place the tip of your brush on the paper in a vertical position and let it slide while exerting light pressure. Do not push down too hard on the base of the brush. This technique makes it possible to obtain different shades from a single application of ink as the brush releases the ink. The part drawn first will be the darkest, but as the brush travels the ink will gradually become diluted and thus lighter in tone.

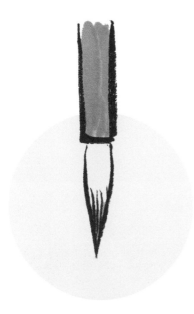

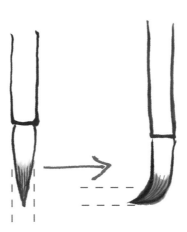

- When painting tiny details, hold the brush in a vertical position.

- When drawing lines, apply light pressure and slide the brush vertically over the paper.

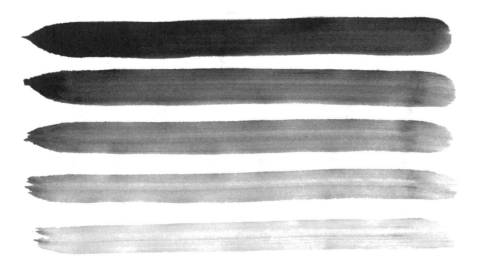

EXAMPLE
Plum blossoms
pages 72–77

The online video tutorial for this page may be viewed on our website:
www.tuttlepublishing.com/beginners-guide-to-sumie

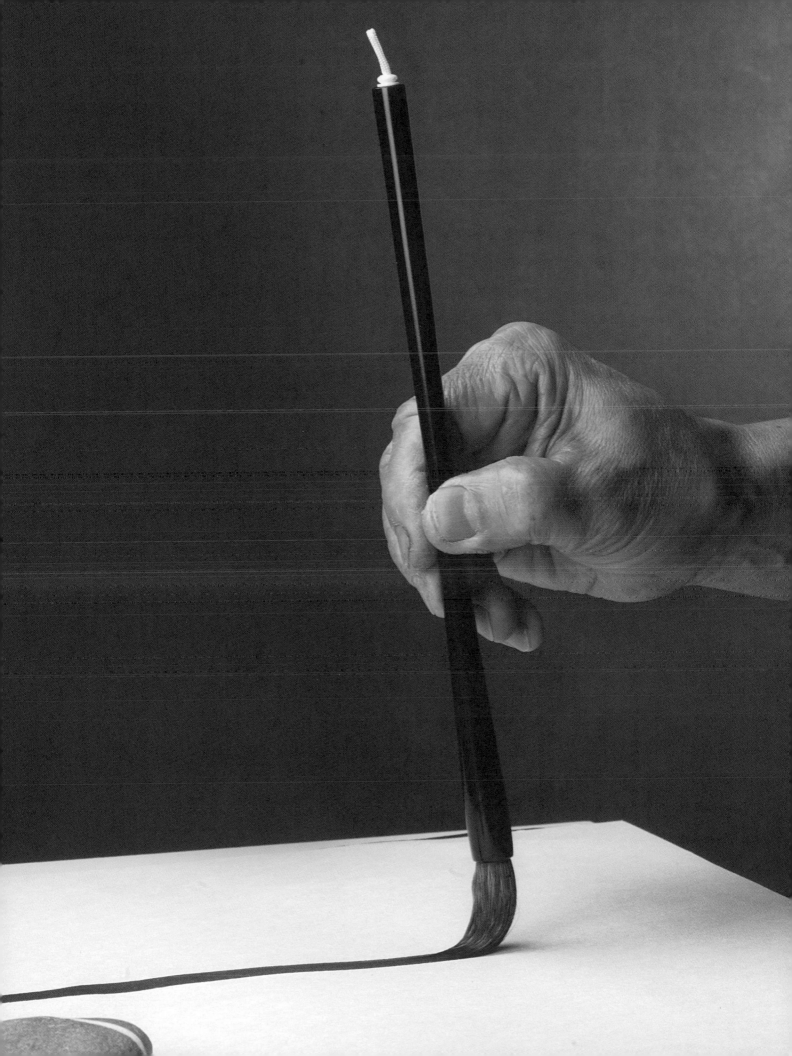

Urafude

裏筆

This technique is widely used for painting stems or branches. The dark areas represent the nodes from which the flowers or leaves emerge.

- Dip your brush in light sumi. Squeeze out excess liquid and shape the tip.

- Put some dark sumi on the edge of the dish and "soil" the bristles of the brush for a moment. If the "soiling" is done correctly, you should be able to paint a stripe in dark sumi using the brush from base to tip.

- Turn the brush around so that the dark sumi is on top.

- Draw the line holding the brush in the inclined *sokuhitsu* position. Stop at regular intervals and press lightly. In this way, you will obtain larger, darker areas to indicate the nodes.

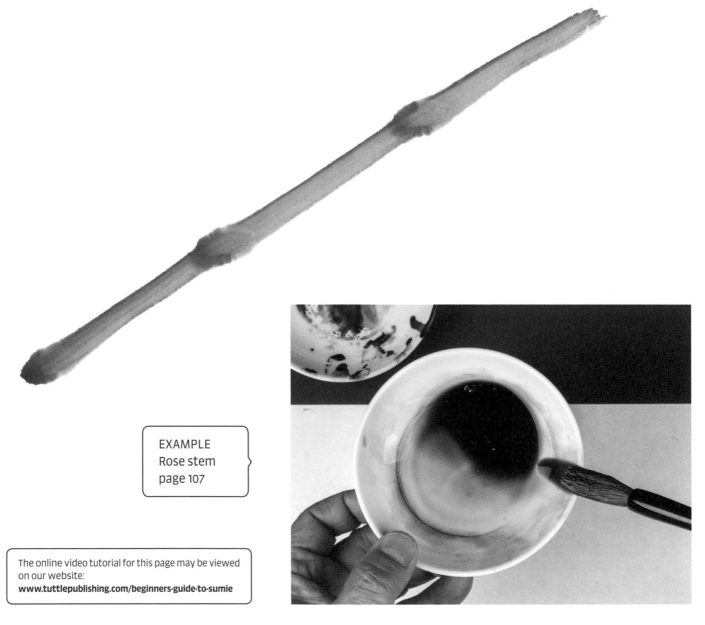

EXAMPLE
Rose stem
page 107

The online video tutorial for this page may be viewed on our website:
www.tuttlepublishing.com/beginners-guide-to-sumie

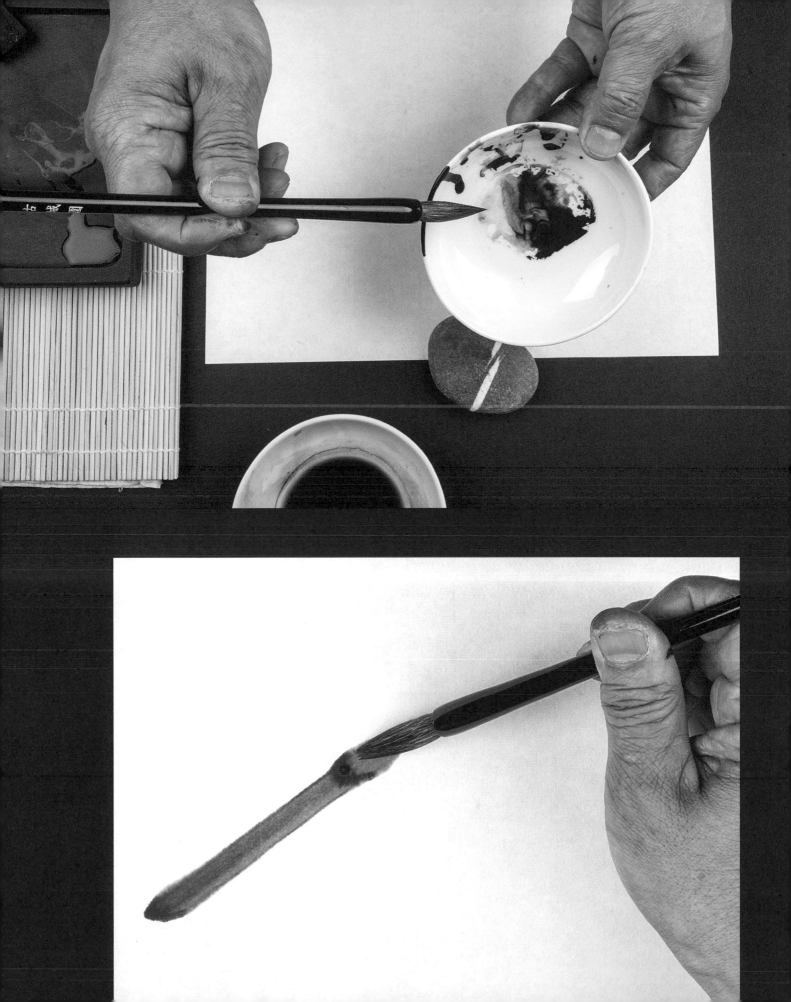

Junpitsu

潤筆

With this technique you can paint soft or delicately textured subjects, such as certain types of leaves and flowers or butterfly wings.

- When working in this technique, do not squeeze the excess liquid from the brush. Prepare the medium sumi in the usual way.

The online video tutorial for this page may be viewed on our website:
www.tuttlepublishing.com/beginners-guide-to-sumie

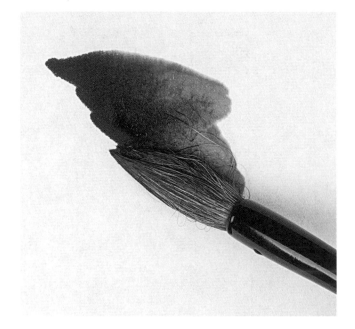

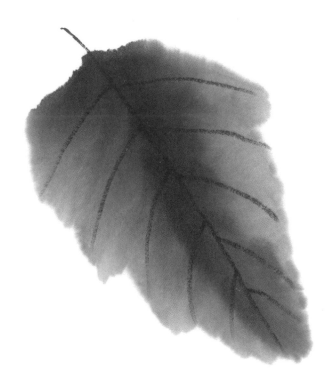

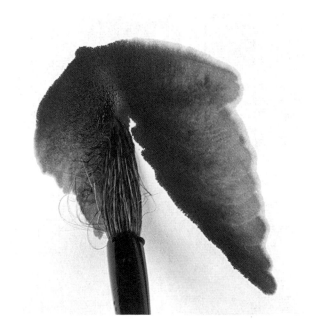

EXAMPLE
Asagao leaf
page 124

Kappitsu

渇筆

This technique is used primarily for painting tree trunks, rocks, mountains and moving water.

- Prepare the medium sumi, making sure to squeeze out as much excess liquid as possible.

- Outline the subject while holding the brush in the vertical *sokuhitsu* position. If you prepare the sumi and perform the action correctly, the brush will splay open and create the illusion of irregular texture through the different tones of the ink.

- In order to create more subtle shapes, such as branches, pull the brush upright in the *chokuhitsu* position.

> The online video tutorial for this page may be viewed on our website:
> **www.tuttlepublishing.com/beginners-guide-to-sumie**

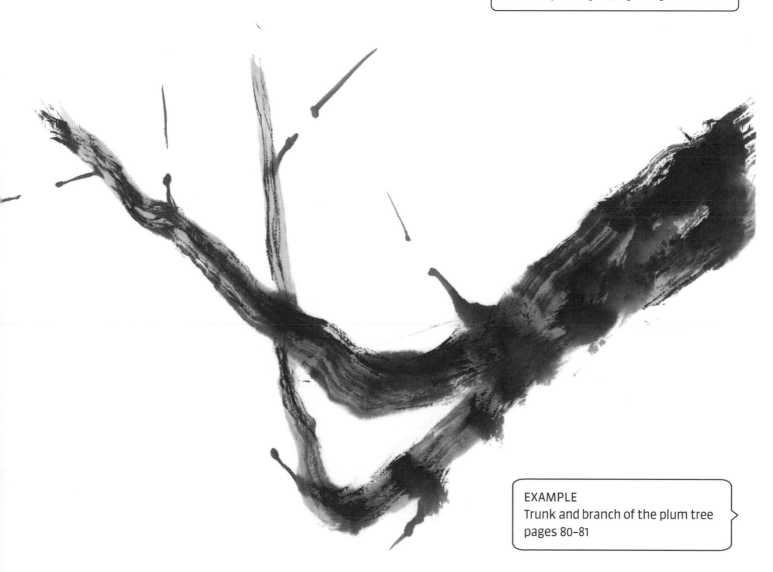

> EXAMPLE
> Trunk and branch of the plum tree
> pages 80–81

Nijimi

In the *nijimi* technique, ink applied to moistened paper spreads beyond the original brushstroke. For this reason, the technique is widely used to depict the fuzziness of animal fur. The *nijimi* effect depends on the absorbency of the paper and the amount of water mixed with the sumi ink.

- Using clean water, moisten your sheet of paper only in the places where you want to paint.

- Apply light sumi in the shape of the animal you want to depict. The light sumi will bleed over the moistened area, producing a fuzzy quality. Then tap the tip of the brush up and down to create texture.

- Before the paper dries, add some medium sumi to create patches of shadow.

The online video tutorial for this page may be viewed on our website:
www.tuttlepublishing.com/beginners-guide-to-sumie

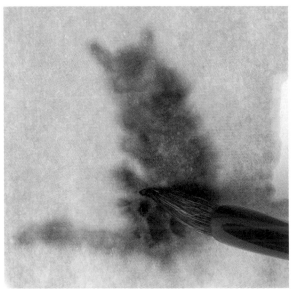

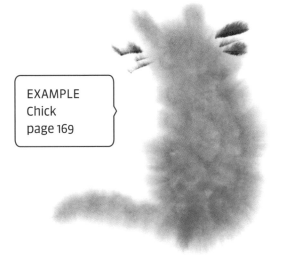

EXAMPLE
Chick
page 169

Mokkotsu 没骨

In the *mokkotsu* technique, no brush-strokes are used to produce contours or outlines. Instead, forms are shaped solely of ink and shading.

EXAMPLE
Butterfly
pages 165–167

Tenbyō
点描

In this technique, the tip of the brush is used to make dots with dark sumi.

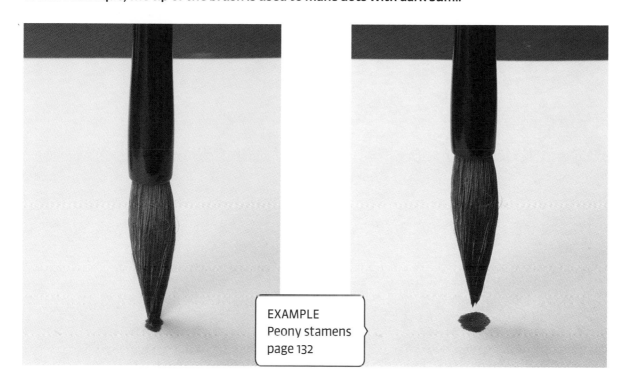

EXAMPLE
Peony stamens
page 132

The online video tutorial for this page may be viewed on our website:
www.tuttlepublishing.com/beginners-guide-to-sumie

Senbyō 線描

In this technique, the tip of the brush is used to draw lines.

EXAMPLE
Thorns of the chestnut burr
page 153

Kasure

掠れ

Kasure is very different from the usual Sumi-e techniques because it is basically a dry brush technique. It is effective in adding realism to tree trunks, rocks and mountains by adding texture and multiple irregular lines. A brush composed of coarse hair, such as a mountain horse hair brush, or a flexible, resilient *choryu* brush, are most suitable for this technique.

- Load the brush with dark sumi ink only or with medium sumi, depending on the subject. Squeeze out all excess liquid so that the brush is quite dry. This will allow the bristles to spread out.

- Holding the brush in the vertical *chokuhitsu* position, outline the subject by moving the brush in an irregular way, twisting it around and dragging it up and down to create the appearance of "coarseness."

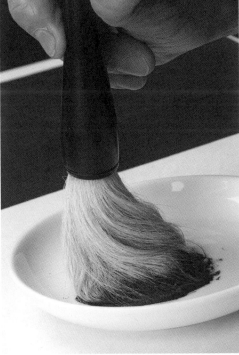

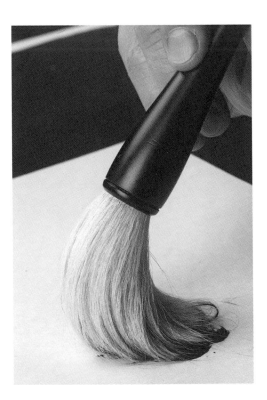

The online video tutorial for this page may be viewed on our website:
www.tuttlepublishing.com/beginners-guide-to-sumie

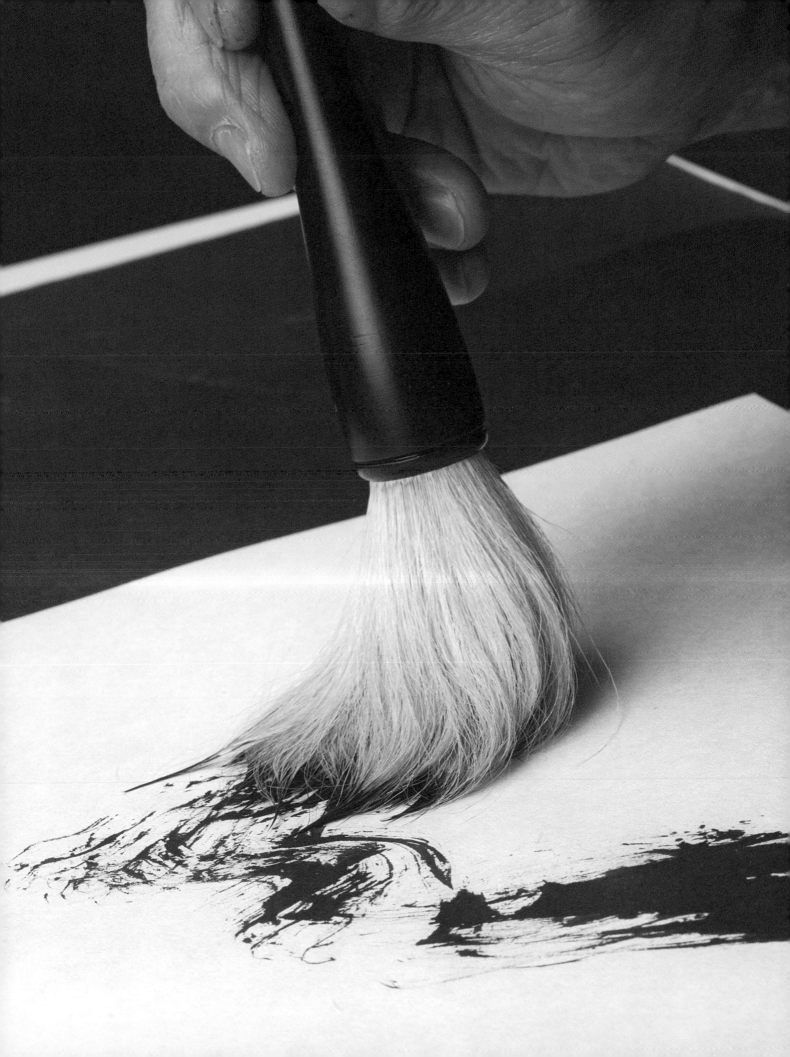

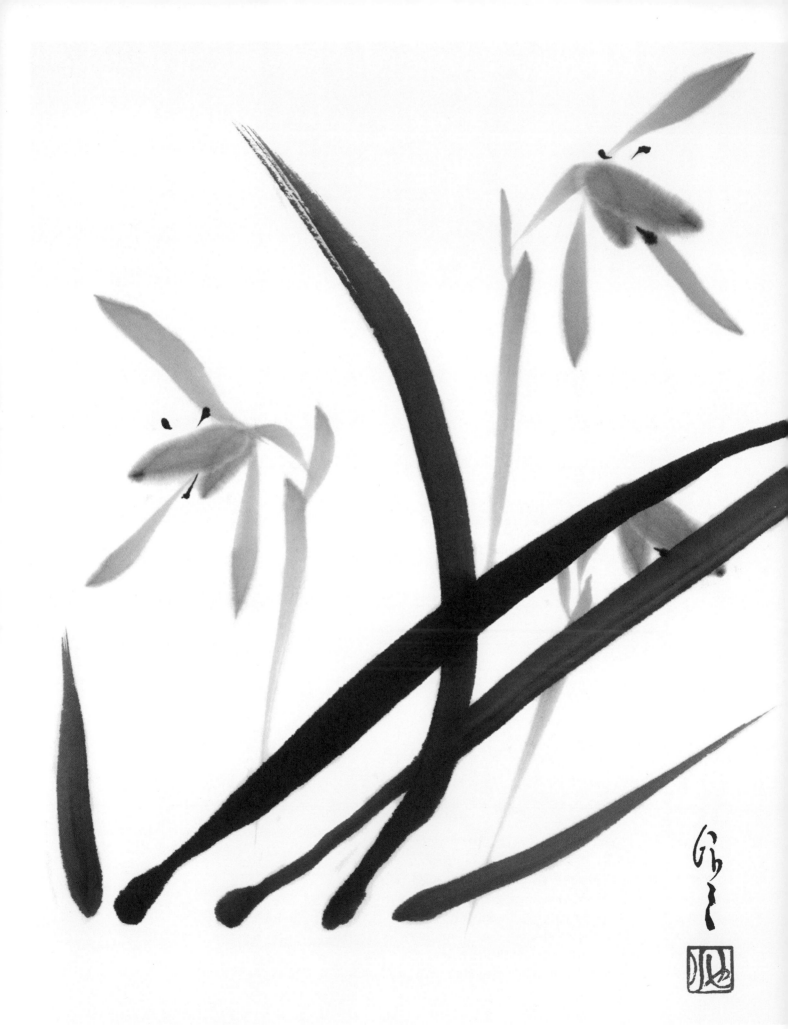

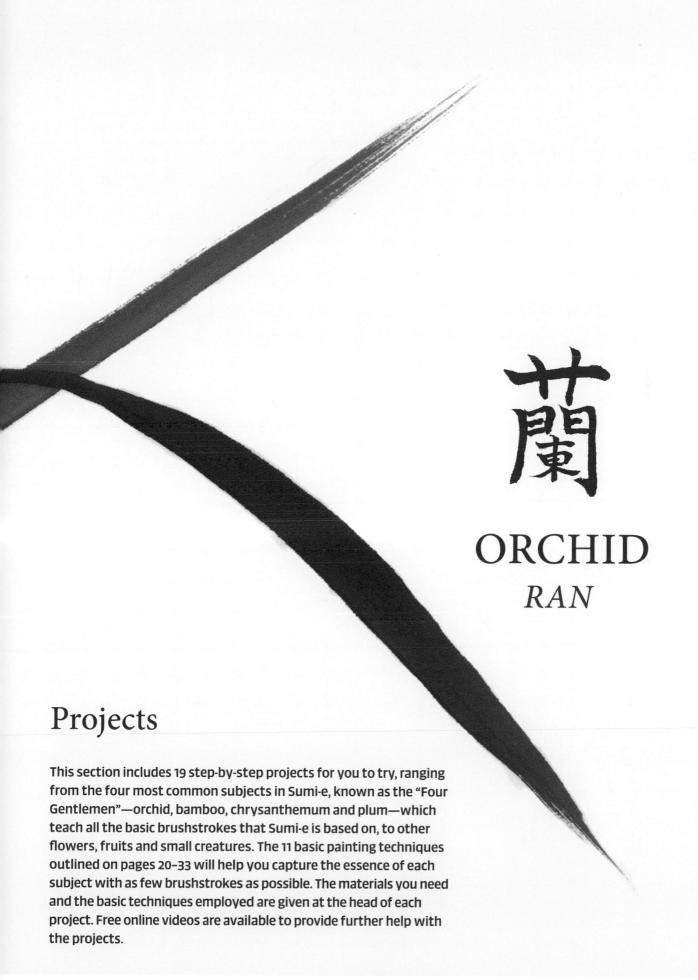

蘭
ORCHID
RAN

Projects

This section includes 19 step-by-step projects for you to try, ranging from the four most common subjects in Sumi-e, known as the "Four Gentlemen"—orchid, bamboo, chrysanthemum and plum—which teach all the basic brushstrokes that Sumi-e is based on, to other flowers, fruits and small creatures. The 11 basic painting techniques outlined on pages 20–33 will help you capture the essence of each subject with as few brushstrokes as possible. The materials you need and the basic techniques employed are given at the head of each project. Free online videos are available to provide further help with the projects.

LEAF 葉 *HA*

LEAF A (MOUNTAIN-SHAPED)

- Large brush
- Medium sumi
- *Senbyō*
- *Chokuhitsu*

Shown here is the wild orchid, a typical Japanese plant with long, slender leaves and individual flowers. The Japanese believe it represents feminine virtues, such as beauty, grace, gentleness and fragility. In this Sumi-e composition, the orchid has two flowers and a bud, each with its own stem, as well as five leaves, three of which are principal leaves and must be painted according to rules.

The online video tutorial for this page may be viewed on our website:
www.tuttlepublishing.com/beginners-guide-to-sumie

�֎ The orchid is one of the four traditional subjects (the "Four Gentlemen") that most students of Sumi-e learn first because they include all the basic strokes necessary to paint other Sumi-e subjects. The other three "Gentlemen" are bamboo, chrysanthemum and plum. The orchid represents spring and is a symbol of hope, new beginnings and the bright promise of beauty. Painting an orchid teaches beginners of Sumi-e how to make curved lines and create gradations in medium sumi ink.

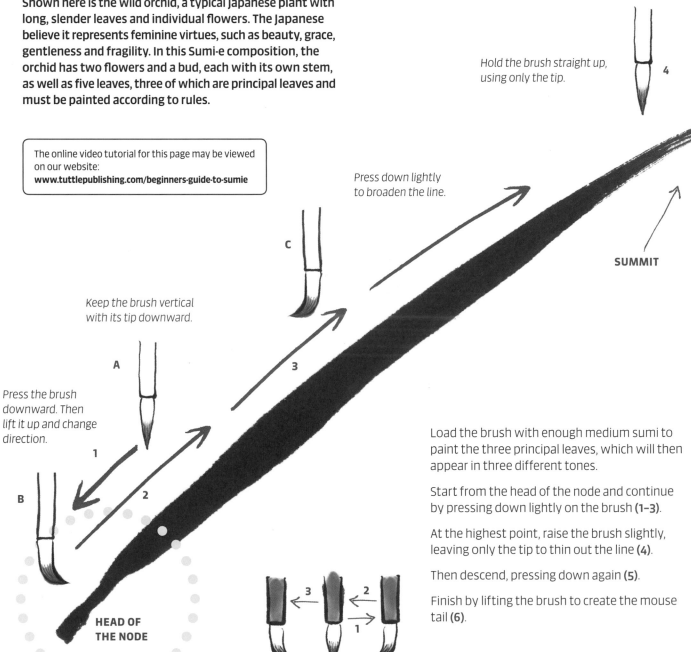

Hold the brush straight up, using only the tip.

4

Press down lightly to broaden the line.

C

SUMMIT

Keep the brush vertical with its tip downward.

A

3

Press the brush downward. Then lift it up and change direction.

1

B

2

HEAD OF THE NODE

Load the brush with enough medium sumi to paint the three principal leaves, which will then appear in three different tones.

Start from the head of the node and continue by pressing down lightly on the brush **(1–3)**.

At the highest point, raise the brush slightly, leaving only the tip to thin out the line **(4)**.

Then descend, pressing down again **(5)**.

Finish by lifting the brush to create the mouse tail **(6)**.

3 ← 2 ←

1 →

C A B

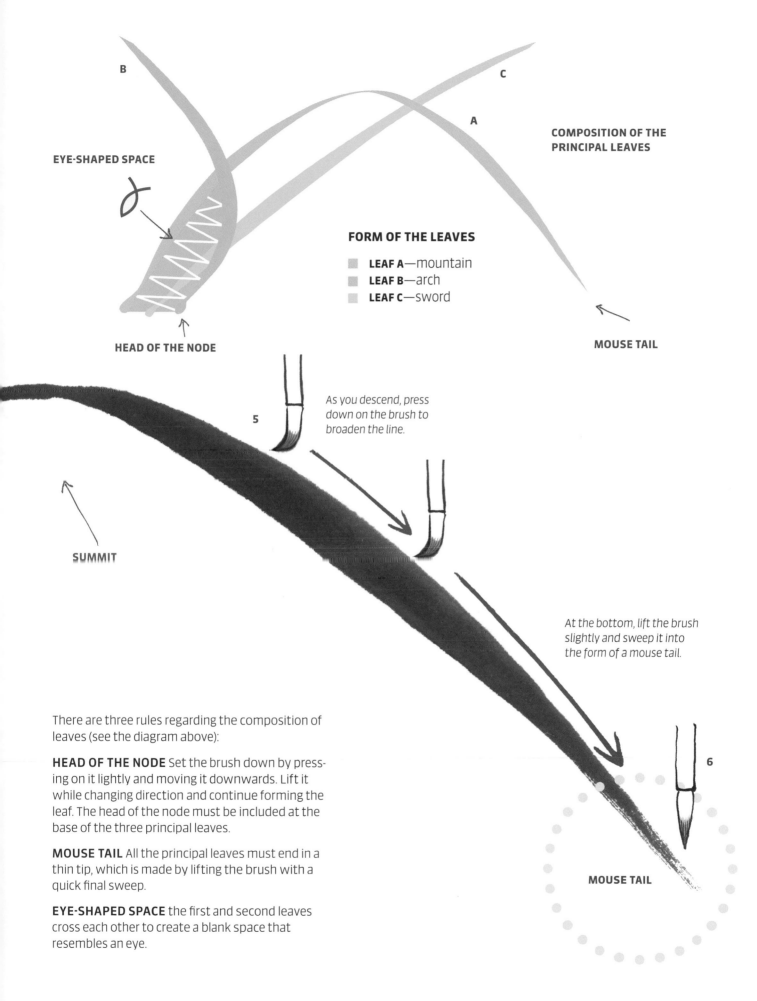

COMPOSITION OF THE PRINCIPAL LEAVES

B

C

A

EYE-SHAPED SPACE

FORM OF THE LEAVES

LEAF A—mountain
LEAF B—arch
LEAF C—sword

HEAD OF THE NODE

MOUSE TAIL

5

As you descend, press down on the brush to broaden the line.

SUMMIT

At the bottom, lift the brush slightly and sweep it into the form of a mouse tail.

6

MOUSE TAIL

There are three rules regarding the composition of leaves (see the diagram above):

HEAD OF THE NODE Set the brush down by pressing on it lightly and moving it downwards. Lift it while changing direction and continue forming the leaf. The head of the node must be included at the base of the three principal leaves.

MOUSE TAIL All the principal leaves must end in a thin tip, which is made by lifting the brush with a quick final sweep.

EYE-SHAPED SPACE the first and second leaves cross each other to create a blank space that resembles an eye.

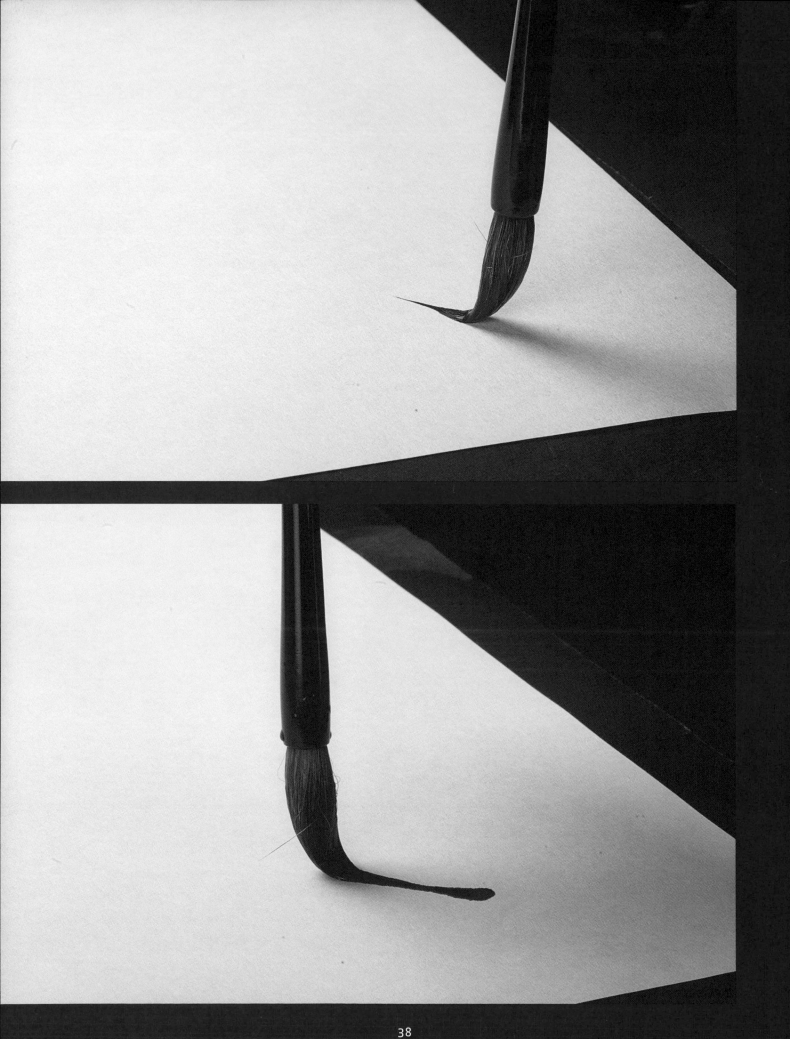

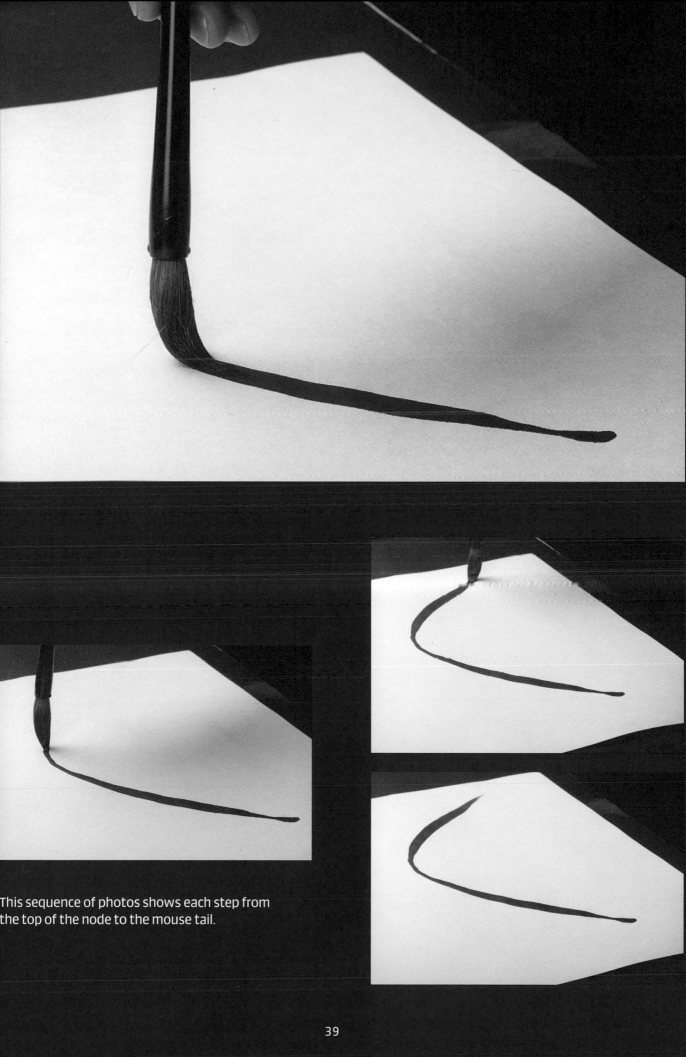

This sequence of photos shows each step from
the top of the node to the mouse tail.

LEAF B (ARC-SHAPED)

• *Chokuhitsu*

Without reloading your brush with more medium sumi, continue to the second, arc-shaped leaf.

Holding the brush in the *chokuhitsu* position, begin from the base line of the preceding leaf.

Create the top of the node as explained on p. 38 **(1, 2)**.

Pressing down lightly on the brush in order to broaden the outline, make an arc-like movement upwards and slightly back **(3)**.

Lift the brush at the end to form the mouse tail **(4)**.

4

MOUSE TAIL

LEAF B

Press on the brush and sweep upwards.

3

3 **2**

1

C **A** **B**

LEAF A

1

2

Ground line

HEAD OF THE NODE

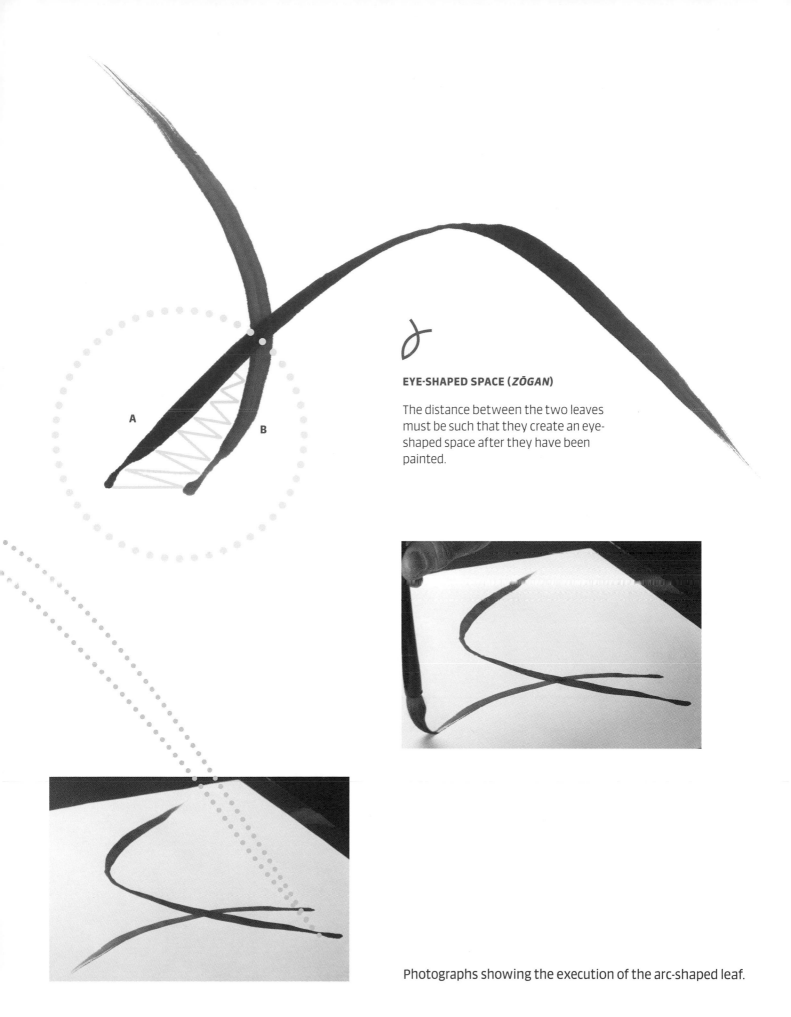

EYE-SHAPED SPACE (*ZŌGAN*)

The distance between the two leaves must be such that they create an eye-shaped space after they have been painted.

Photographs showing the execution of the arc-shaped leaf.

LEAF C (SWORD-SHAPED)

• *Chokuhitsu*

The third leaf is sword-shaped. Its base lies halfway between the other two leaves, as indicated, but still on the ground line.

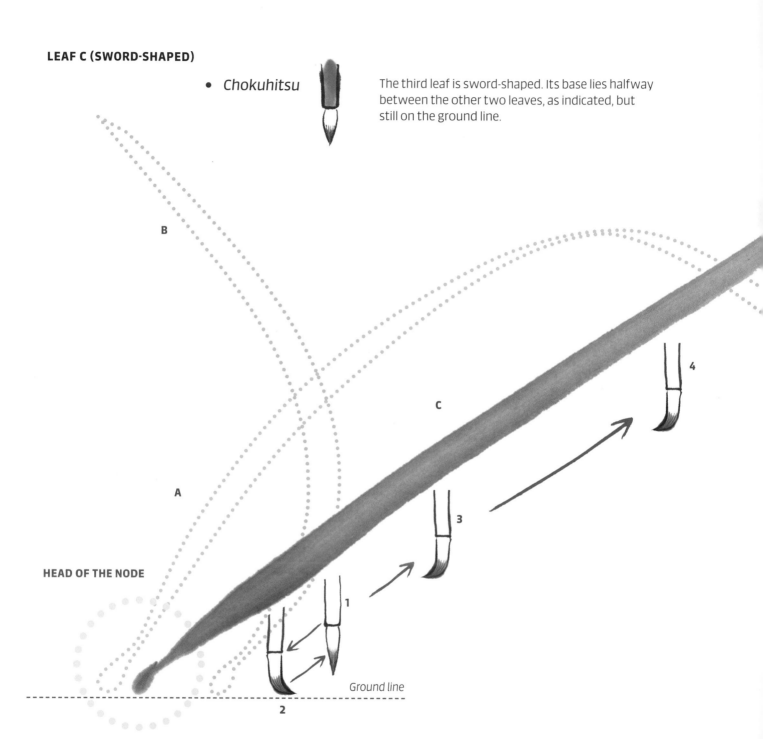

B

C

A

HEAD OF THE NODE

Ground line

Each leaf tip ought to point towards a different corner of the paper.

Shape the head of the node, then proceed with the *chokuhitsu* position in a straight line, crossing the other two leaves **(1, 2)**.

As in the preceding case, apply light pressure to broaden the line the length of the entire leaf **(3, 4)**.

Complete the leaf with the mouse tail **(5)**.

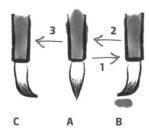

C **A** **B**

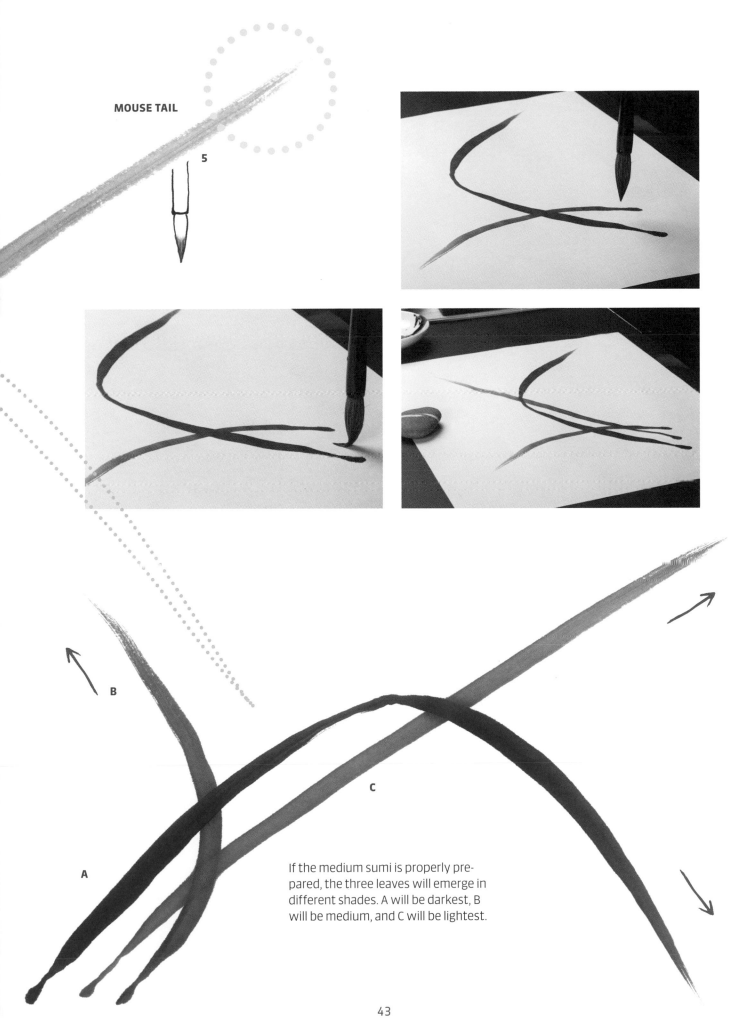

MOUSE TAIL

5

If the medium sumi is properly prepared, the three leaves will emerge in different shades. A will be darkest, B will be medium, and C will be lightest.

A

B

C

SIDE LEAVES, D AND E

- Large brush
- Medium sumi
- Senbyō

- *Chokuhitsu*

To complete the composition, add the two side leaves. Using the large brush and medium sumi, paint the two leaves according to the diagram.

For these side leaves, you do not need to follow the technique used for the head of the node.

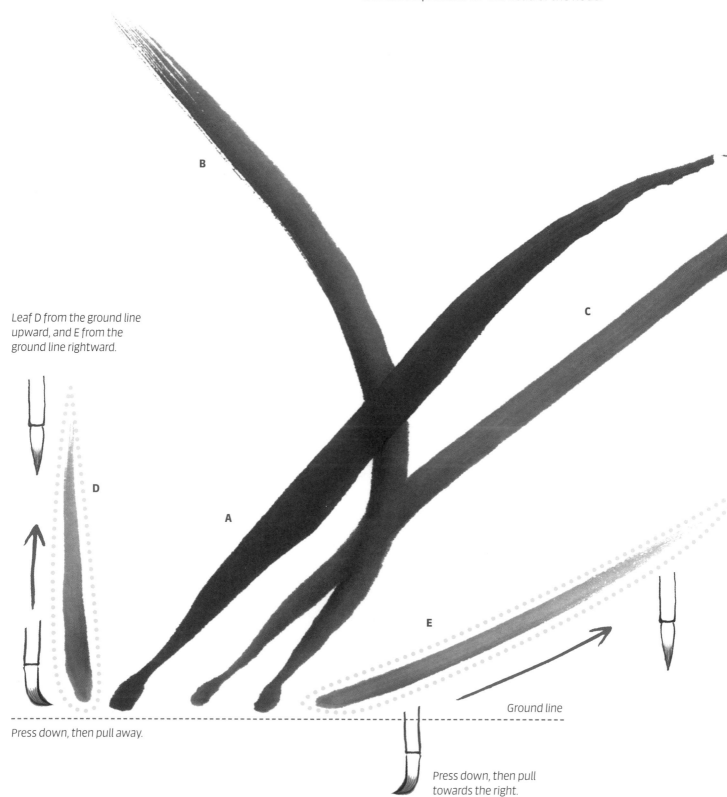

Leaf D from the ground line upward, and E from the ground line rightward.

B

C

D

A

E

Press down, then pull away.

Ground line

Press down, then pull towards the right.

44

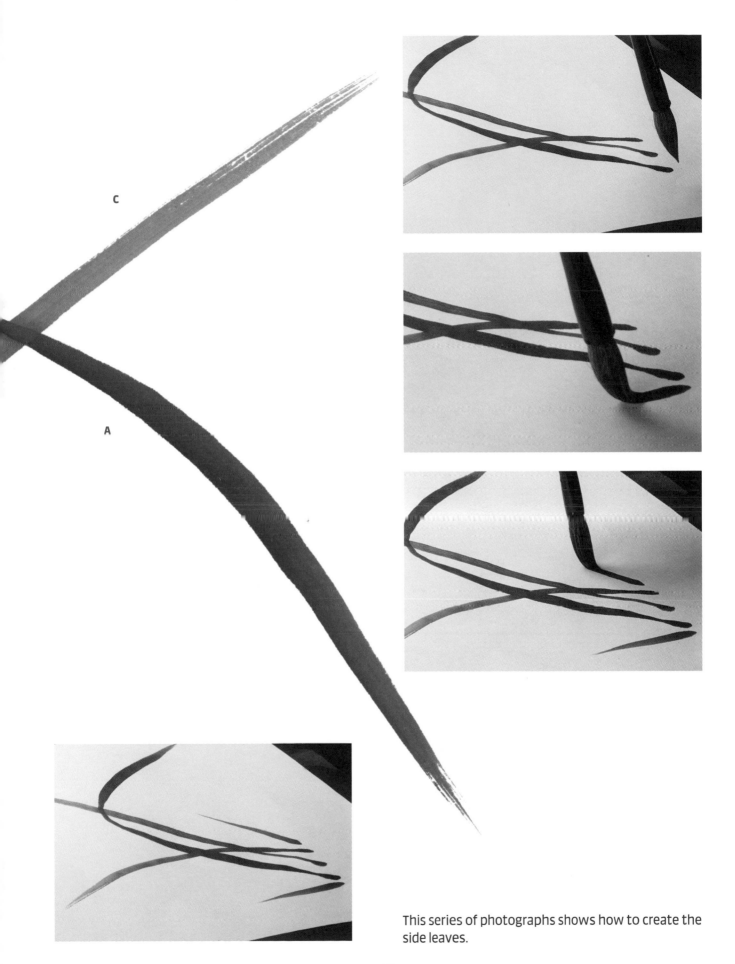

C

A

This series of photographs shows how to create the side leaves.

45

FLOWER 花 *HANA*

FLOWER—LEFT SIDE

- Large brush
- Light + dark sumi
- *Mokkotsu*
- *Sokuhitsu*
- *Chokuhitsu*

❖ The orchid flower consists of five petals. A traditional composition contains two flowers and a bud, each with a stem.

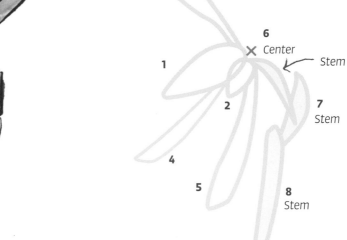

Diagram of the flower

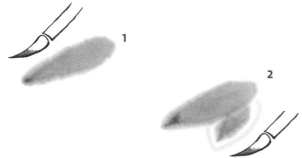

After dipping the brush in light sumi, squeeze out the excess liquid by running the brush over the edge of the dish, then dipping only the tip into the dark sumi. You must paint the entire flower and its stem with this amount of ink.

Lay the brush down, then lift it in the *sokuhitsu* position. This movement must be done quickly to prevent the sumi from spreading too far and bleeding **(1)**.

Create the second petal with a similar action, but using only the tip of the brush to paint a smaller petal that slightly overlaps the first one, as in the diagram **(2)**.

Keeping the brush in the *chokuhitsu* position, draw the remaining petals **(3–5)**, always working from the outside inwards towards the center.

It is important that the angle and position of the petals be correct. In addition, their dimensions should not be identical. Petal 3 should be slightly larger, while petal 4 should be smaller.

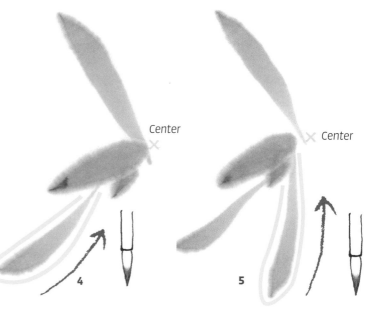

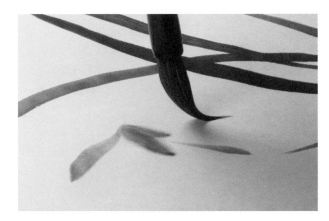

FLOWER STEM—LEFT SIDE

- Large brush
- Light + dark sumi
- *Mokkotsu*
- *Chokuhitsu*

If the bristles of the brush have dried out, apply a drop of water to the bottom of the brush, near the handle, with your finger.

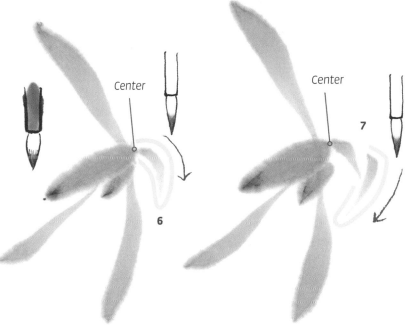

Center

6

Center

7

Starting at the center of the flower, make three strokes in the *chokuhitsu* position for the stem, then make two shorter ones **(6, 7)**, and a final longer one **(8)**, as shown in the diagram.

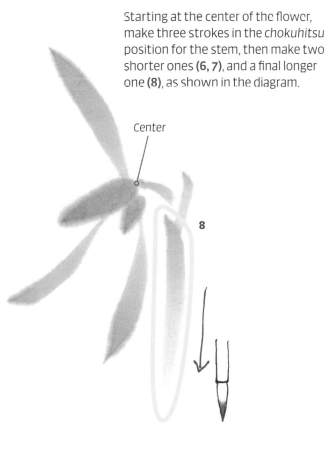

Center

8

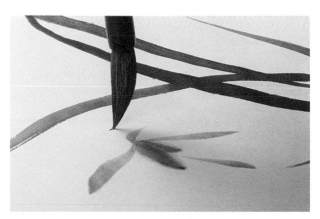

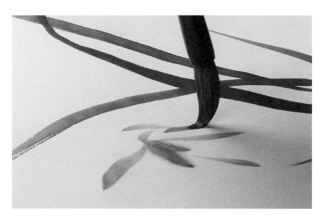

FLOWER—RIGHT SIDE

- Large brush
- Light + dark sumi
- Mokkotsu
- Sokuhitsu
- Chokuhitsu

Make the flower on the right in the same way as the one on the left. As one is the mirror image of the other, you must draw their features in reverse.

Diagram of the flower

The tip of the brush must point to the right (**1, 2**). Draw the petals from right to left (**3–5**), always headed towards the center.

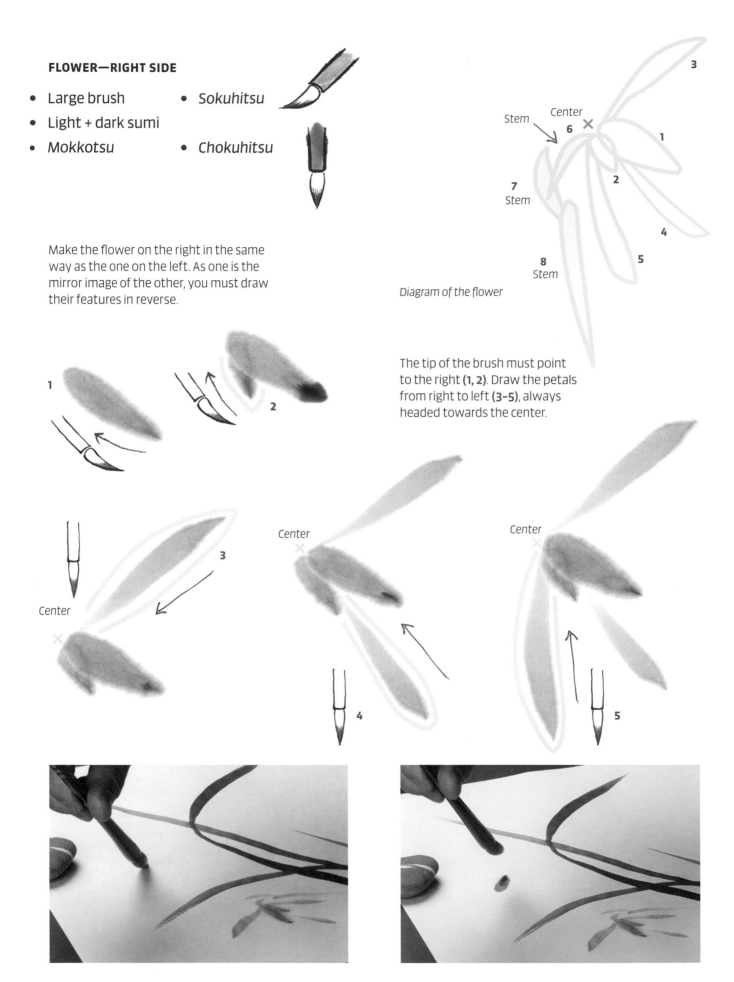

FLOWER STEM—RIGHT PART

- Large brush
- Light sumi
- *Mokkotsu*
- *Chokuhitsu*

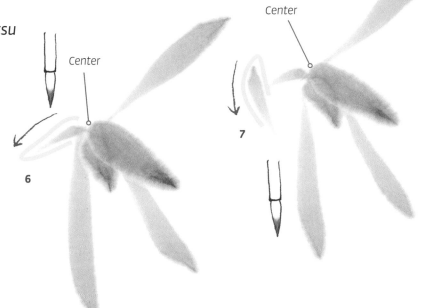

Center

Center

6

7

The stem must be drawn to the left of the flower **(6–8)**.

Center

8

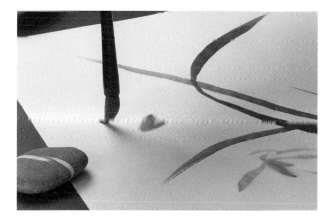

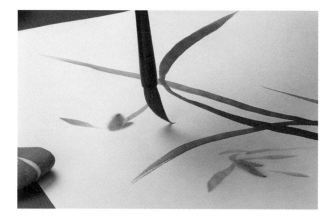

The photo sequence shows the steps for painting the flower on the right.

BUD 蕾 *TSUBOMI*

- Large brush
- Light + dark sumi
- *Mokkotsu*

- *Sokuhitsu*

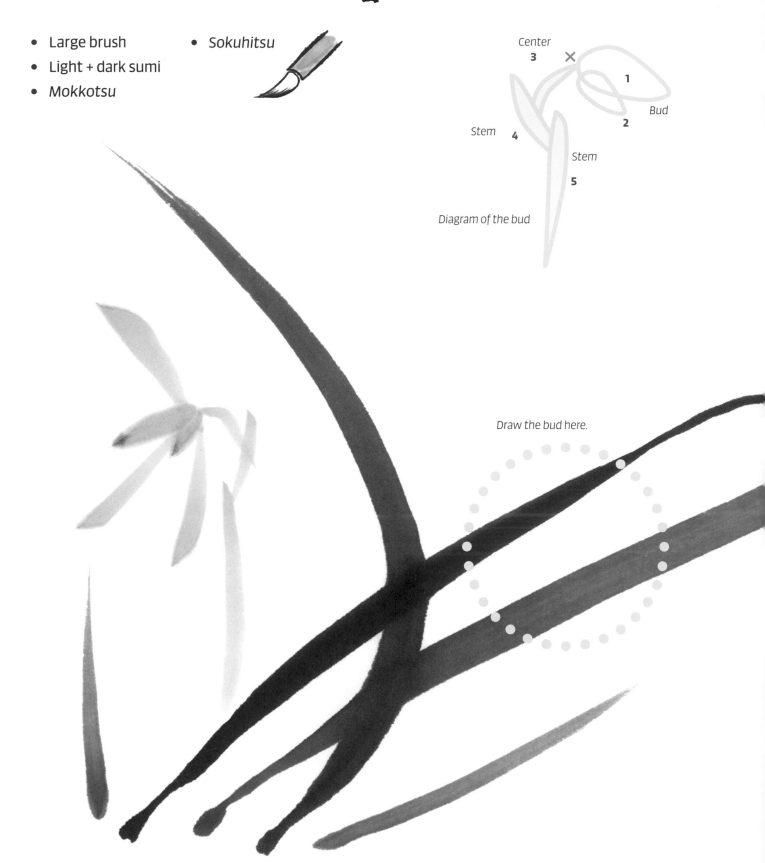

Center
3 ✕

1

2 Bud

Stem **4**

Stem

5

Diagram of the bud

Draw the bud here.

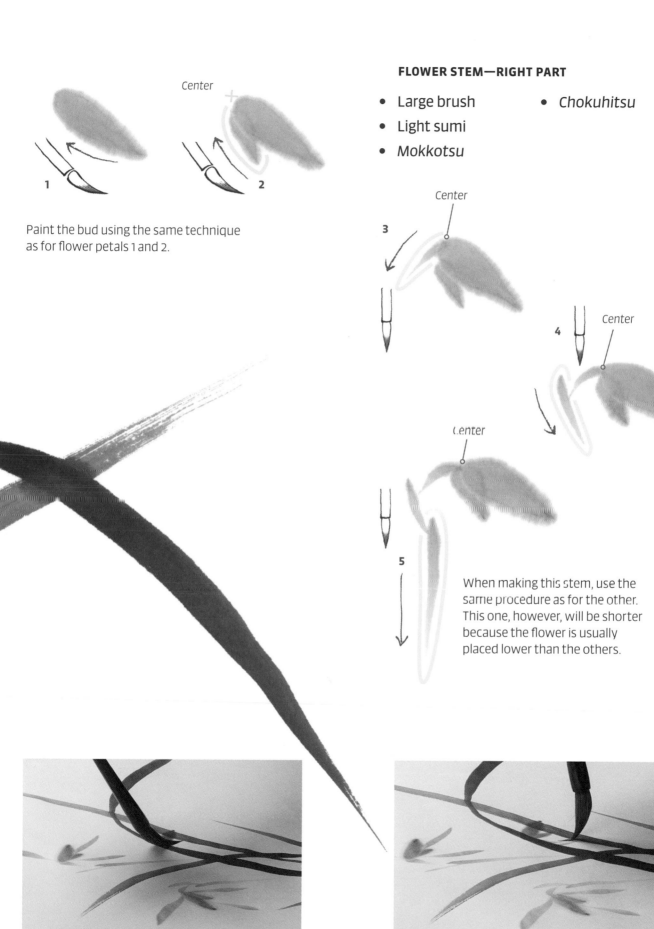

Center

1

2

Paint the bud using the same technique as for flower petals 1 and 2.

FLOWER STEM—RIGHT PART

- Large brush
- Light sumi
- *Mokkotsu*
- *Chokuhitsu*

Center

3

Center

4

Center

5

When making this stem, use the same procedure as for the other. This one, however, will be shorter because the flower is usually placed lower than the others.

PISTIL/STAMEN 心点 *SHINTEN*

- Small brush
- Dark sumi
- *Senbyō*

- *Chokuhitsu*

�֍ To complete the composition, place the heart inside the flower in accordance with the Japanese meaning of the word: *shin* means "heart" while *ten* means "dots."

Using the small brush and dark sumi, lay the bristles down and pull from the outside inwards.

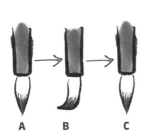

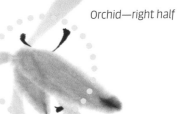

Orchid—right half

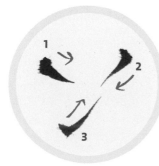

Orchid—left half

It is important to pay attention to the shape and size of the stamens as well as their position, as illustrated in the diagrams and photographs.

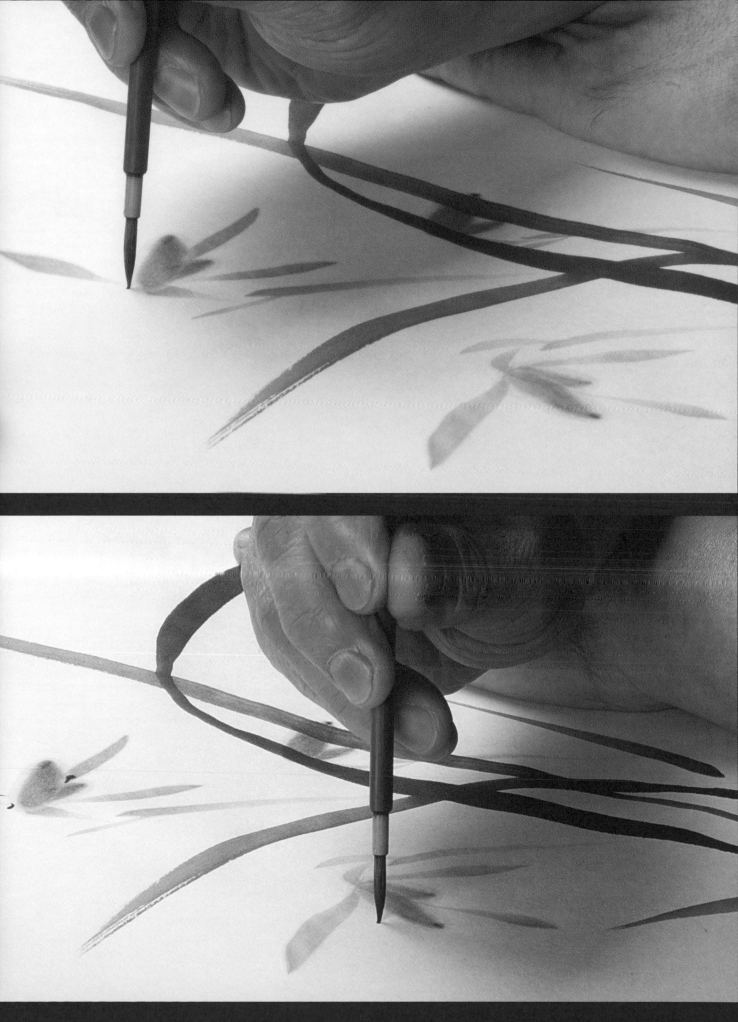

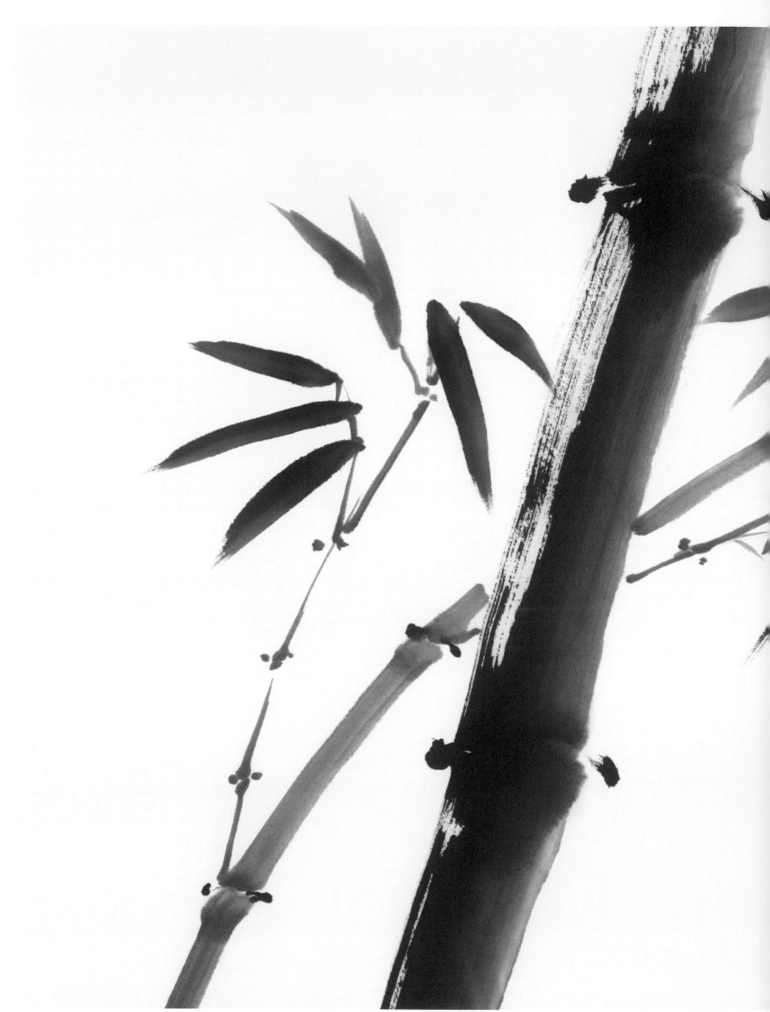

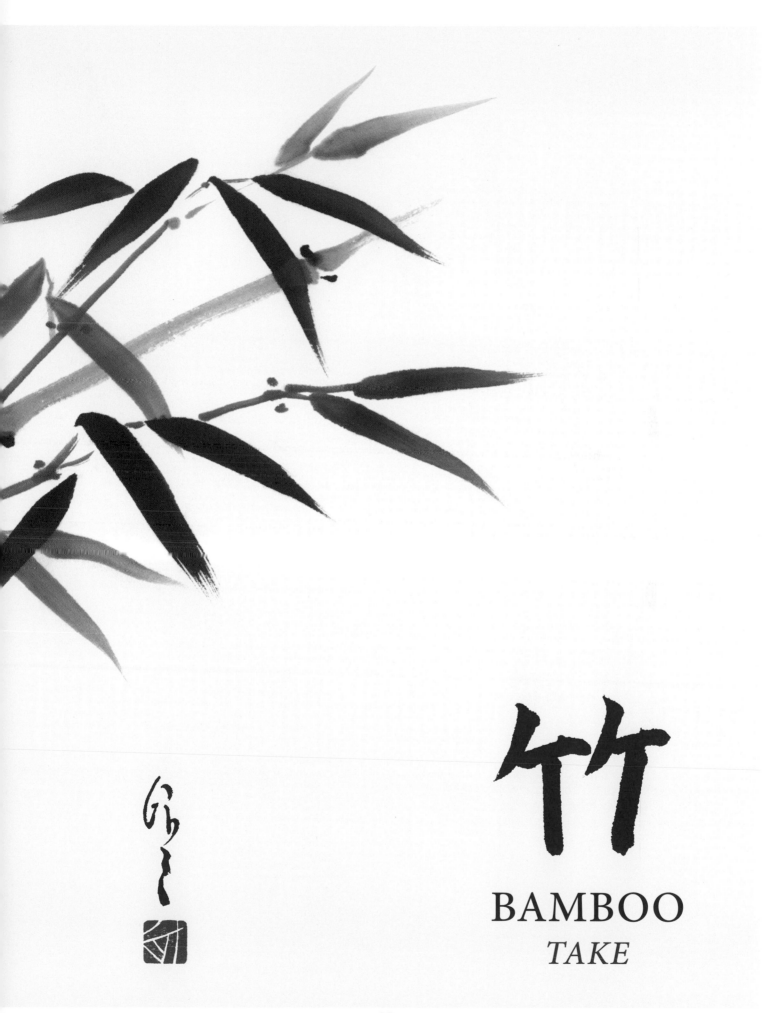

BAMBOO
TAKE

COMPOSITION OF THE WORK

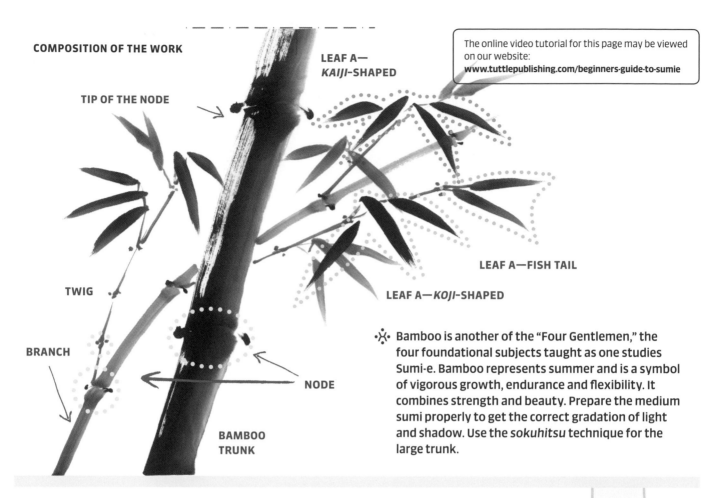

TIP OF THE NODE

LEAF A—*KAIJI*-SHAPED

The online video tutorial for this page may be viewed on our website: **www.tuttlepublishing.com/beginners-guide-to-sumie**

TWIG

BRANCH

NODE

BAMBOO TRUNK

LEAF A—FISH TAIL

LEAF A—*KOJI*-SHAPED

✵ Bamboo is another of the "Four Gentlemen," the four foundational subjects taught as one studies Sumi-e. Bamboo represents summer and is a symbol of vigorous growth, endurance and flexibility. It combines strength and beauty. Prepare the medium sumi properly to get the correct gradation of light and shadow. Use the *sokuhitsu* technique for the large trunk.

TRUNK *SAO*

- Large brush
- Medium sumi
- *Junpitsu + Mokkotsu*
- *Sokuhitsu*

✵ Bamboo's identifying feature is its straight trunk, which is composed of internodes of various lengths. The closer the internodes are to the top of the bamboo, the shorter and thinner they are. The first internode is usually short, the middle one medium-sized, and the top one extends beyond the page.

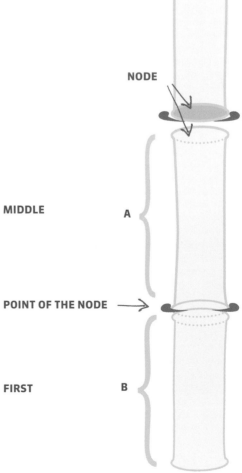

NODE

MIDDLE — A

POINT OF THE NODE →

FIRST — B

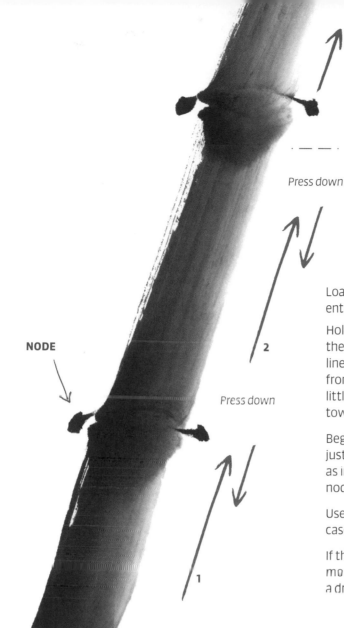

NODE

Press down

Press down

Load the large brush with enough medium sumi to draw the entire trunk.

Holding the brush in the *sokuhitsu* position, start from the base and slide the brush up to the first node with a linear and uniform movement **(1)**. Without lifting the brush from the paper, press down on it to spread out the ink a little. Then, with a quick movement, turn the brush around towards the already painted stem and pull it up **(2)**.

Begin the second internode, superimposing it on the one just completed and dragging the brush to the next node, as in the previous step. Repeat the instructions for the first node.

Use the same method for the third internode, which, in this case, will end at the edge of the paper **(3)**.

If the brush dries out after the first or second internode, moisten the base of the bristles, near the handle, with a drop of clean water.

TIP OF THE NODE 節 *FUSHI*

- Large brush
- Dark sumi
- *Tenbyō*
- *Chokuhitsu*

Move the brush in a semicircular motion from the outside to the inside to form a kind of comma. The nodes—another important bamboo feature—must be added to all the stems, branches and twigs only after the medium sumi on the trunk has dried in order to prevent the marks from bleeding.

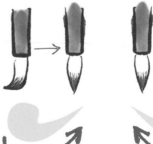

The form is shaped like a comma.

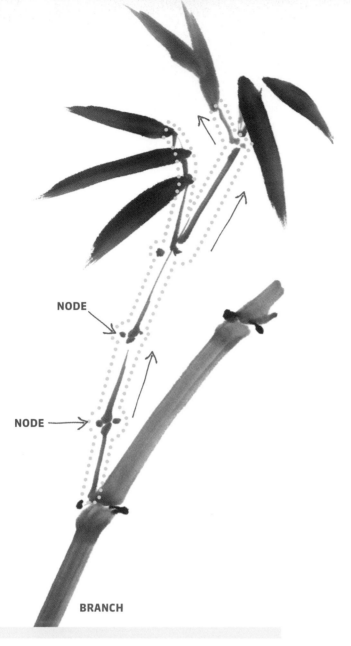

TWIG 小枝 *KOEDA*

- Small brush
- Medium sumi
- *Senbyō*

- *Chokuhitsu*

☼ **The twigs grow just above the nodes of the branches or stems. For a balanced and harmonious composition, add a twig for each node, but on alternate sides of the branch, that is, paint a twig on one side of the branch and the next on the other side.**

After completing the stem or branch, use the small brush and medium sumi to draw a straight, thin line, shaping the node of the twig by exerting slight pressure on the brush. Then continue as shown in the diagrams.

NODE

NODE

BRANCH

NODE

BRANCH 枝 *EDA*

- Large brush
- Light + dark sumi
- *Urafude*
- *Sokuhitsu*

NODE

To paint the branch, prepare the large brush as described for the *urafude* technique on p. 26. Starting from the bottom, draw a straight branch **(1)**. At the top of the node, rotate the tip of the brush clockwise.

For the second internode, start from the previous internode, rotate the brush counterclockwise, then continue with the stem **(2)**. Repeat the process for the next node.

58

This photo sequence shows the steps for painting the bamboo stem and branch.

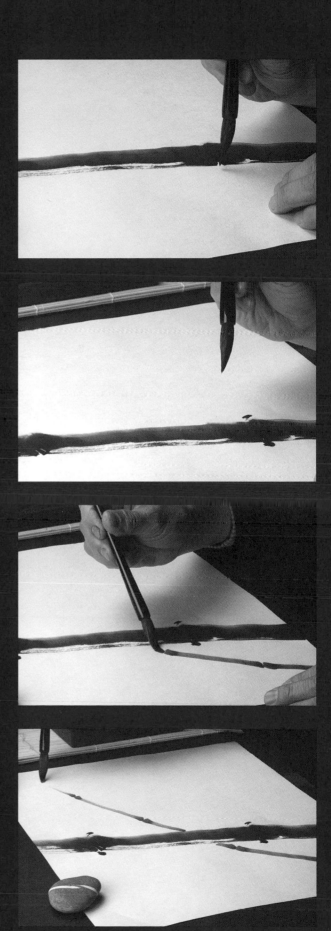

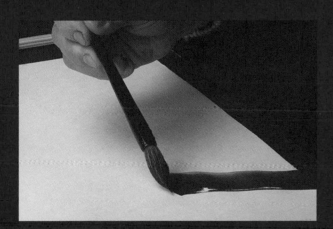

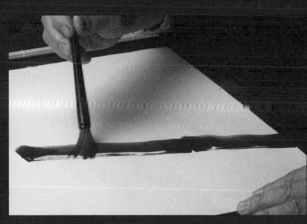

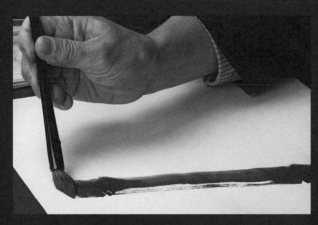

LEAF 葉 *HA*

BASIC FORM

- Large brush
- Medium sumi
- *Junpitsu + Mokkotsu*

- *Chokuhitsu*

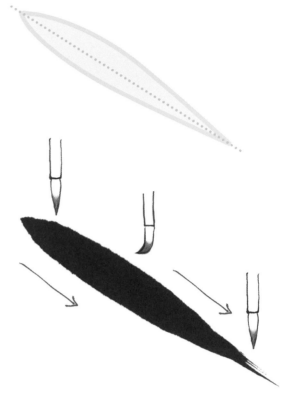

BASE Holding the brush in the *chokuhitsu* position, put it in place, apply light pressure, then slide it, as in the diagram on the right, and finally pull it up to form the tip of the leaf.

COMBINATION

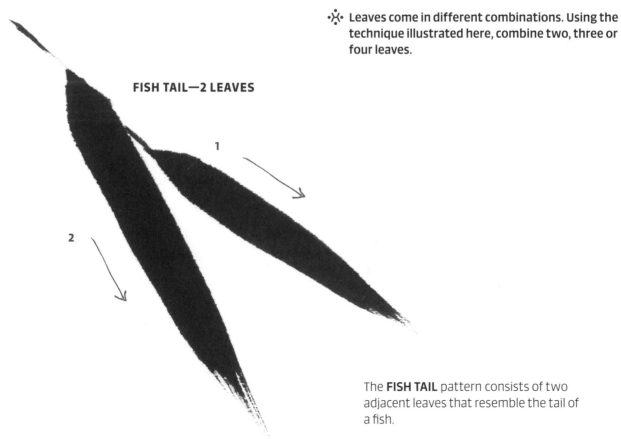

❖ Leaves come in different combinations. Using the technique illustrated here, combine two, three or four leaves.

FISH TAIL—2 LEAVES

The **FISH TAIL** pattern consists of two adjacent leaves that resemble the tail of a fish.

60

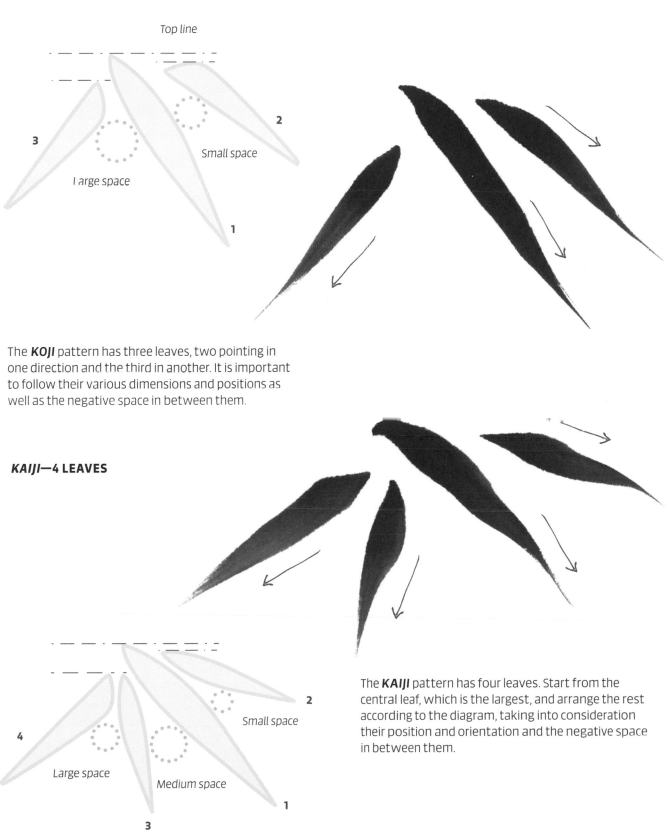

KOJI—3 LEAVES

Top line

3

2

Small space

Large space

1

The **KOJI** pattern has three leaves, two pointing in one direction and the third in another. It is important to follow their various dimensions and positions as well as the negative space in between them.

KAIJI—4 LEAVES

2

Small space

4

Large space

Medium space

1

3

The **KAIJI** pattern has four leaves. Start from the central leaf, which is the largest, and arrange the rest according to the diagram, taking into consideration their position and orientation and the negative space in between them.

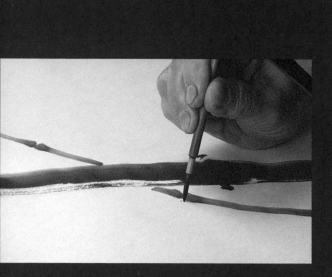

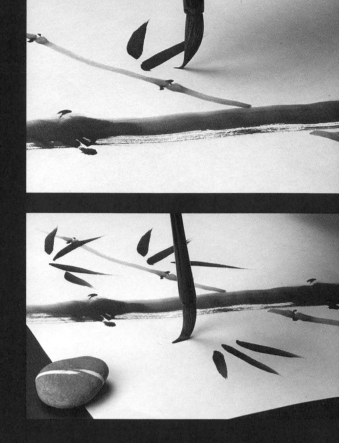

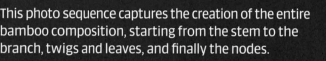

This photo sequence captures the creation of the entire bamboo composition, starting from the stem to the branch, twigs and leaves, and finally the nodes.

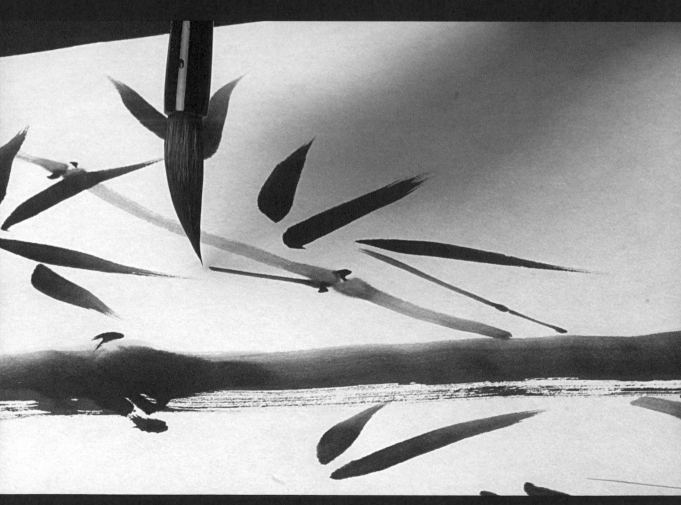

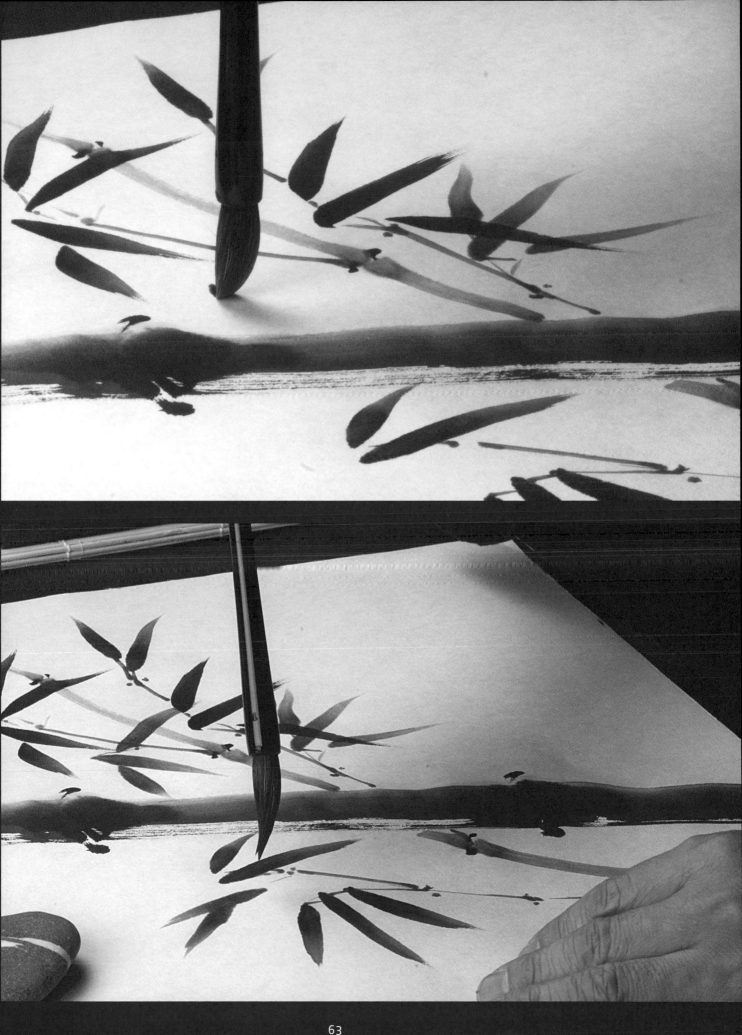

CHRYSANTHEMUM

KIKU

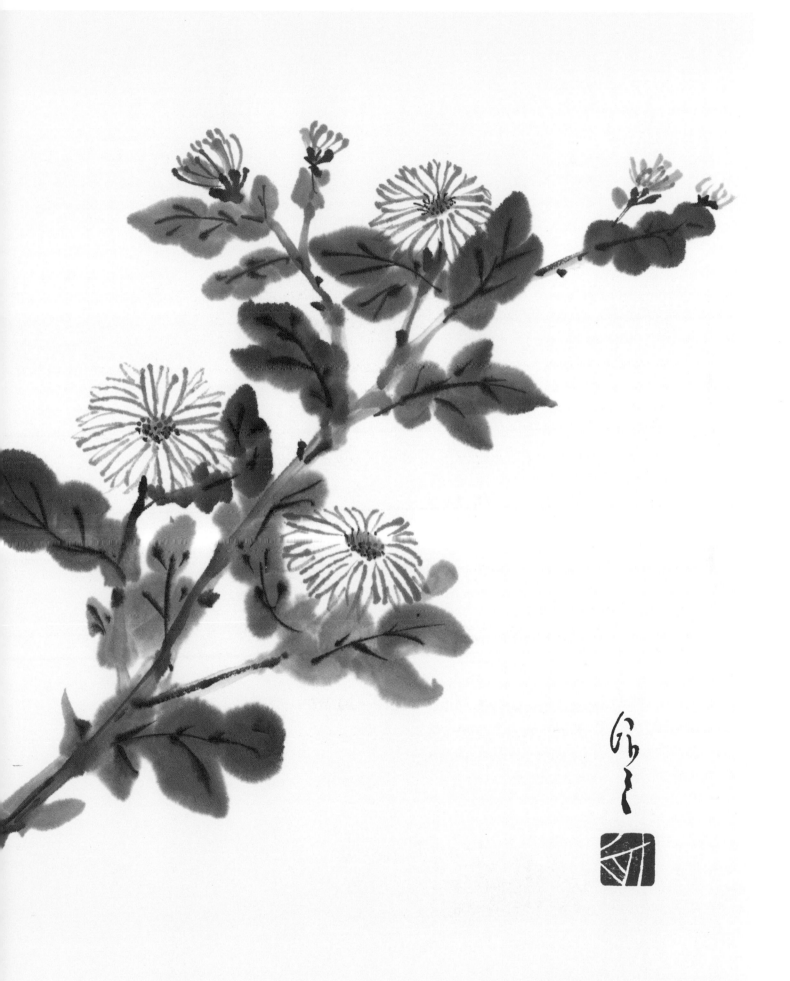

PETALS 花弁 *HANABIRA*

- Large brush
- Medium sumi
- *Senbyō*
- *Chokuhitsu*

The online video tutorial for this page may be viewed on our website:
www.tuttlepublishing.com/beginners-guide-to-sumie

�֎ The chrysanthemum is another of the four basic subjects (the "Four Gentlemen") that most beginners of Sumi-e start with in order to learn curved and straight lines and other techniques. The chrysanthemum represents autumn and is also a symbol of strength and perseverance. The flower is the imperial symbol of Japan's royal family and thus appears in the royal crest.

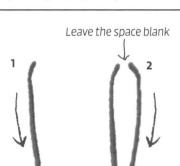

Leave the space blank

Shape of the petal

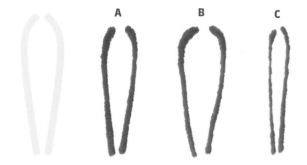

Each chrysanthemum petal consists of two lines. Load the large brush with medium sumi and, holding it in the *chokuhitsu* position, draw two lines, making sure they do not meet at the top.

The shape may vary slightly depending on the desired size of the petals, as in the examples above.

FLOWER 花 *HANA*

Basic form

Center

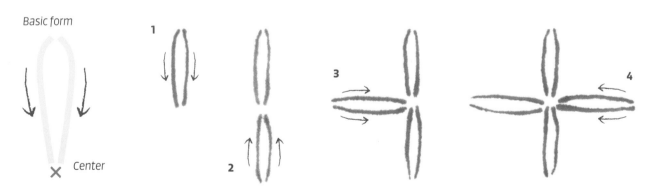

Draw the lines from the outside towards the center of the flower to form the petals. The correct order is shown in the diagram. Paint two vertical and two horizontal petals to form a cross **(1–4)**, then four on a diagonal **(5)**, and finally the rest, which are only partly visible, to fill in the empty space and build a circular shape **(6)**.

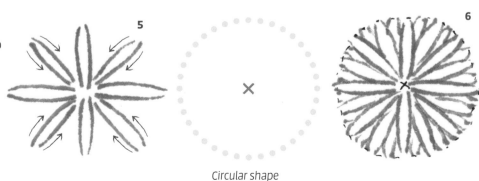

Circular shape

In the photo sequence, you can see the creation of the flower from the front.

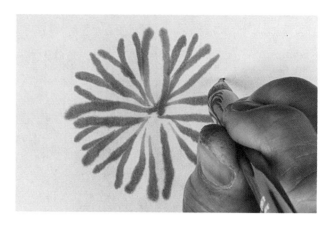

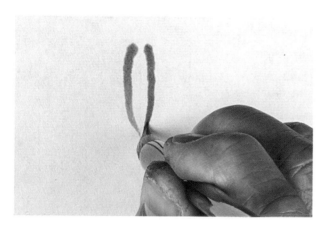

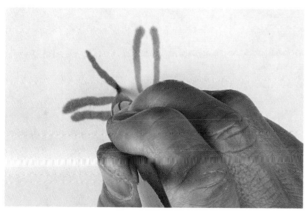

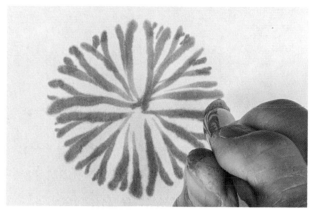

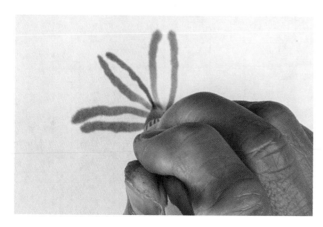

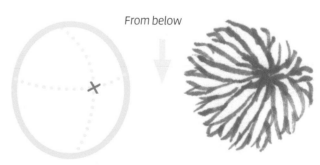

In the diagram on the right, you can see chrysanthemums depicted at other angles. To ensure a natural and balanced composition, insert flowers of various sizes.

VARIETY OF FLOWERS—POSITIONS

From above

From below

Sideways

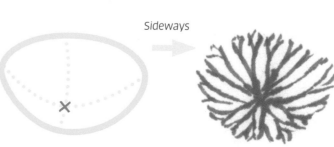

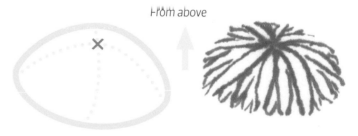

STAMENS OSHIBE CALYX 萼 GAKU

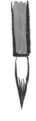

- Small brush
- Dark sumi
- Senbyō

- *Chokuhitsu*

WITH A TRADITIONAL STAMEN

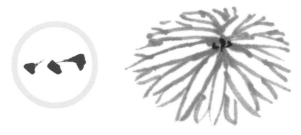

The traditional flower has a small stamen at its center. Paint the stamen with the small brush and dark sumi. Position the brush vertically, then press down and pull from the outer edge towards the center of the flower, as shown in the diagram.

WITH A DAISY-TYPE STAMEN

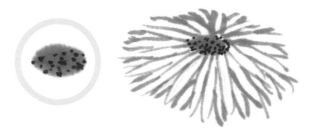

The daisy-shaped flower has an oval stamen. You can draw the stamen first, then the petals around it, or vice versa. Use the large brush and medium sumi for the stamen. Lie the brush down and press it as far as its belly, then lift it. Wait for the sumi to dry, then paint the dots inside with a small brush and dark sumi.

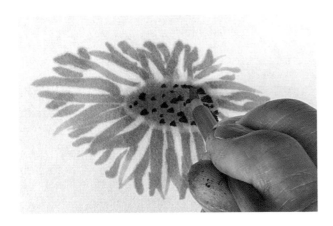

- Small brush
- Dark sumi
- Senbyō

- *Chokuhitsu*

Shape the calyx (the cone-shaped base of the flower) with the small brush and dark sumi. Lay the brush down, then press hard and pull it away as shown in the diagram (1–3).

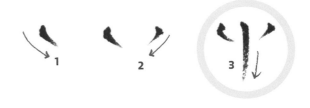

BUD 蕾 *TSUBOMI*

- Large brush
- Dark sumi
- Senbyō

- *Chokuhitsu*

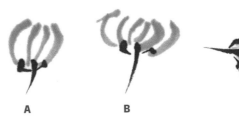

Draw lines from the outside towards the flower's calyx, beginning with those that will form the central petals (1, 2), to which others will be added (3). It is important that the base of each bud rests on the calyx. The bud can be depicted in various positions (A, B or C).

LEAF 葉 *HA*

- Large brush
- Medium sumi
- *Junpitsu + Mokkotsu*

- *Sokuhitsu*

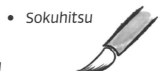

☀ This type of leaf is known as *goki shiketsu*. Typically it has five (*go*) branches (*ki*) and four (*shi*) forks (*ketsu*).

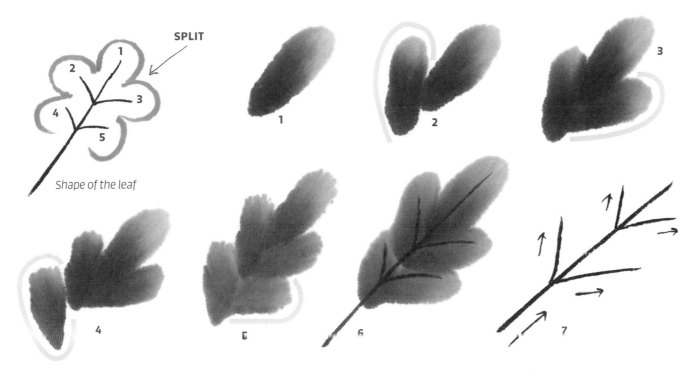

SPLIT

Shape of the leaf

Load the large brush with enough medium sumi to paint the entire leaf. Position the brush with its tip towards the center of the leaf and its belly facing out. Starting at the tip of the leaf, lay the brush down, then immediately pull it away. Continue with the other strokes **(2–5)**, as in the diagram. When the sumi is sufficiently dry, draw the veining with the small brush and dark sumi **(6)**.

VEINS

- Small brush
- Dark sumi
- *Senbyō*

STEM 茎 *KUKI*

Complete the composition by using the *urafude* technique to add the stem. Without lifting the brush from the page, draw a line from top to bottom, halting at the nodes corresponding to the lateral branches **(7)**.

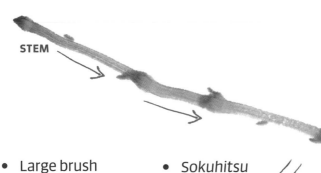

STEM

- Large brush
- Dark + light sumi
- *Urafude*

- *Sokuhitsu*

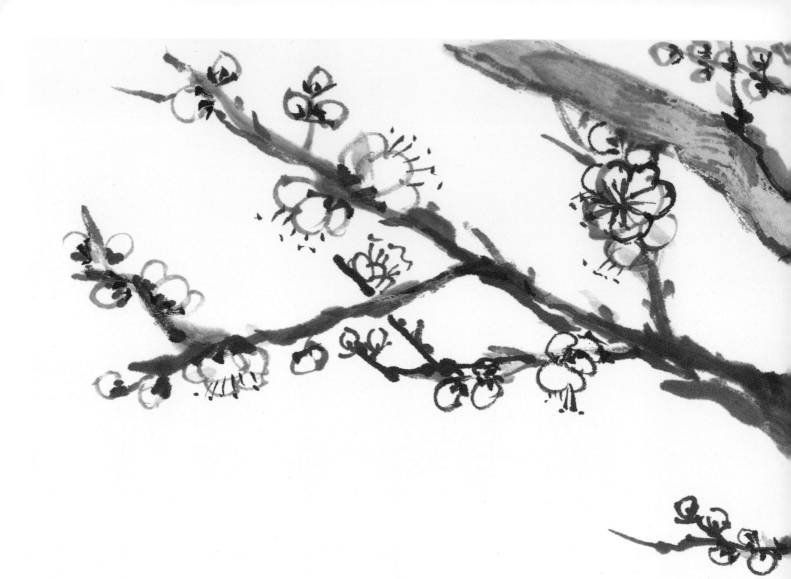

PLUM

UME

WHITE PLUM BLOSSOM 白梅 *HAKUBAI*

- Large brush
- Light sumi
- Senbyō

- *Chokuhitsu*

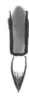

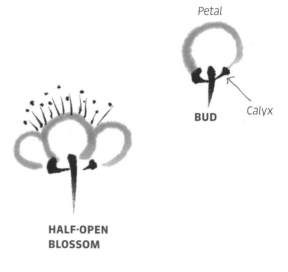

❖ The plum is another of the four traditional subjects (the "Four Gentlemen") used to teach the basic strokes in Sumi-e. The flower, long a beloved subject in traditional painting and in poetry, is usually called plum blossom. Plum blossoms, which begin blooming ahead of cherry blossoms, around the middle of February, signal the end of winter. They represent the joy of renewal and the promise of life.

As shown in the diagrams below, plum blossoms in Sumi-e can assume several different shapes, such as buds, half-open blossoms, half-open blossoms viewed in profile, flowers in full bloom viewed from the front, and flowers in full bloom viewed from the rear. The beauty of the plum tree lies in the contrast between the rough, gnarled trunks and branches of the tree and the fragile, ephemeral blossoms.

Petal

BUD *Calyx*

FLOWER IN FULL BLOOM (PROFILE)

HALF-OPEN BLOSSOM

FLOWER IN FULL BLOOM (FRONT VIEW)

The online video tutorial for this page may be viewed on our website:
www.tuttlepublishing.com/beginners-guide-to-sumie

For each round petal, hold the brush erect in the *chokuhitsu* position and use only the tip, always dipped in light sumi. Moving from left to right, draw an open circle in which the calyx will later be painted with a small brush dipped in dark sumi.

The bud is created from a half-open petal with a calyx. For other types of flowers, always start in the middle with the uppermost petal (**1**), then proceed with the one on the right (**2**), then the one on the left (**3**).

For the flower in full bloom (profile), add two smaller petals above the three main ones to create semicircles (**4, 5**), and finish with the stamens and the calyx as per the instructions on pages 76 and 77.

For the flower in full bloom (front), start in the center with the top petal (**1**), then proceed with the one on the right (**2**) and continue with those on the left (**3, 4**). Close the corolla by drawing the petal on the bottom right (**5**). Finish with the stamens and calyx as per pages 76 and 77.

HALF-OPEN BLOSSOM *3 petals + stamens + calyx*

FLOWER IN FULL BLOOM (PROFILE) *5 petals + stamens + calyx*

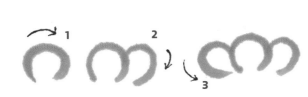 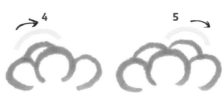

FLOWER IN FULL BLOOM (FRONT VIEW) *5 petals + stamens*

FLOWER IN FULL BLOOM (REAR VIEW) *5 petals + branch + calyx*

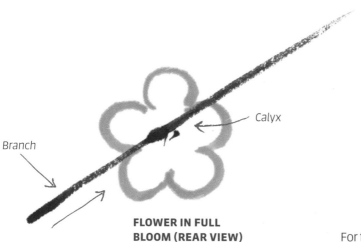

Branch

Calyx

**FLOWER IN FULL
BLOOM (REAR VIEW)**

For the flower in full bloom seen from behind (rear view), use the tip of the brush to paint five semicircles to form the corolla. Using the small brush, draw the branch with a simple stroke of dark sumi, then finish with the calyx.

RED PLUM BLOSSOM 紅梅 *KŌBAI*

- Large brush
- Light sumi
- Mokkotsu

- *Chokuhitsu*

In the Sumi-e tradition of using variations in shading, ink density and tonality through the movement of the brush and the flow of the ink, gray is usually used to render the red plum blossom. Although color is used sparingly in traditional Sumi-e, red plum blossoms are sometimes painted with red sumi ink. Another example is the camellia on pages 98–99.

BUD

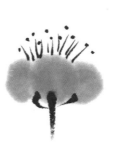

HALF-OPEN BLOSSOM

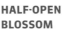

FLOWER IN FULL BLOOM (PROFILE)

FLOWER IN FULL BLOOM (FRONT VIEW)

Before painting, be sure to dilute the sumi to the correct degree. After dissolving the ink in the saucer, drag the brush along the edge. The intensity of the color oozing from the brush will correspond to the tint that will appear on the paper. For the colored petals, hold the brush upright in the *chokuhitsu* position. After dipping the brush in the sumi of the desired tint, lay the tip down and press lightly, then rotate the handle of the brush between your fingers to form the first colored petal, which is the bud.

For the half-open blossom, add only two petals to the right and to the left of the central one, while for the flower in full bloom (profile), add two smaller petals above the three main ones by resting the tip of the brush on the surface and squeezing lightly without rotating the handle. Later, when the sumi is dry, finish off both flowers with the calyx and stamens.

For the flower in full bloom (front), continue adding petals to the central one in the order indicated on page 73 for the white plum blossom. Slightly overlap the first central petal in order to form a corolla of five petals, but make sure that its center remains blank because this is where the stamens will be placed.

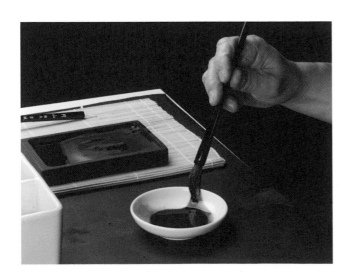

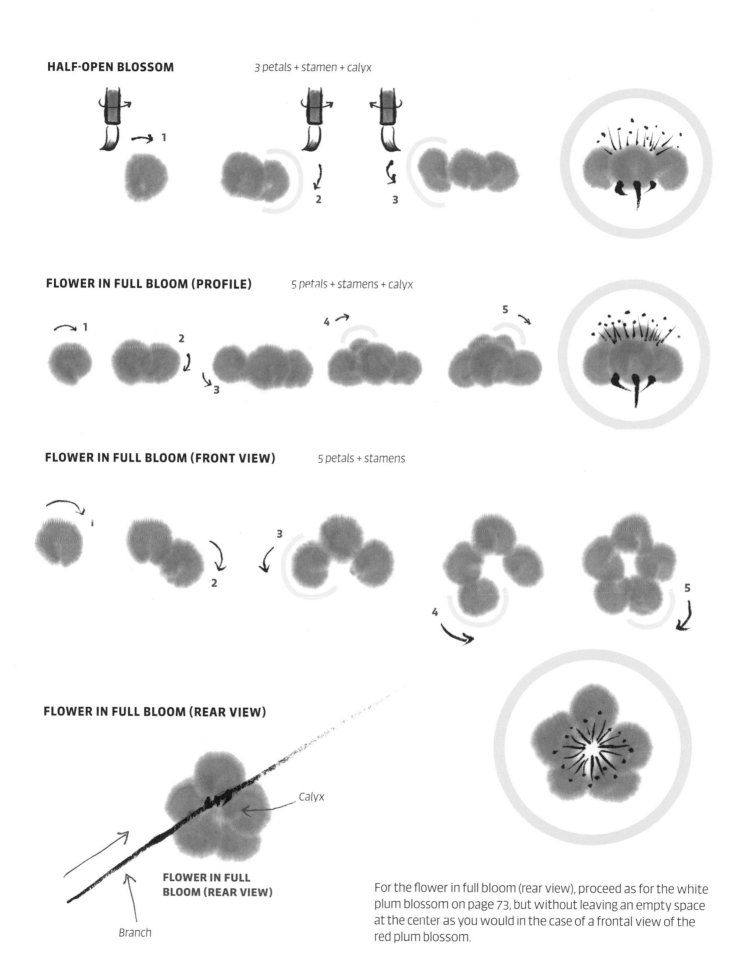

HALF-OPEN BLOSSOM *3 petals + stamen + calyx*

FLOWER IN FULL BLOOM (PROFILE) *5 petals + stamens + calyx*

FLOWER IN FULL BLOOM (FRONT VIEW) *5 petals + stamens*

FLOWER IN FULL BLOOM (REAR VIEW)

FLOWER IN FULL
BLOOM (REAR VIEW)

Branch

Calyx

For the flower in full bloom (rear view), proceed as for the white plum blossom on page 73, but without leaving an empty space at the center as you would in the case of a frontal view of the red plum blossom.

STAMENS 雄蕊 *OSHIBE*

- Small brush
- *Chokuhitsu*
- Dark sumi
- *Senbyō + Tenbyō*

STAMENS FOR FLOWERS IN PROFILE VIEW

Dip the brush in the dark sumi and draw fine lines. The arrow indicates the direction of each stroke, from the bottom upwards.

STAMENS FOR FLOWERS SEEN FROM THE FRONT

Here, the arrows indicate the direction of the stroke, which changes according to the steps. Draw an open cross at the center, then continue following the diagram and draw a second cross with four lines that overlaps the previous one at a 45-degree angle.

Add some shorter lines, then fill the center of the corolla, between the petals, with dots.

CALYX 萼 *GAKU*

- Small brush
- Dark sumi
- *Senbyō*

- *Chokuhitsu*

Dip the small brush in the dark sumi and, holding it erect in the *chokuhitsu* position, press on the tip and pull it diagonally downwards, first from left to right (**1**), then from right to left (**2**).

Draw a vertical line down the center, from top to bottom, pressing down, then pulling up (**3**).

BRANCH WITH BLOSSOM 枝 *EDA*

- Large brush
- Dark sumi
- *Senbyō*

- *Chokuhitsu*

The twigs in the upper section must protrude from the main branch at angles of 60–90 degrees.

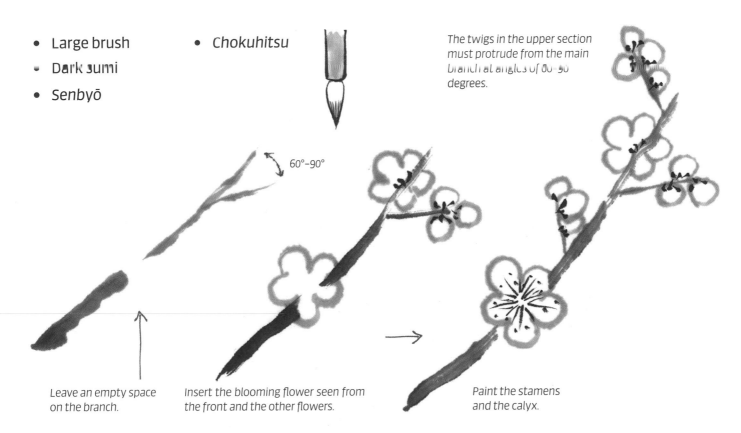

60°–90°

Leave an empty space on the branch.

Insert the blooming flower seen from the front and the other flowers.

Paint the stamens and the calyx.

When painting the flowering branch, decide in advance where to insert the flower in full bloom viewed from the front, as you will need to leave an empty space for it on the branch. However, you need not leave any empty space for the flower depicted from the rear.

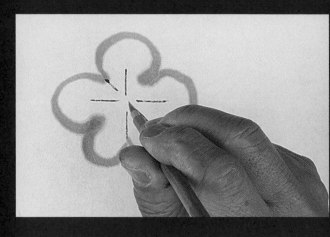

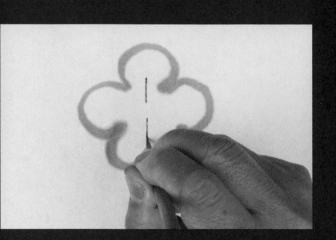

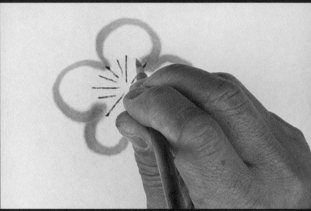

Do not extend the dots and lines beyond the outline of the petals, and leave a circular white space at the center.

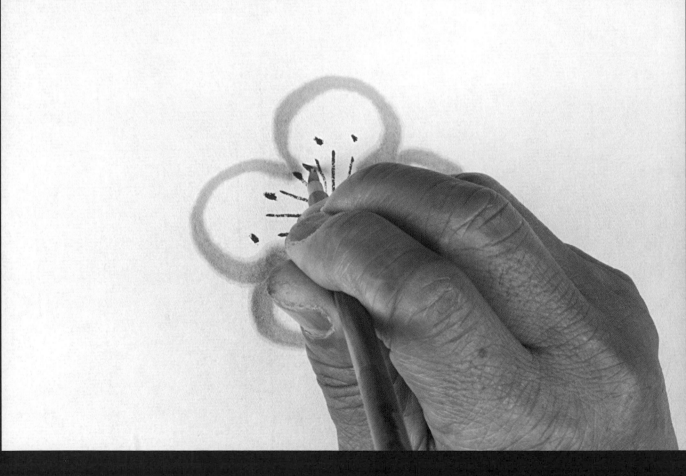

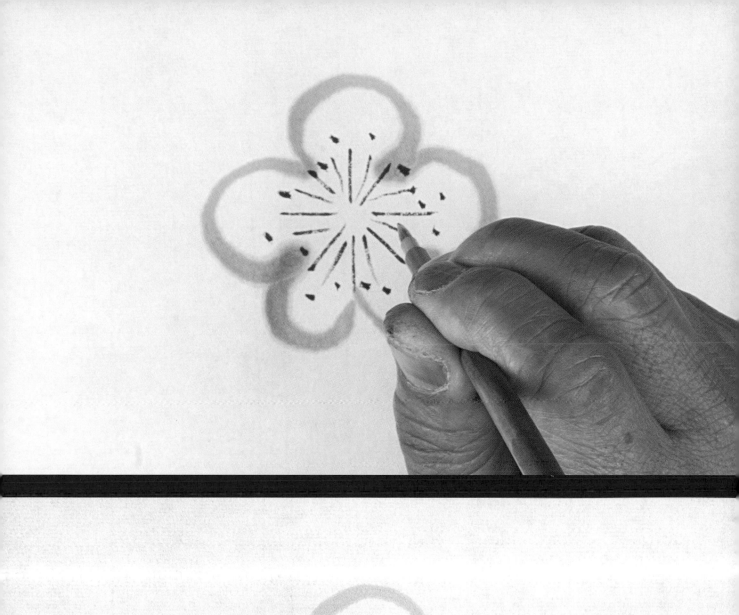

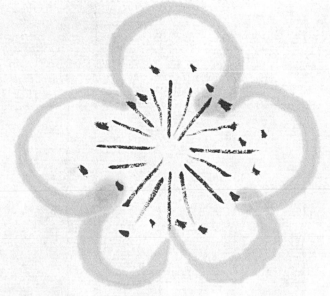

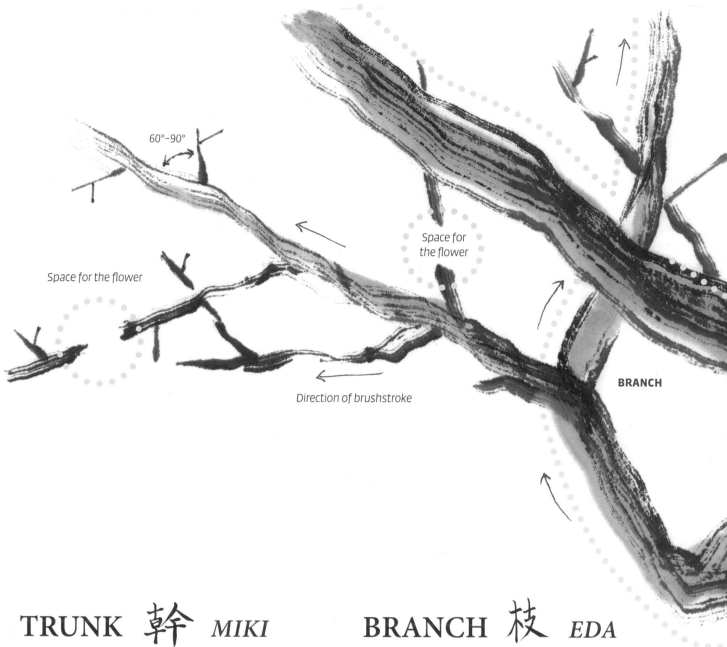

60°–90°

Space for the flower

Space for the flower

Space for
the flower

Direction of brushstroke

BRANCH

TRUNK 幹 *MIKI*

BRANCH 枝 *EDA*

- Large brush
- Medium + light sumi
- *Kappitsu*
- *Sokuhitsu*

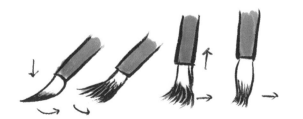

Use the *kappitsu* technique, described on page 29, which involves dragging a dry brush, to paint the trunk and the main branch. After loading the medium sumi, squeeze out the excess liquid by blotting the belly of the brush. Then, starting in the inclined *sokuhitsu* position, press the brush on the paper, rotate it, and lift it slowly, as shown in the diagram on the left.

After painting the basic structure with *kappitsu*, highlight the trunk and main branch with light sumi. Finally, add the smaller branches at angles between 60 and 90 degrees from the main branch.

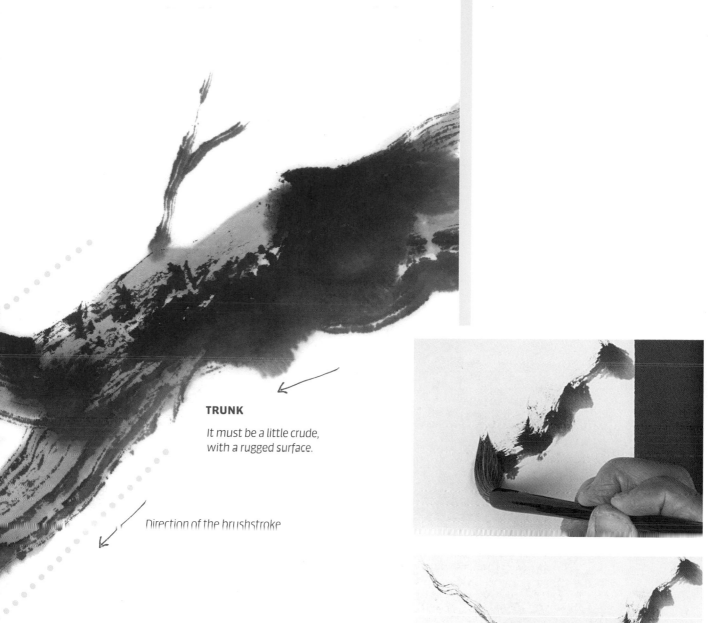

TRUNK

It must be a little crude, with a rugged surface.

Direction of the brushstroke

 The trunk and the branch must intersect as in the kanji 女 (*onna*), which signifies "woman."

The traditional composition of the trunk and branch must follow precise rules:

The trunk and branch must intersect, as shown in the diagram.

The shapes of the trunk and branches must vary—long, short, thin and wide.

Color should be graded, with darker and lighter areas.

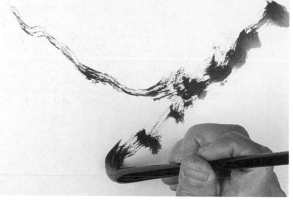

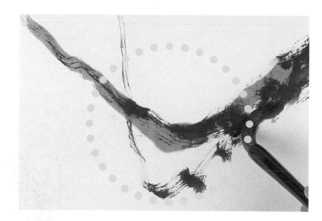

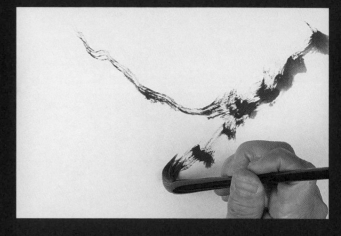

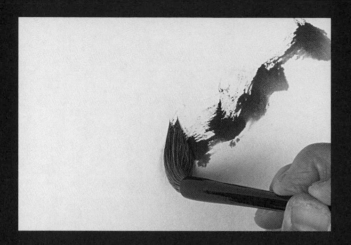

Keep in mind the rules of traditional composition and intersect the branch and trunk correctly.

The twigs must emerge from the main branch at angles of 60–90 degrees.

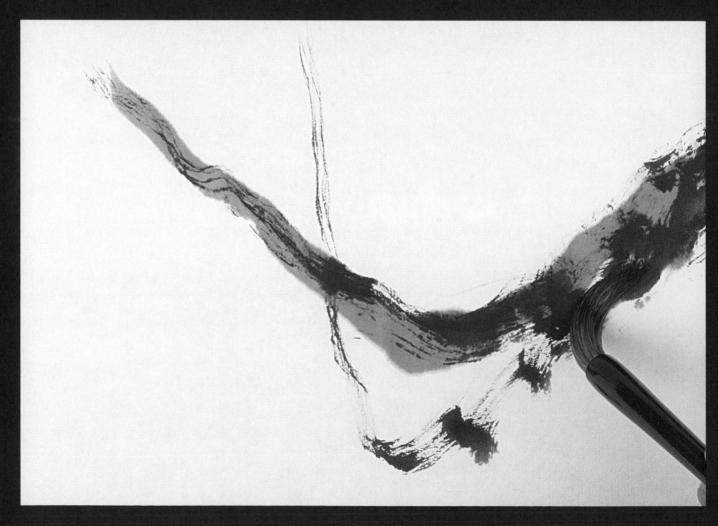

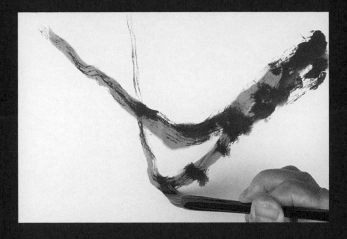

The light sumi helps define the form.

Remember to leave some blank spaces for blossoms on the branches.

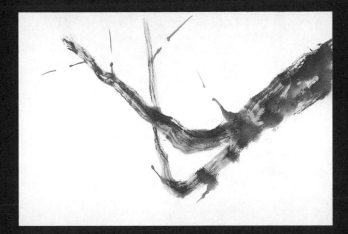

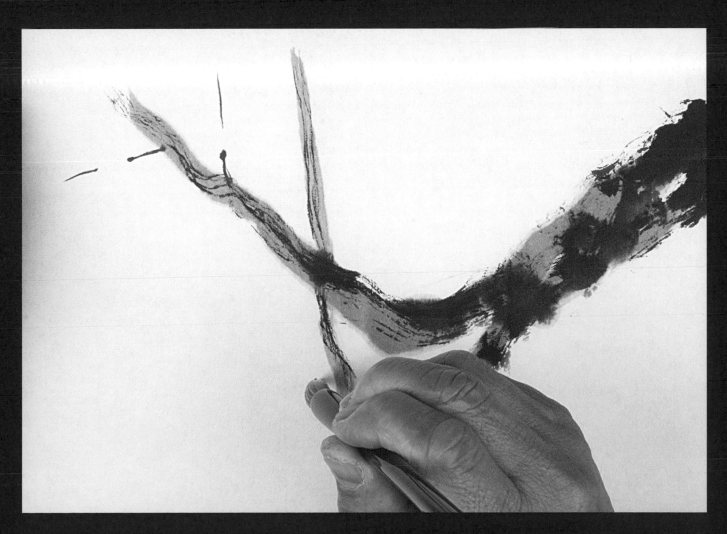

茄子

EGGPLANT

NASU

CALYX 萼 *GAKU*

- Large brush
- Light + dark sumi
- *Junpitsu*

- *Chokuhitsu*

·✳· The Japanese word *nasu* means "eggplant," sometimes called brinjal or aubergine. *Nasu* also suggests something great that has finally been achieved or obtained. In Japanese culture, the eggplant is thus a symbol of good luck and is valued for its nutrient-dense skin. The fruit of the plant is often depicted on various good luck objects.

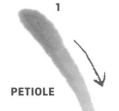

PETIOLE

1

LEAF 2

LEAF 3

LEAF 4

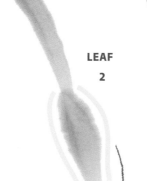

Dip the brush once in the light sumi, then dab the tip in a little dark sumi. Holding the brush in the *chokuhitsu* position, outline the petal with a single movement, as shown in the diagram **(1)**.

Next draw the leaves of the calyx. Begin with the one at the center, then add the ones at the sides **(2–4)**.

> The online video tutorial for this page may be viewed on our website:
> **www.tuttlepublishing.com/beginners-guide-to-sumie**

5

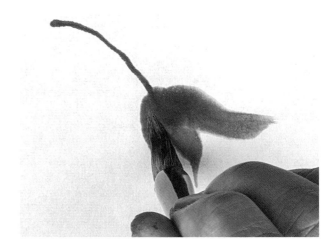

THORNS

- Small brush
- Medium sumi
- *Tenbyō*

- *Chokuhitsu*

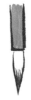

Once the calyx and petiole—the stalk that joins the leaf to a stem—are dry, insert the thorns with tiny brushstrokes of medium sumi **(5)**.

FRUIT 果実 *KAJITSU*

VERSION A

- Large brush
- Medium sumi
- *Junpitsu*
- *Sokuhitsu*

Load enough medium sumi to paint the entire fruit.

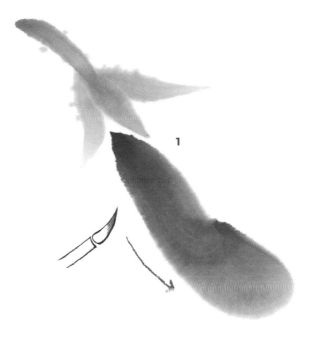

With the brush in the *sokuhitsu* position, begin at the side with the calyx leaves, then, with a sweeping gesture, draw one side of the fruit.

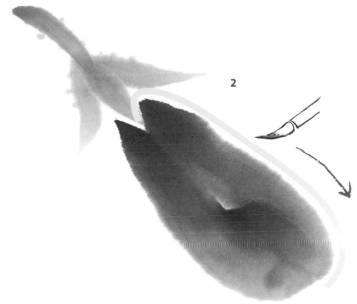

Use the same technique to draw the other side.

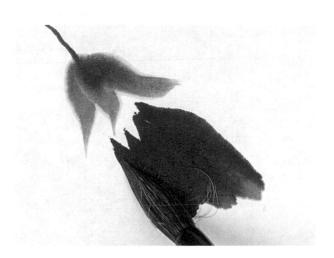

VERSION B

- Large brush
- Medium sumi
- *Junpitsu + Mokkotsu*

- *Sokuhitsu*

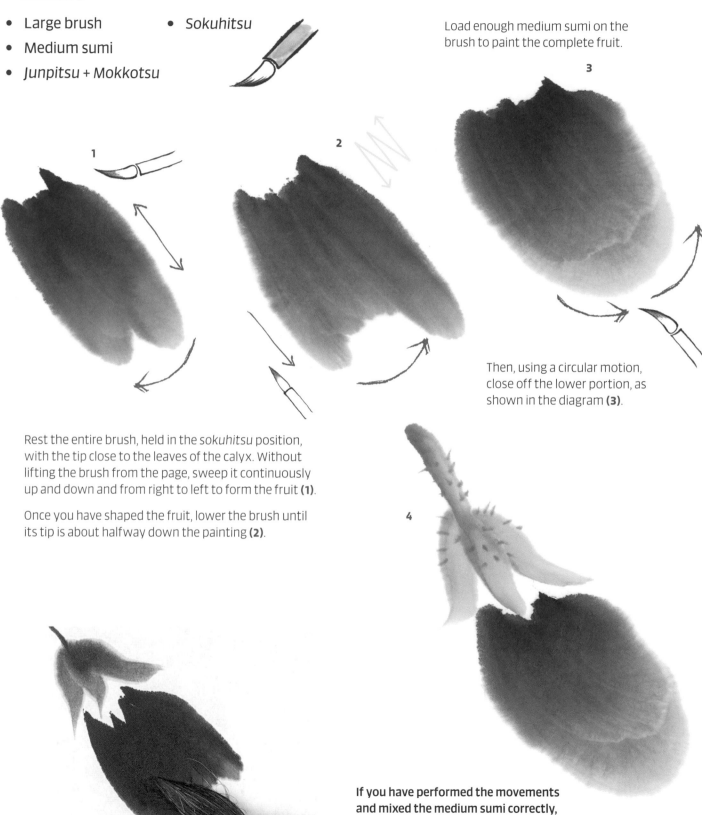

Load enough medium sumi on the brush to paint the complete fruit.

Rest the entire brush, held in the *sokuhitsu* position, with the tip close to the leaves of the calyx. Without lifting the brush from the page, sweep it continuously up and down and from right to left to form the fruit **(1)**.

Once you have shaped the fruit, lower the brush until its tip is about halfway down the painting **(2)**.

Then, using a circular motion, close off the lower portion, as shown in the diagram **(3)**.

If you have performed the movements and mixed the medium sumi correctly, you will end up with a gradation from dark to light, as in the diagram.

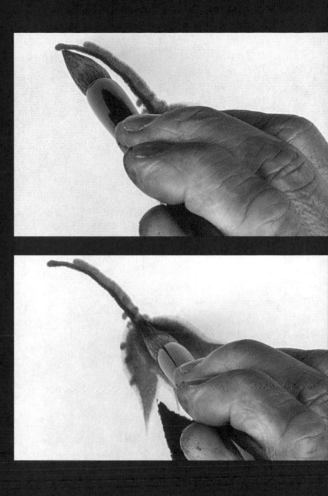

The photographs show the procedure for constructing the calyx and inserting the thorns.

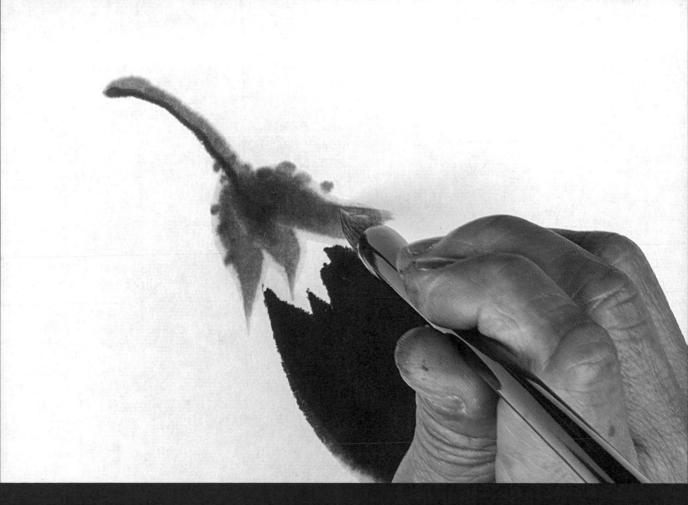

CAMELLIA

TSUBAKI

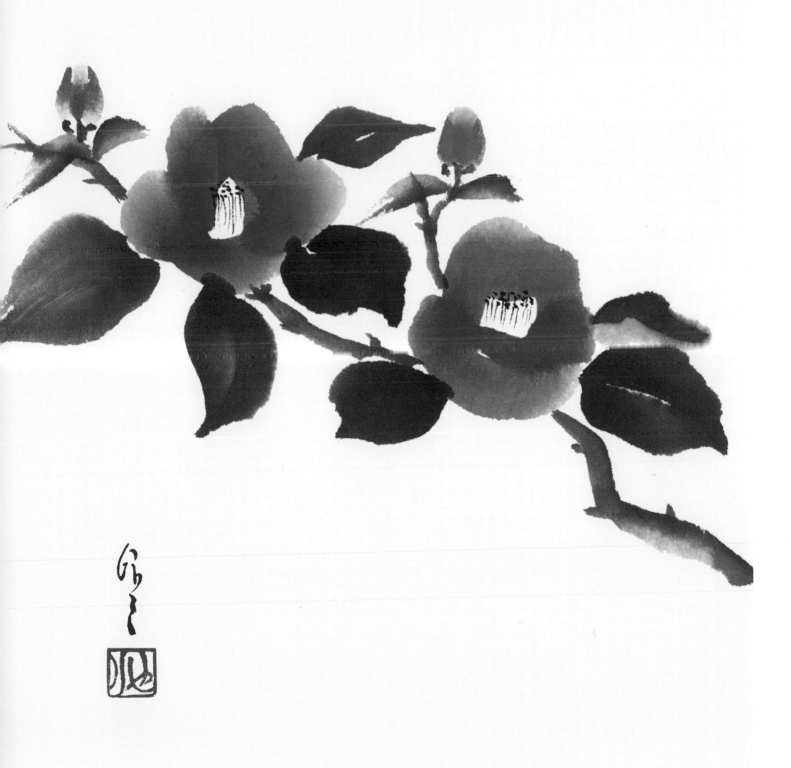

FLOWER A AND B 花 *HANA*

- Large brush
- *Sokuhitsu*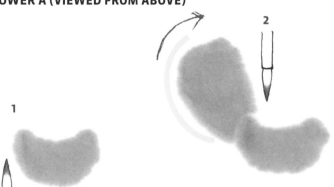
- Medium sumi
- *Junpitsu + Mokkotsu*

Sometimes called the "Japanese rose," the flowers of the Japanese camellia (*Camellia japonica*) are typically red and single in form, with 5–6 petals. Follow the steps below to create a five-petal camellia.

FLOWER A (VIEWED FROM ABOVE)

✻ Camellias are a favorite flowering shrub known for their conspicuous blooms, which come in all sizes, with single, semidouble or double forms and colors ranging from pure white to soft pink to dark red, and a mass of yellow stamens. The blossoms symbolize admiration and perfection.

It is important to leave a blank space for inserting the stamens at the center.

The online video tutorial for this page may be viewed on our website:
www.tuttlepublishing.com/beginners-guide-to-sumie

STAMENS

- Small brush
- *Chokuhitsu*
- Dark sumi
- *Tenbyō + Senbyō*

When making the first petal of flower A, place the bristles of the brush down, then pull the brush into a half-moon shape **(1)**. Place the brush down again and pull once more to create the second petal on the left **(2)**. For the third petal, simply lay the brush down without pulling it, letting it slightly overlap the second petal **(3)**.

To complete the remainder of the petals, rest the brush near the third petal, then pull downward until you reach the first petal **(4)**. Complete the corolla with the fifth and sixth petals, following the diagrams **(5, 6)**.

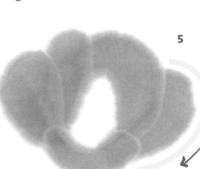

FLOWER B (VIEWED FROM BELOW)

Flower B is painted from the bottom front. Lay the tip of the brush down and pull it to create a thick, lip-shaped line **(1)**. To close the first petal, draw a circular shape by twisting the brush between your fingers **(2)**.

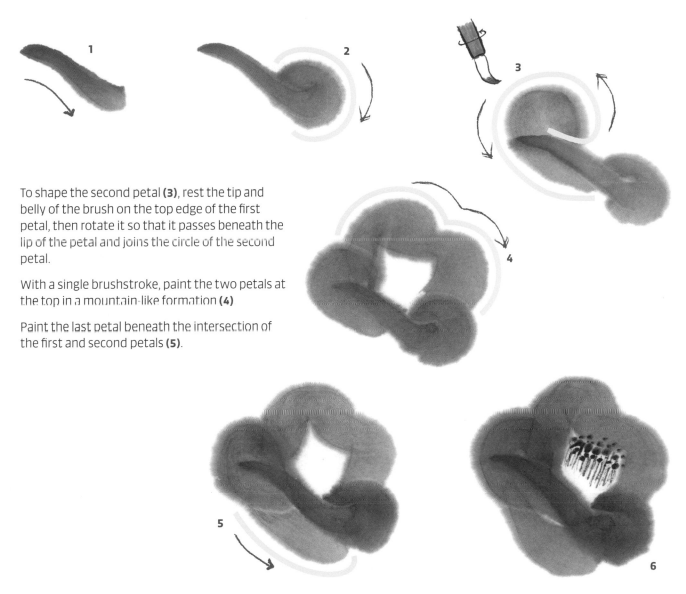

To shape the second petal **(3)**, rest the tip and belly of the brush on the top edge of the first petal, then rotate it so that it passes beneath the lip of the petal and joins the circle of the second petal.

With a single brushstroke, paint the two petals at the top in a mountain-like formation **(4)**

Paint the last petal beneath the intersection of the first and second petals **(5)**.

As for flower A, leave a blank space at the center of the corolla for the stamens **(6)**.

LEAF 葉 *HA*

- Large brush
- Medium + dark sumi
- *Junpitsu + Mokkotsu*

- *Sokuhitsu*

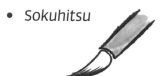

⚘ Camellia leaves are typically thick and shiny. They come in many forms and are depicted facing in different directions or from different perspectives. However, the method for painting them is the same as that used for the basic leaf.

BASIC LEAF

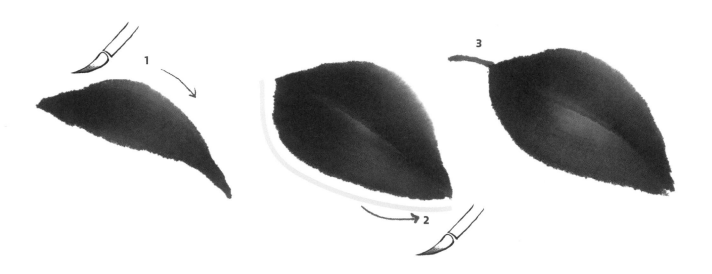

First, dip the brush in medium sumi, then lay the tip on your paper. Press down while pulling the brush to form the raised shape and then the tapered tip of the leaf **(1)**. To complete the other side of the leaf, rest the tip of the brush at the far end of the leaf, then press down on the belly to form a leaf shape before raising the brush **(2)**. Finally, add the petiole using the tip of the brush dipped in dark sumi **(3)**.

The leaves have no veins, but once they are done, they will have a white line running down their center. In the final composition, as seen in the following pages, these will be added to the flowers and the branch, which will be painted using the *urafude* technique.

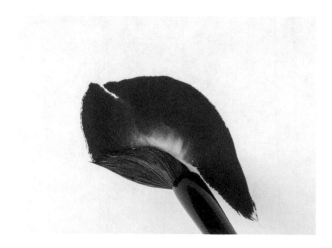

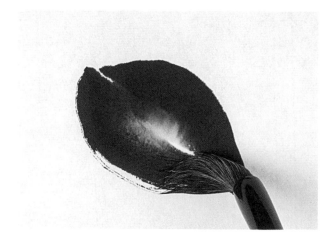

VARIATIONS OF THE BASIC LEAF

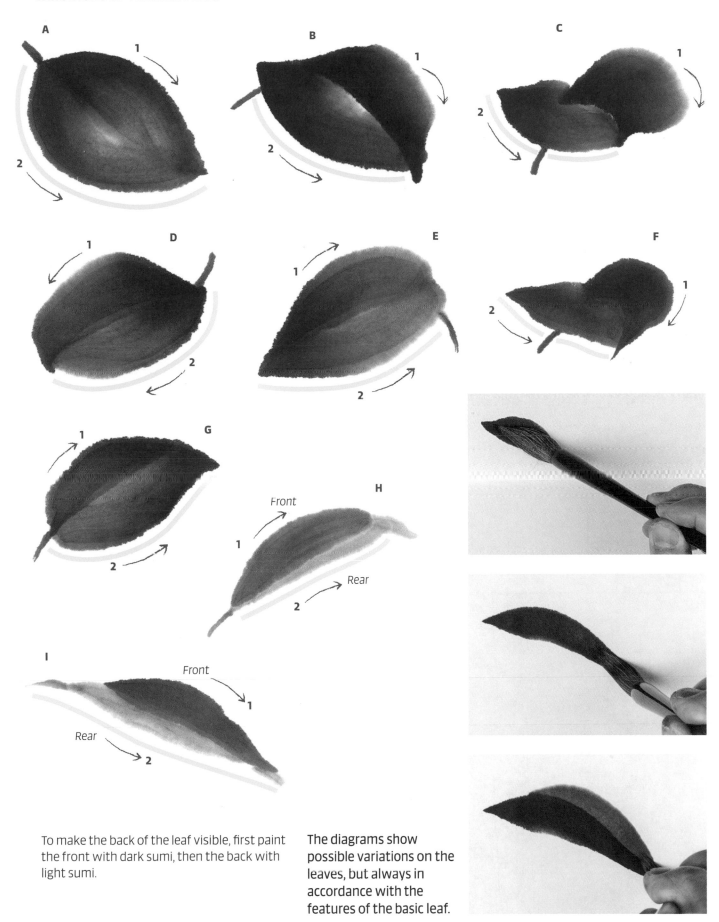

A

B

C

D

E

F

G

H

Front

Rear

I

Front

Rear

To make the back of the leaf visible, first paint the front with dark sumi, then the back with light sumi.

The diagrams show possible variations on the leaves, but always in accordance with the features of the basic leaf.

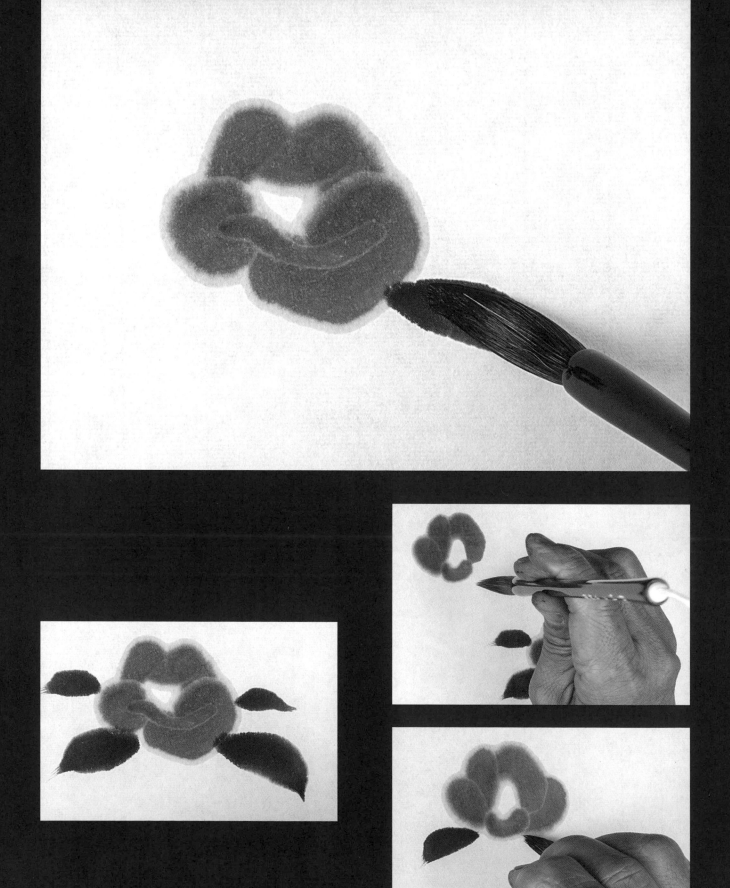

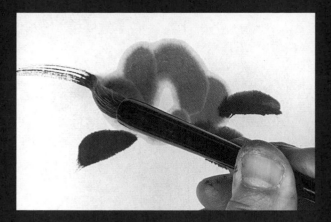

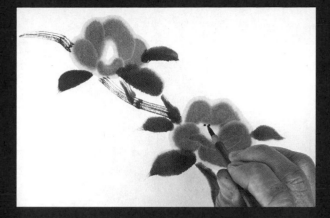

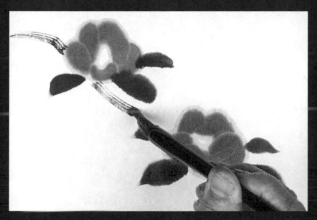

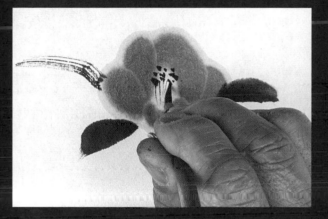

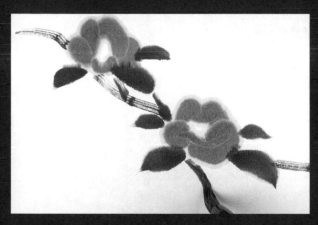

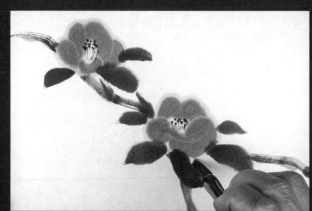

In the composition, the leaves must be added around the flower. Then the branch is drawn in the *urafude* technique to connect the flowers. Finally, the stamens are painted at the center, in the blank space between the petals.

RED BLOSSOM 花 *HANA*

- Large brush
- *Junpitsu + Mokkotsu*
- Red ink*
- Dark sumi

- *Sokuhitsu*

BLOSSOM A—5 PETALS

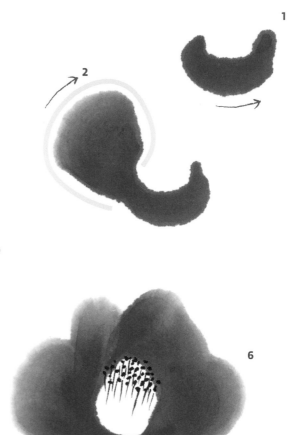

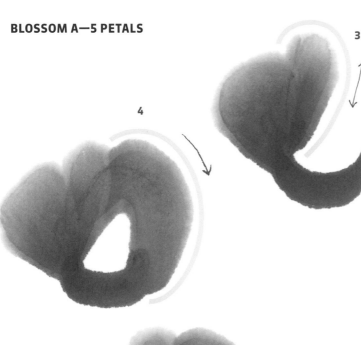

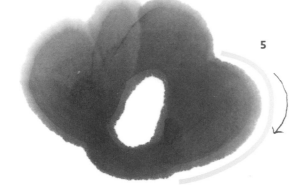

*Red ink is available in concentrated form in tubes or as powders or dried chips to which water is added. When preparing the red tint for the camellia blossoms, follow the same procedure as you would to make gradations in black ink (chōboku) on page 20.

98

BLOSSOM B—5 PETALS

✣ The Japanese camellia blossom is traditionally painted red. Its most notable feature is the dense bouquet of stamens in the center of the corolla.

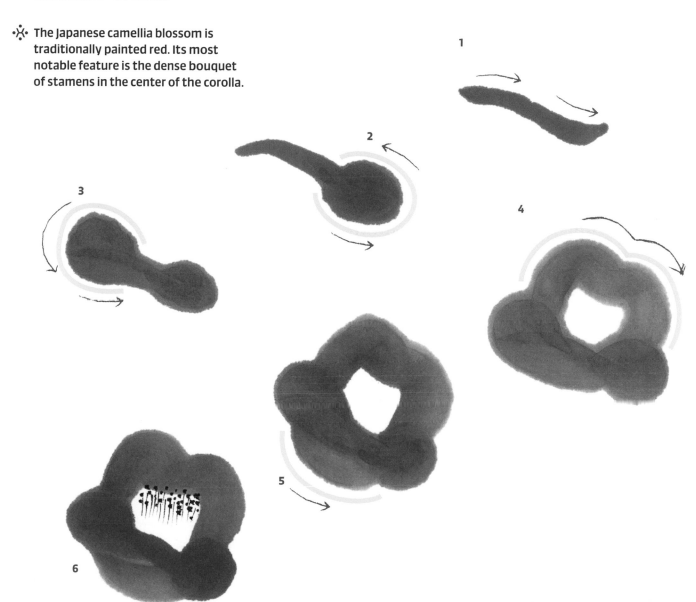

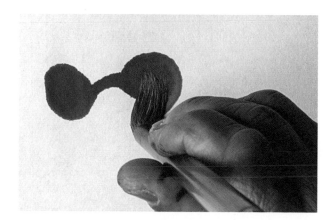

When painting red blossoms, both types A and B, follow the procedure for painting the petals in black ink on pages 92–93.

Leave a blank space at the center for the stamens—the only element in black—which you should add at the end with a small brush dipped in dark sumi.

薔薇

ROSE
BARA

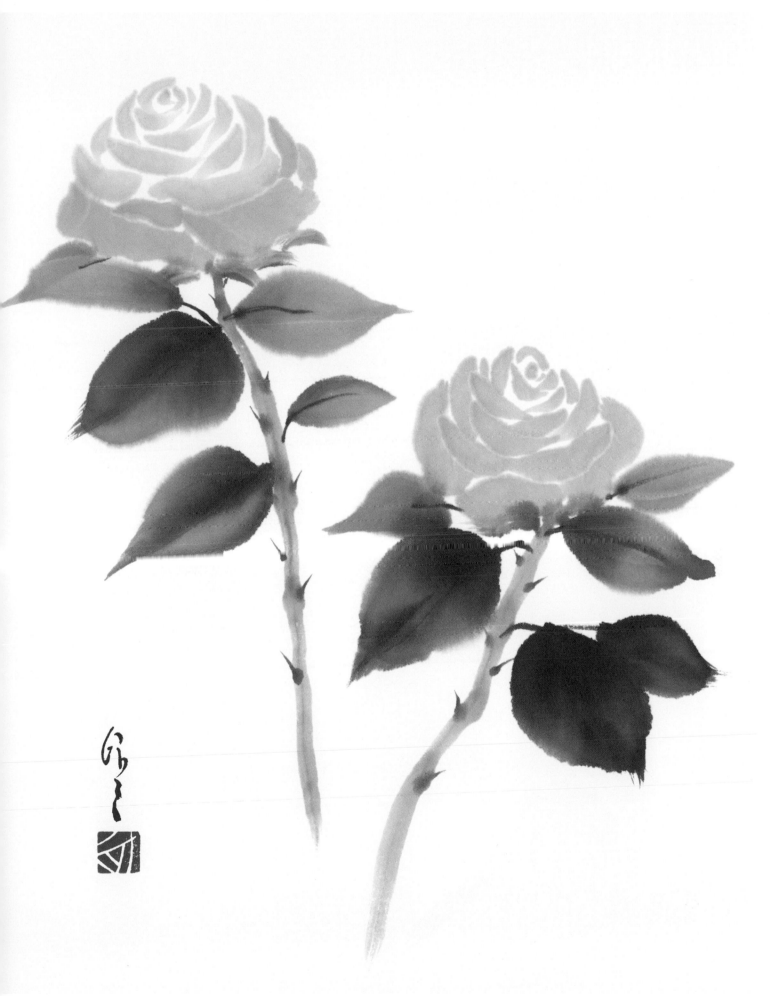

BLOSSOM 花 *HANA*

- Large brush
- Light + dark sumi
- *Mokkotsu*
- *Chokuhitsu*

The online video tutorial for this page may be viewed on our website:
www.tuttlepublishing.com/beginners-guide-to-sumie

�֎ **Roses have a long and colorful history. They have been symbols of love, beauty, war and politics. A popular garden plant, the blooms are often fragrant while the stems are armed with sharp thorns. Flowers vary in size, shape and color and generally have multiple sets of petals, as in the Sumi-e example below.**

Exerting slight pressure, lay the brush down up to its belly and pull it up with a circular motion to form a shape like a comma **(1)**. Position the second petal around the first but in the opposite direction **(2)**. Add the third petal by pressing down on the brush and making a broader movement that embraces the other two petals **(3)**. The third petal should appear at the center of the two previous ones, like a valley enclosed between the slopes of two mountains.

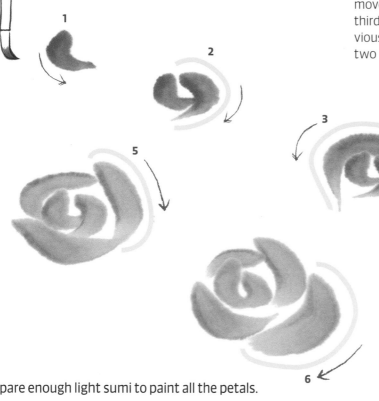

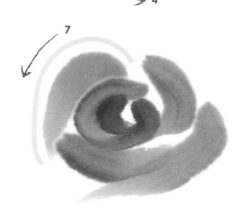

Prepare enough light sumi to paint all the petals.

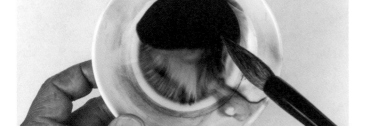

Continue building up the rose following the sequence shown above **(5-7)**.

As you add petals, increase their density and twist them around those already in place. From step 8 on, hold your brush in the inclined *sokuhitsu* position to add more volume to the petals.

Lightly overlap the petals to create the effect of contrasted light and shade (*chiaroscuro*), as well as volume.

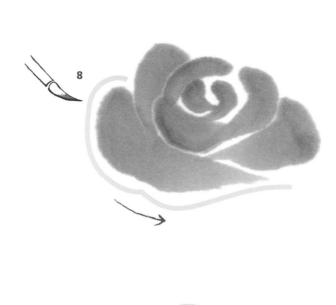

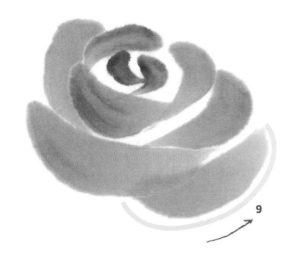

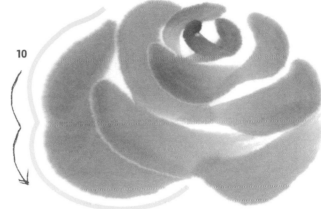

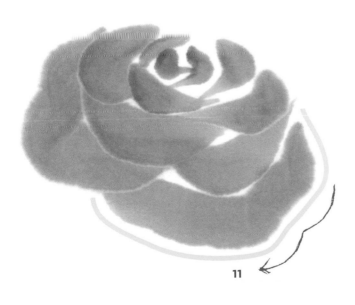

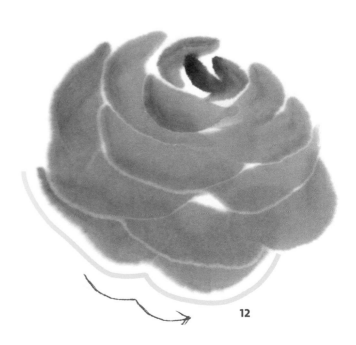

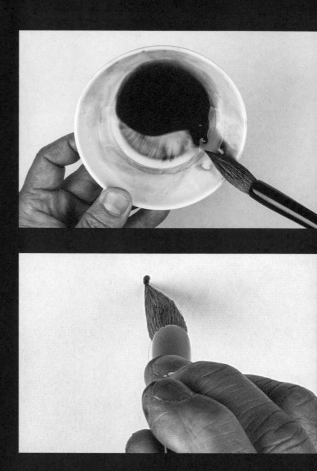

Load the brush with light sumi and shape the tip before you start painting the rose petals, one by one.

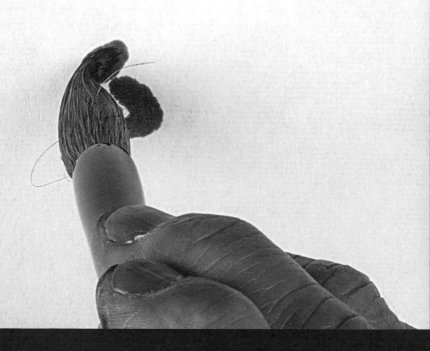

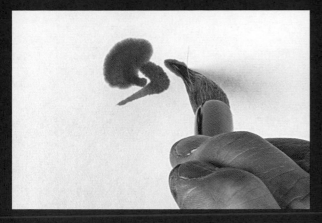

Apply ever larger brushstrokes and change the angle of the brush to make the flower appear more three-dimensional.

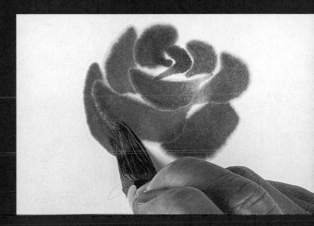

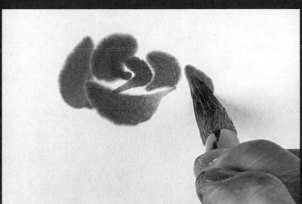

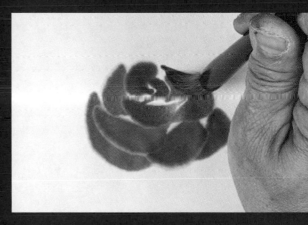

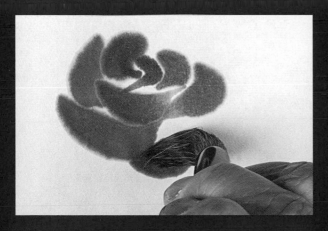

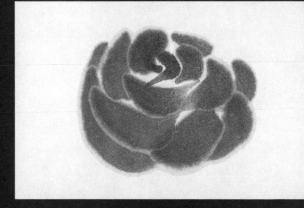

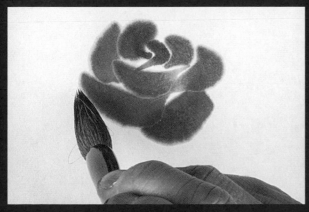

LEAF 葉 *HA*

- Large brush
- Medium sumi
- *Mokkotsu*

- *Chokuhitsu*

Make the leaf with two brush-strokes. Press the brush down, then pull up slowly to form the tip.

LEAF A

1

2

3

LEAF B

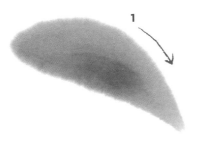

1

2

Orientate leaves A and B in different directions.

The shade should be visible at the center of the leaf as this is what creates a sense of volume.

3

STALK

- Large brush
- Dark sumi
- *Senbyō*

- *Chokuhitsu*

For the petiole, make a firm brushstroke from the leaf outwards to connect it to the stem.

STEM WITH THORNS 茎 *KUKI*

- Large brush
- Light + dark sumi
- *Urafude*

- *Sokuhitsu*

✺ **In the *urafude* technique, the brush is loaded with light and dark sumi and only the tip is used to draw the stem.**

For the stem, draw a straight line with the brush held at an angle in the *sokuhitsu* position. To create the nodes to which the leaves will be attached, stop the brush at regular intervals and apply light pressure, then continue without lifting the brush from the paper.

NODE

THORN

- Small brush
- Dark sumi
- *Senbyō*

- *Chokuhitsu*

Paint thorns with short strokes from the stem outwards.

WISTERIA

FUJI

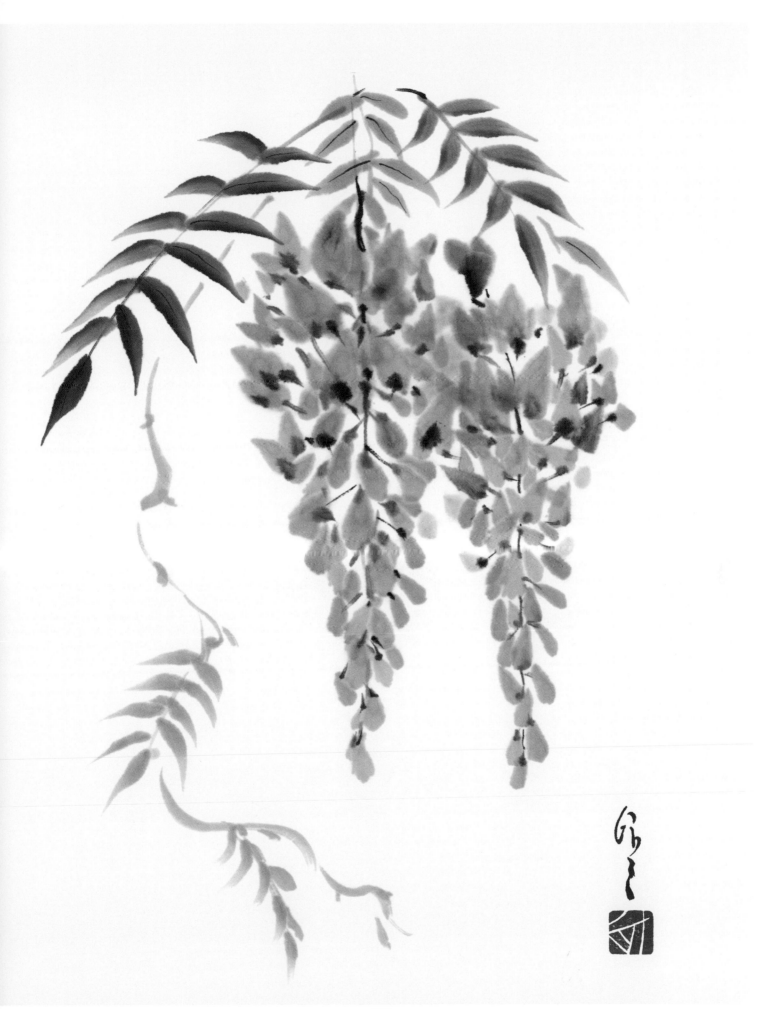

CLUSTER OF FLOWERS 花房 *HANA FUSA*

❄ Wisteria is a climbing vine that twists its stems around any available support. Its flowers, which grow in large, drooping lilac-blue clusters, are composed of three types of petals (A–C) joined by stalks to the main stem. Wisteria is a popular spring motif in ceramic and textile designs, for example, on kimono.

When shaping this cluster, first paint the different shaped petals, then the stalks, and finally the stem that joins all the elements together. In petal A, the stem will emerge from the rear, as shown in the diagram.

To add depth to the drawing, insert more petals in light sumi after painting the stalks.

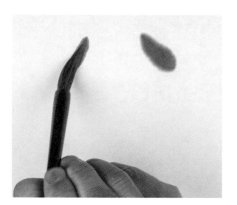

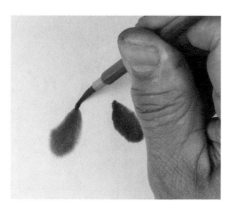

The online video tutorial for this page may be viewed on our website:
www.tuttlepublishing.com/beginners-guide-to-sumie

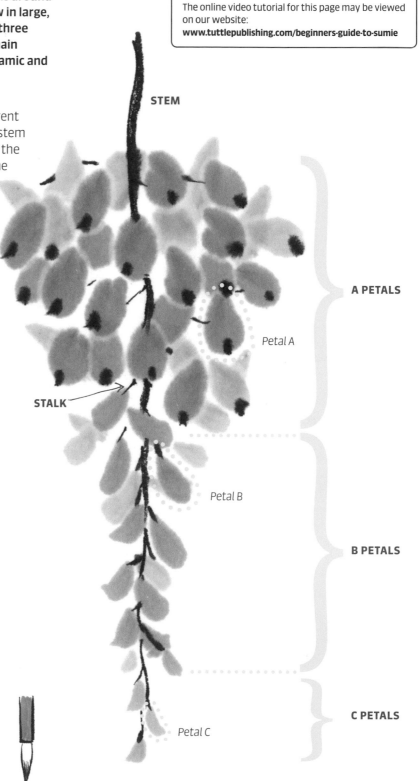

STEM

A PETALS

Petal A

STALK

Petal B

B PETALS

C PETALS

Petal C

STEM

- Small brush
- Dark sumi
- Senbyō
- *Chokuhitsu*

The photos above left show how to paint the pod-like B petals.

PETALS 花弁 *HANABIRA*

PETALS A AND B

- Large brush
- Sokohitsu
- Light + medium sumi
- Mokkotsu

✳ **Petal A resembles an upside-down heart or spade.**

These petals are seen from the front. Place the brush on the paper. Keep the tip in place while rotating the belly of the brush slightly to the right.

For petal B, lay the brush down from its tip to its belly, apply light pressure, then lift. These are the petals that are on the left and right of the stem.

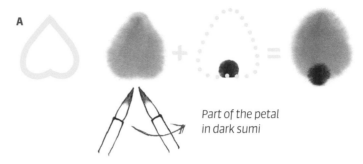

A

Part of the petal in dark sumi

With stalk

B

Left *Right*

PETAL C

- Small brush
- Sokohitsu
- Medium sumi
- Mokkotsu

With stalk

C

Petal C is a smaller version of petal B. Use the small brush and medium sumi.

STALK

- Small brush
- Chokuhitsu
- Dark sumi
- Senbyō

To draw the stalks that join petals B and C to the stem, use the small brush and dark sumi. Lay down the brush, then lift it from the bottom upwards.

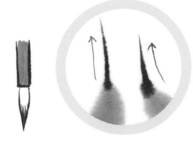

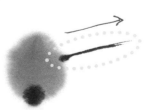

✳ **Petal A's stalk is drawn as a line emerging from the petal's side because it is behind the flower.**

LEAF 葉 *HA*

- Large brush
- Medium sumi
- *Mokkotsu*
- *Chokuhitsu*

❉ Wisteria has multiple shiny green leaves growing near the top of clusters of flowers. The leaves are made up of pairs of leaflets growing on either side of a midrib or central vein, with a single leaflet at the tip. The leaflets are identical in shape to those of the bamboo (pages 60–61).

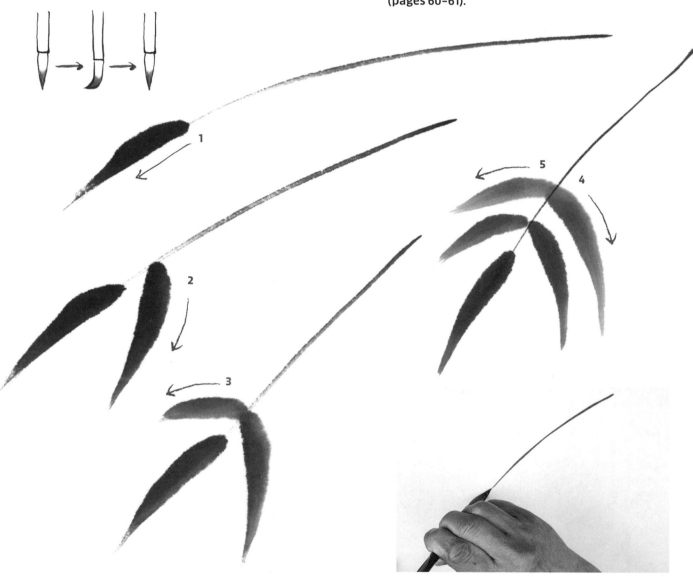

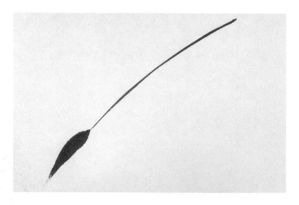

Begin the composition by painting the midrib or central vein with the large brush, then draw the first leaflet at its tip **(1)**.

Dip the brush once in the medium sumi and paint the composition without interruption, following the steps in the diagram **(2–5)**. If the ink has been carefully prepared, various tones will be visible in the completed leaf.

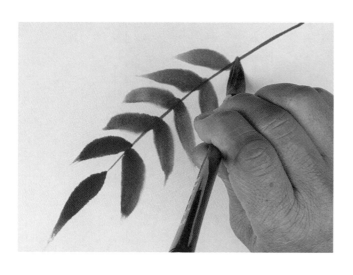

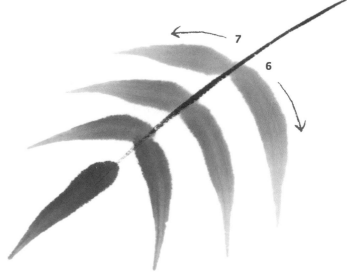

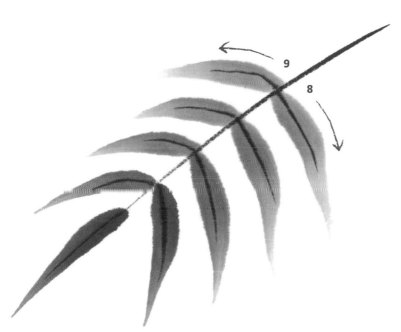

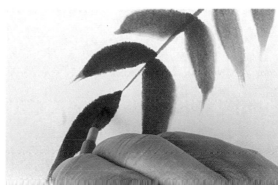

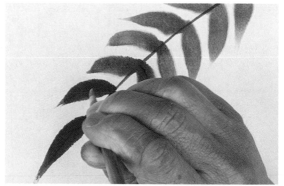

VEINS

- Small brush
- Dark sumi
- *Senbyō*

- *Chokuhitsu*

To finish, use the small brush to draw fine lines from the midrib or central vein to the tip of each small leaf.

芥子

POPPY
KESHI

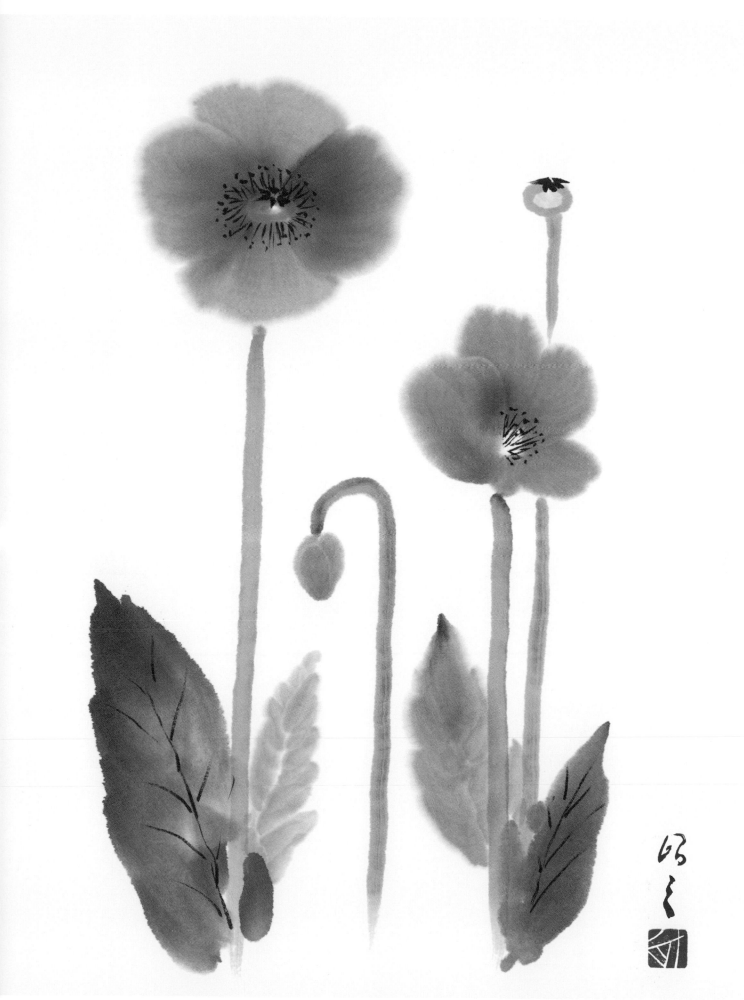

FLOWER *HANA*

FORM A

- Large brush
- Medium sumi
- *Junpitsu*
- *Sokuhitsu*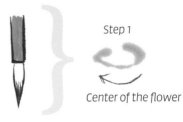

Start by drawing the center of the four-petal flower (see Step 1). Holding the large brush in the *chokuhitsu* position and using only the tip, draw an oval that is slightly open at the top.

For the petals, keep the brush inclined in the *sokuhitsu* position. With the tip resting firmly on the paper, press the brush down and twist its belly.

✸ Poppies are often grown for their colorful, showy flowers. The poppy blossom, which is short-lived, typically has 4–6 petals. The stamens form a conspicuous whorl in the center. Poppies have long been used as a symbol of sleep, peace and death, partly because of their blood-red color.

- *Chokuhitsu*

Step 1

Center of the flower

Proceed with the other petals as shown in the diagrams below. Each petal needs to rest on the outside of the blank oval center of the flower.

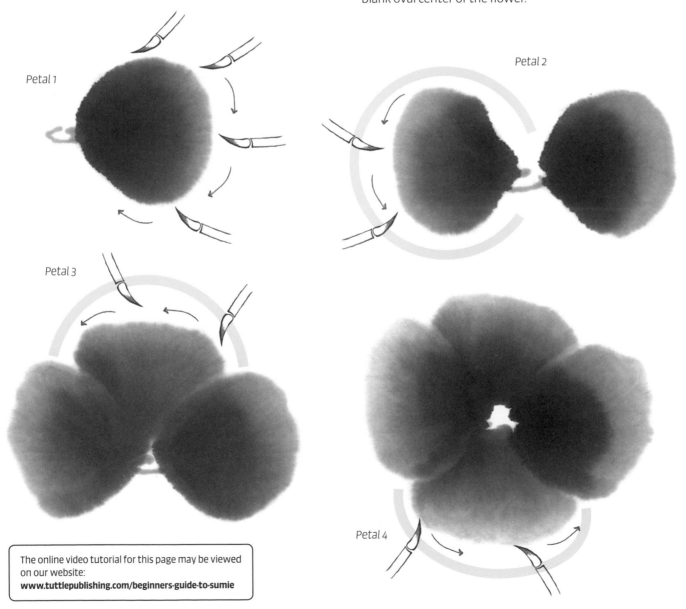

Petal 1

Petal 2

Petal 3

Petal 4

The online video tutorial for this page may be viewed on our website:
www.tuttlepublishing.com/beginners-guide-to-sumie

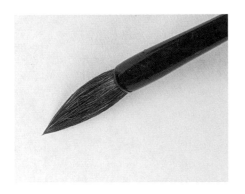
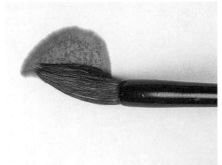
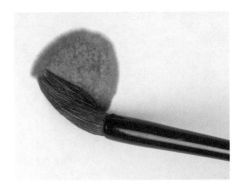

This sequence shows how to create Form A.

Load the medium sumi on the large brush, then lay it down. Keeping the tip in place, twist the belly on the paper. If the medium sumi has been prepared correctly and the brush movements are also correct, the varied gradations of the sumi should bc visible in each petal.

FORM B

- Large brush
- Medium sumi
- *Junpitsu*
- *Sokuhitsu*

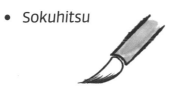

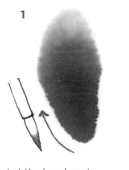

1

Let the brush rest.

2

Let the brush rest.

3

Twist the brush.

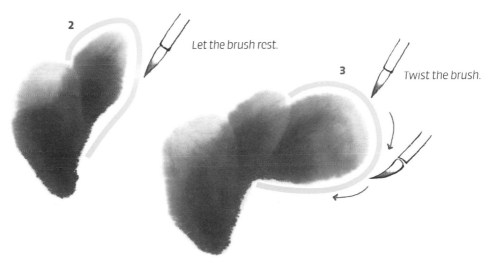

To form the first two petals, lay the brush down from tip to belly, then lift the brush **(1–2)**. The second petal is behind the first. For the third petal, keep the tip of the brush near the base of the second one and slightly twist the belly of the brush **(3)**. The fourth petal is larger than the others. Paint it using the technique for Form A by twisting and dragging the brush. Be sure to leave a blank space for the stamens at the center, among the petals.

Form A shows the flower face front on, while Form B captures it from the side.

To make petal 4, twist and drag the brush.

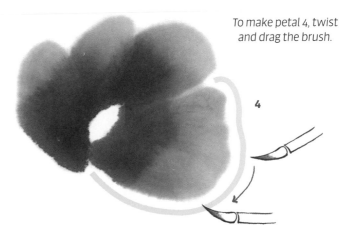

4

BUD 蕾 *TSUBOMI*

- Small brush
- Light sumi
- *Junpitsu*
- *Sokuhitsu*

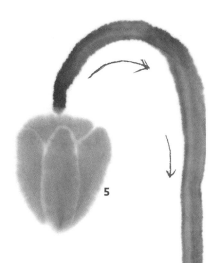

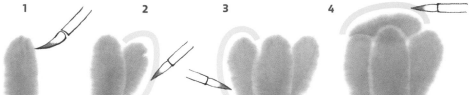

Paint the bud with three or four strokes, based on the desired size.

With a firm but delicate motion, lay the brush tip down, then raise it, first in the middle **(1)**, then to the right **(2)** and left **(3)**, overlapping the brush-strokes as in the diagram. The last stroke on top should be horizontal, like a cap **(4)**.

STEM 茎
GAMBO

- Large brush
- Light + dark sumi
- *Urafude*

After the flower wilts and loses its petals, all that is left is the calyx. To depict it, paint a semicircle at the top of the stem and paint the bud at the tip **(5)**.

CALYX 萼 *GAKU*

COROLLA

- Large brush
- Light sumi
- *Urafude + Senbyō*
- *Chokuhitsu*

PISTIL AND STAMENS

- Small brush
- Dark sumi
- Senbyō
- Chokuhitsu

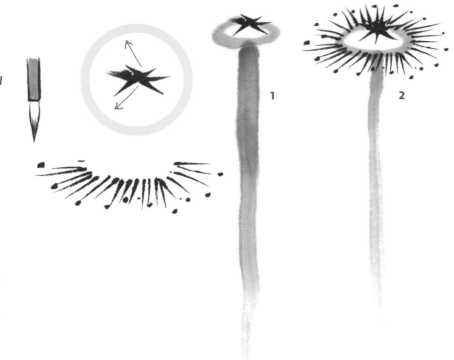

Using the small brush, draw the pistil at the center and the stamens around the corolla.

For the pistil, the brushstroke must go from the inside outwards **(1)**.

For the stamens, the brushstroke must also go from the inside outwards, with the dots arranged however you like **(2)**.

LEAF 葉 *HA*

- Large + small brush
- Medium + dark sumi
- Mokkotsu
- Sokuhitsu

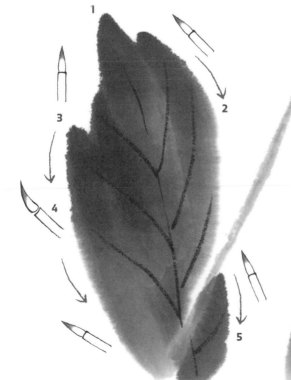

Load enough medium sumi on the brush to paint a complete leaf.

To form the leaf, first lay the brush down with the tip facing up **(1)**. Then, with up and down motions, complete the leaf, first on the right side **(2)**, then on the left side **(3, 4)**, and again at bottom right **(5)**. Be sure to leave a blank space for the stem.

Use the *urafude* technique for the stem, and make it thread between the leaves.

Use the small brush and dark sumi for the veins (as for the peony on page 134).

朝顔

MORNING GLORY
ASAGAO

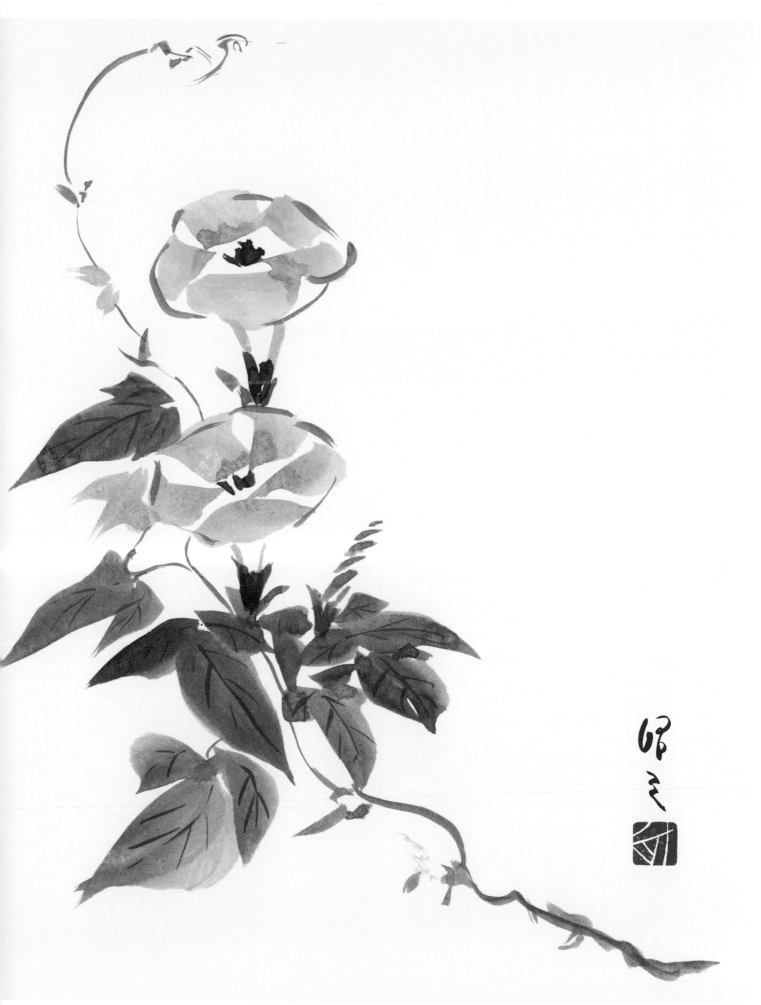

FLOWER 花 *HANA*

The online video tutorial for this page may be viewed on our website:
www.tuttlepublishing.com/beginners-guide-to-sumie

⁑ Known as Japan's symbol of summer, the morning glory is a climber with twining stems, colorful trumpet-like flowers often with a white throat, and heart-shaped emerald green leaves. Its Japanese name, asagao, derives from asa ("morning") and gao ("face") because the flowers open in the morning and close by the afternoon.

⁑ The flowers consist of five lobed petals ending in a cone-shaped base.

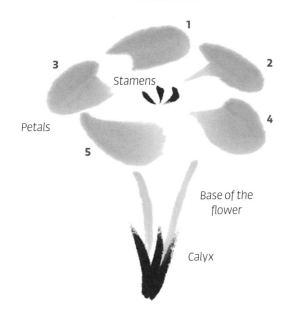

PETALS

- Large brush
- Light + medium sumi
- Mokkotsu

- *Sokuhitsu*

Paint each petal with light sumi by laying the brush down, then pulling it towards the center, finally lifting it up to shape the tip of a "comma" **(1–4)**. Pay attention to the positioning of the petals. Once complete, the petals must form an oval, as in the diagram on the right **(5)**.

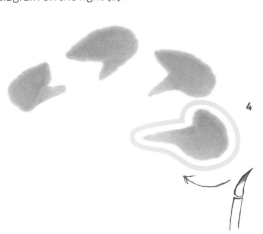

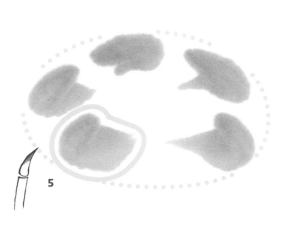

To obtain the outline of the flower, use the medium sumi and the tip of the brush to draw lines that connect the petals, as shown in the finished painting on page 121.

CALYX 萼 *GAKU*

- Small brush
- Dark sumi
- *Senbyō*
- *Chokuhitsu*

To create the cone-shaped base of the flower, use the light sumi to draw two lines emerging from beneath the petals you have just painted, and make these merge at the calyx, painted in dark sumi. Use the dark sumi to also draw the stamens between the petals.

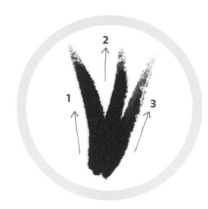

Short strokes from bottom to top

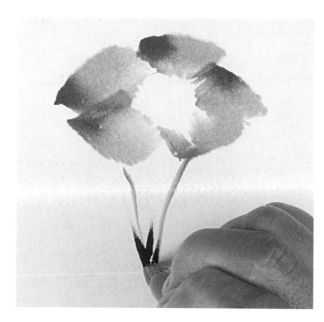

STAMENS 雄蕊 *OSHIBE*

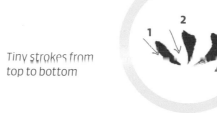

Tiny strokes from top to bottom

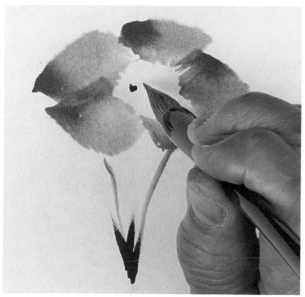

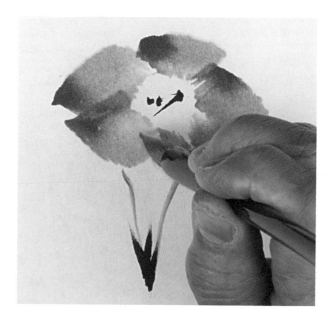

These photographs show a variant of the flower, in which the petals are painted with larger brush-strokes.

LEAF 葉 *HA*

- Large brush
- Medium sumi
- *Mokkotsu + Junpitsu*

- *Sokuhitsu*

✻ The roughly heart-shaped leaf resembles a head with two large ears.

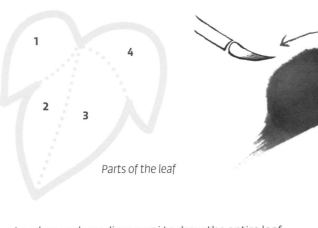

Parts of the leaf

Load enough medium sumi to draw the entire leaf.

Lie the brush down in the *sokuhitsu* position, making sure to create a tip at the end. Proceed through steps 1–4 in the diagram. If the medium sumi has been properly made, variations in the light and dark shading will make the leaf appear three-dimensional.

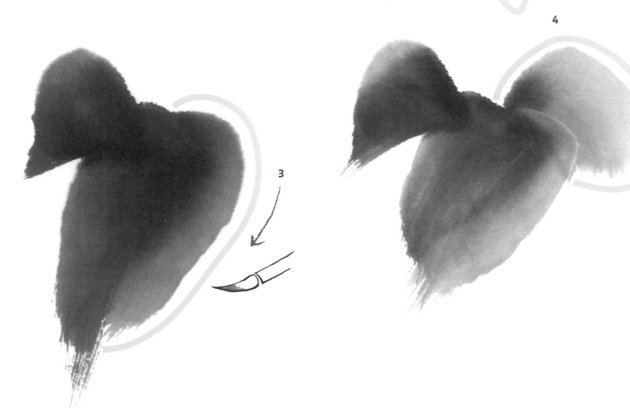

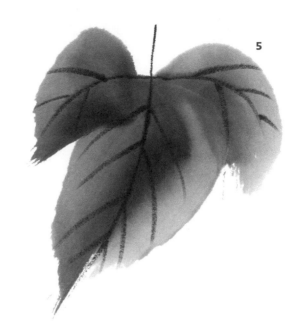

VEINS

- Small brush
- Dark sumi
- *Senbyō*
- *Chokuhitsu*

Wait until the medium sumi on the leaf is dry, then, using the small brush and dark sumi, draw the veins according to the diagram.

BUD

- Large brush
- Light + dark sumi
- *Mokkotsu*
- *Chokuhitsu*

Paint the bud below the second flower, a little to the right (see page 121). With the tip of the large brush in the *chokuhitsu* position, press down on it lightly to form a row of tiny dots, one beneath the other **(1–5)**. The number of dots will vary according to the size of the bud. Draw a calyx at the base of the bud by making short strokes in dark sumi from bottom to top.

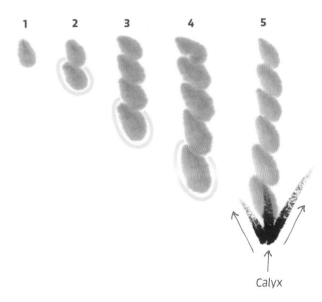

Calyx

Branch

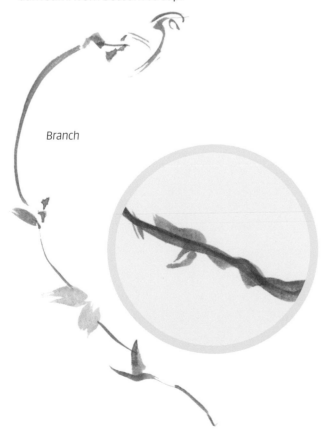

BRANCH

- Small brush
- Medium sumi
- *Senbyō*
- *Chokuhitsu*

The branch must have soft and undulating lines, typical of climbing plants.

Paint the branch last, after the flowers and leaves have been done. At this point, you can also add a few more leaves and other tiny details, as in the diagram.

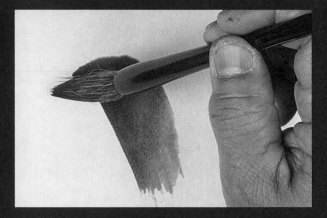

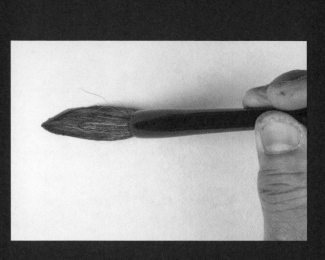

These photographs show you how to paint the leaf. Use the large brush for the four parts of the leaf, then the small brush for the veins.

Note that the sequence in which the composition is painted may vary. In this instance, it began with the inner leaf.

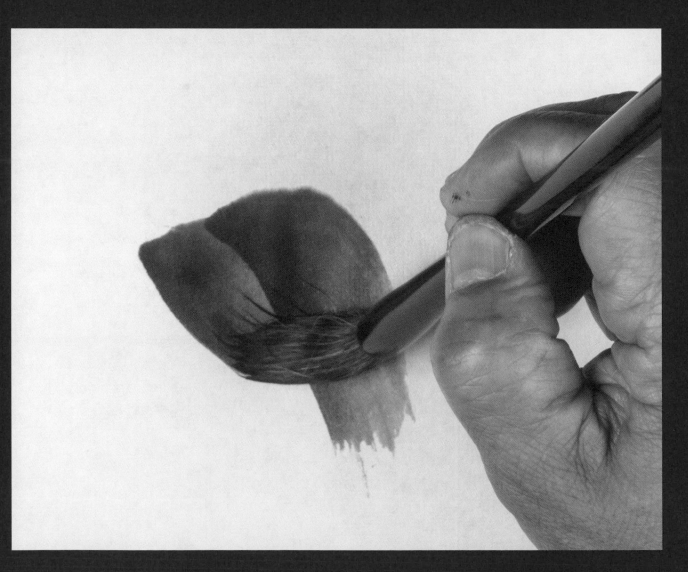

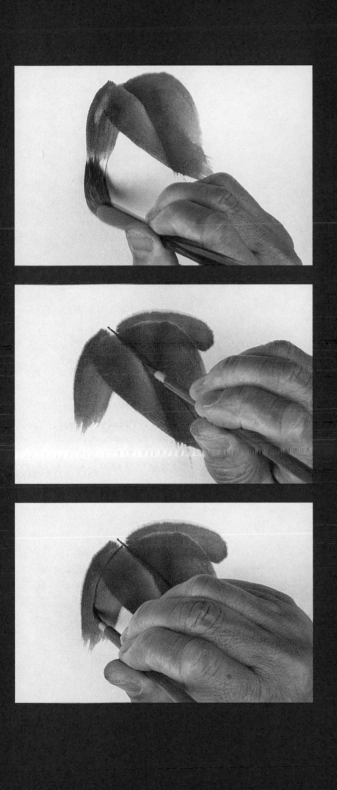
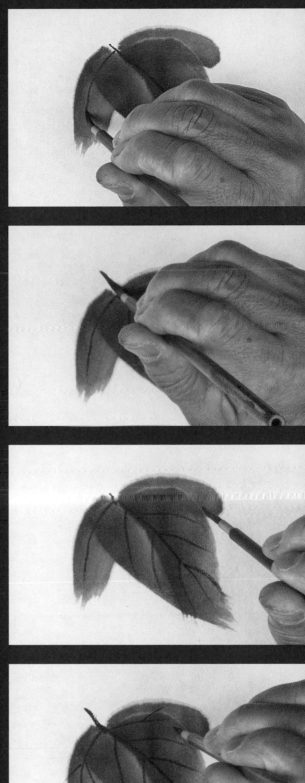

牡丹

PEONY
BOTAN

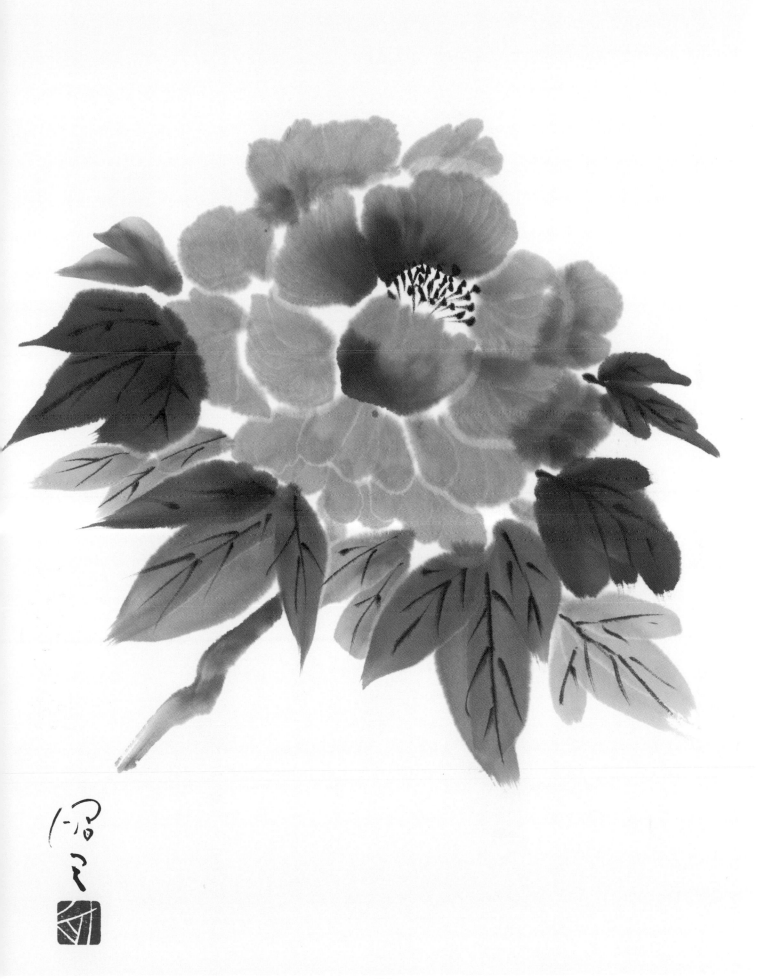

FLOWER HANA

- Large brush
- Light + medium sumi
- Mokkotsu + Junpitsu

- Sokuhitsu

The online video tutorial for this page may be viewed on our website:
www.tuttlepublishing.com/beginners-guide-to-sumie

✵ The poeny is a garden plant with large red, pink or white flowers. In Japan, it is known as the "king of flowers" and is much loved for its bold size and colors. It is regarded as a symbol of good fortune, bravery, wealth and honor. It also represents spring. Peony blossoms are also associated with female beauty.

In Sumi-e, the peony blossom is typically composed of large "ruffled" petals, each consisting of three or four slightly overlapping basic forms painted with a single brushstroke loaded with ink. Blended together, they shape the corolla.

To make the basic form, load the brush with light sumi, then dip the tip in medium sumi. Lay the brush down from tip to end, then raise it. The tip of the basic form will be darker than the rest of the brushstroke. Use one load of ink for each group of 3–4 overlapping basic forms.

PETALS

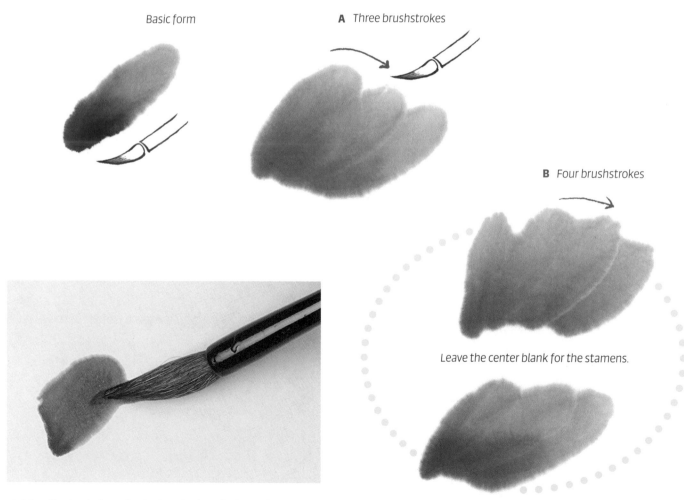

Basic form

A Three brushstrokes

B Four brushstrokes

Leave the center blank for the stamens.

A Three brushstrokes

Making the basic form by laying the brush down from tip to end, then raising it.

130

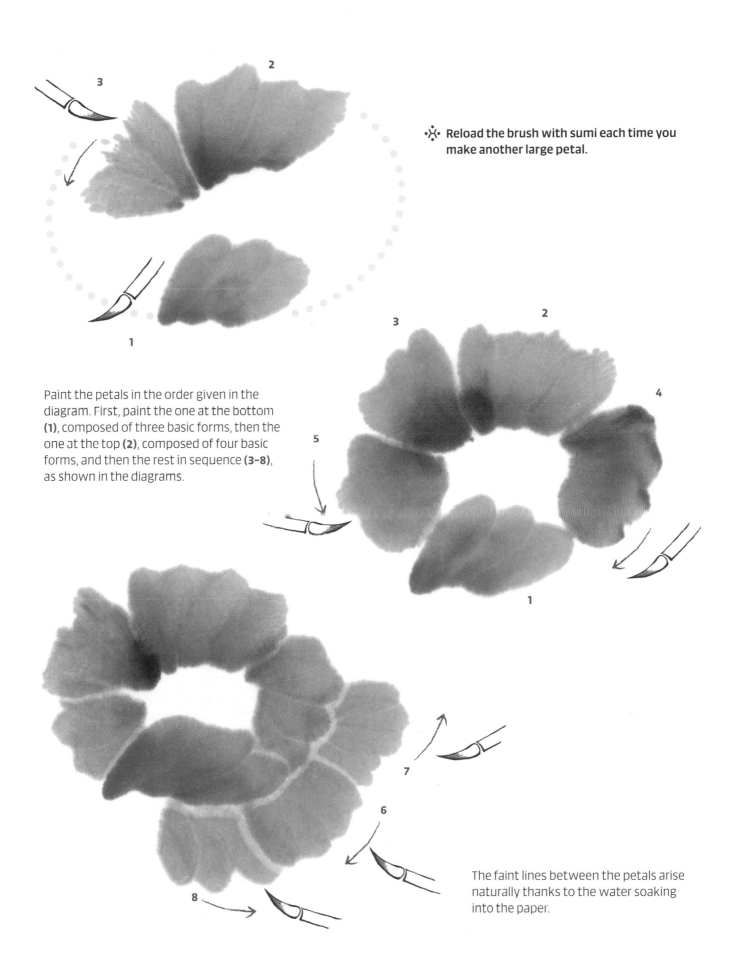

❖ Reload the brush with sumi each time you make another large petal.

Paint the petals in the order given in the diagram. First, paint the one at the bottom **(1)**, composed of three basic forms, then the one at the top **(2)**, composed of four basic forms, and then the rest in sequence **(3–8)**, as shown in the diagrams.

The faint lines between the petals arise naturally thanks to the water soaking into the paper.

131

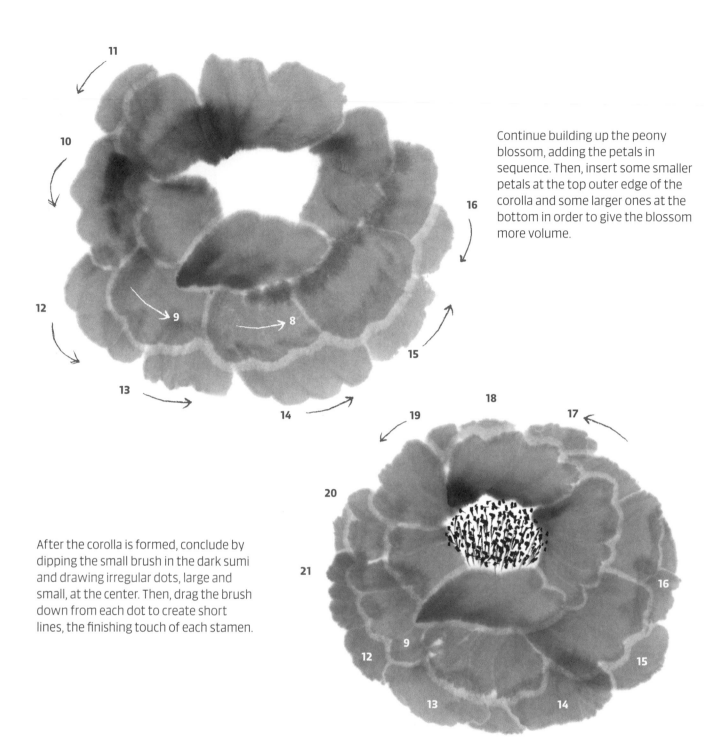

Continue building up the peony blossom, adding the petals in sequence. Then, insert some smaller petals at the top outer edge of the corolla and some larger ones at the bottom in order to give the blossom more volume.

After the corolla is formed, conclude by dipping the small brush in the dark sumi and drawing irregular dots, large and small, at the center. Then, drag the brush down from each dot to create short lines, the finishing touch of each stamen.

STAMENS 雄蕊 *OSHIBE*

- Small brush
- Dark sumi
- *Senbyō + Tenbyō*
- *Chokuhitsu*

LEAF 葉 *HA*

LEAF A

- Large brush
- Medium sumi
- Junpitsu + Mokkotsu
- *Sokuhitsu*

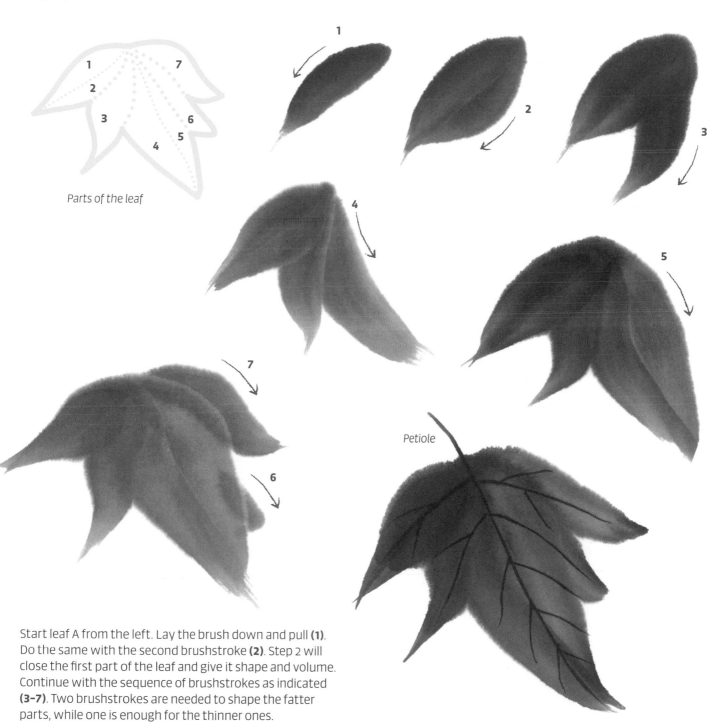

Parts of the leaf

Petiole

Start leaf A from the left. Lay the brush down and pull **(1)**. Do the same with the second brushstroke **(2)**. Step 2 will close the first part of the leaf and give it shape and volume. Continue with the sequence of brushstrokes as indicated **(3-7)**. Two brushstrokes are needed to shape the fatter parts, while one is enough for the thinner ones.

For both leaf A and leaf B, load the brush only once with medium sumi, and complete the entire leaf with it.

To draw the veins that travel down to the petiole on leaf A, see the directions for leaf B on page 134.

133

LEAF B

- Large brush
- Medium sumi
- *Junpitsu + Mokkotsu*

- *Sokuhitsu*

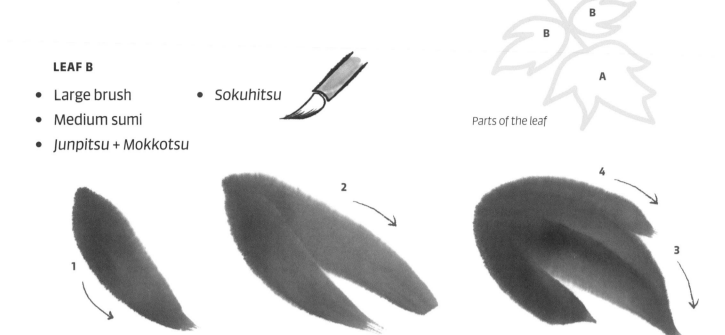

Parts of the leaf

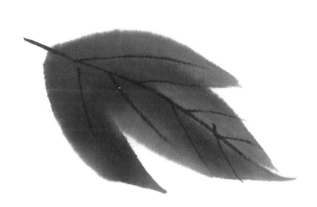

B is a smaller type of leaf that is attached to the branch laterally. See composition A and B in the diagram above. Paint it with the method used for leaf A, though with fewer steps, as it is smaller.

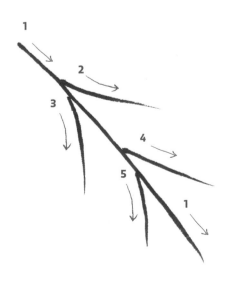

VEINS

- Small brush
- Dark sumi
- *Senbyō*

- *Chokuhitsu*

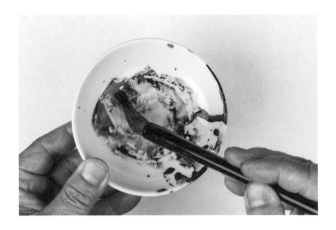

Using a small brush and dark sumi, draw the midrib **(1)**, then the veins on the side **(2–5)**, adapting them to fit the spaces of the leaf, which will be larger in the type A leaf than in the type B one.

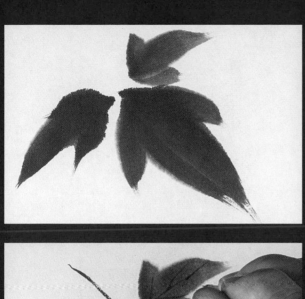

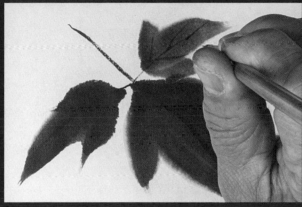

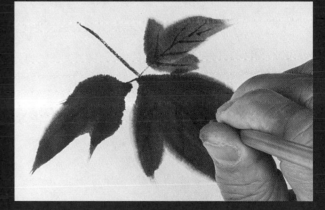

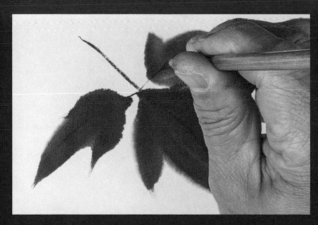

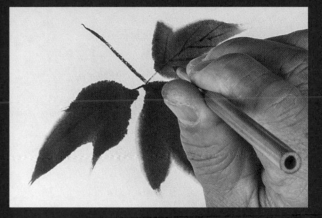

This photo sequence shows how to position leaf types A and B on a branch. To complete the painting, draw the veins with a small brush.

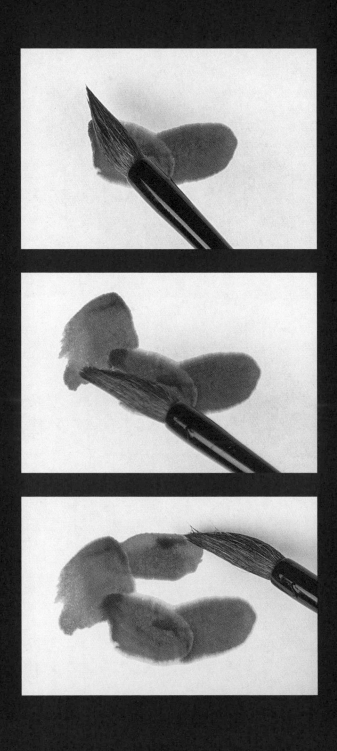

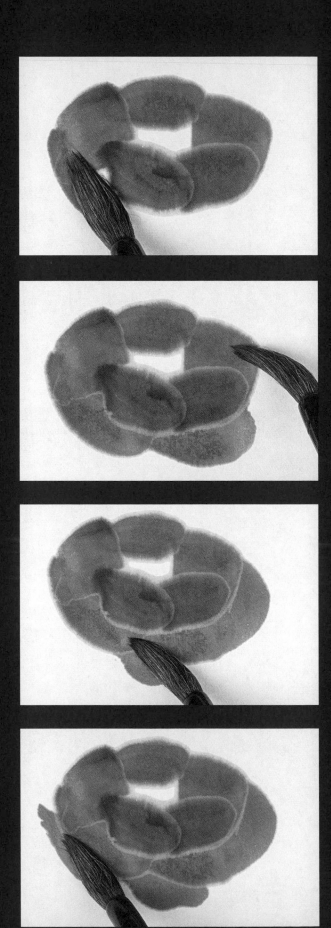

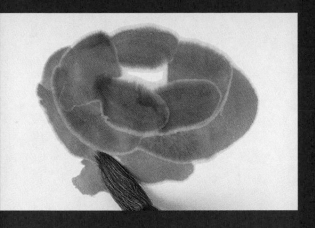

This photo sequence presents a variation on the composition of the flower with petals forming a more tightly packed corolla.

Let the brush rest on and overlap the previously drawn petal, making sure to leave a blank area at the center for the stamens.

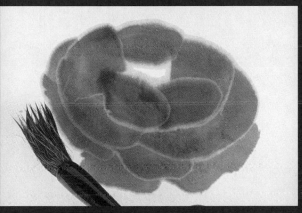

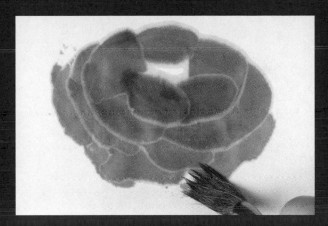

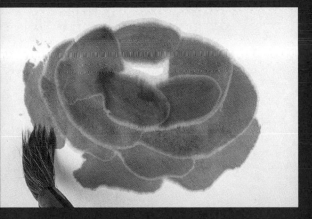

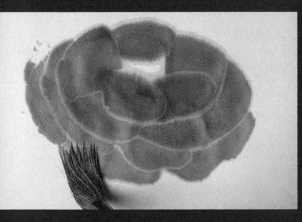

枇杷

LOQUAT

BIWA

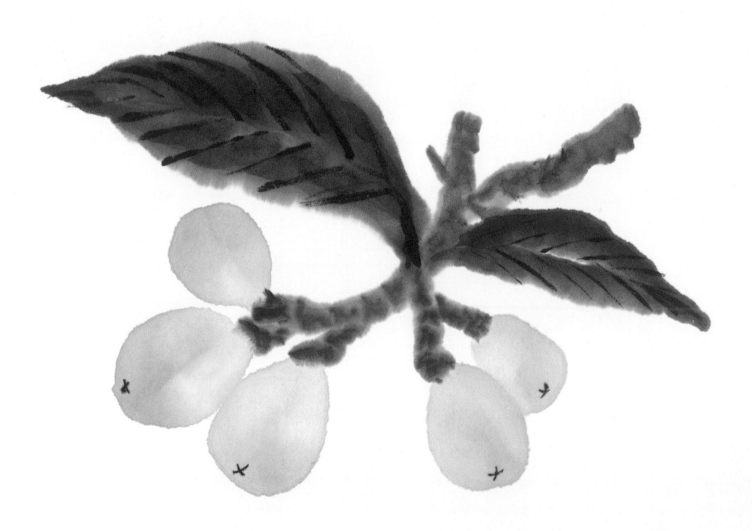

FRUIT 果実 *KAJITSU*

- Large + small brush
- Light + dark sumi
- *Senbyō*
- *Chokuhitsu*

❀ The loquat tree, also known as the "Japanese plum," has been grown in Japan for over 1,000 years for its orange fruit and for its leaves, which are made into tea (*biwa cha*). It is also a popular ornamental plant. The fruits, which grow in clusters, are usually round or oval and are eaten fresh.

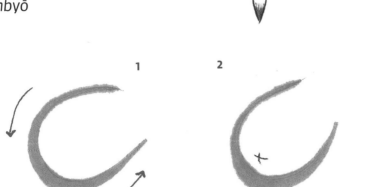

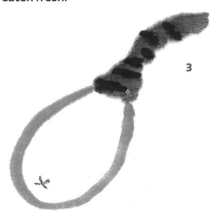

Using the large brush dipped in light sumi, paint the fruit in a single brushstroke, leaving it open on one side for the insertion of the branch. Then make a small cross at the base with the small brush and dark sumi.

BRANCH 枝 *EDA*

- Large brush
- Medium + dark sumi
- *Senbyō*
- *Chokuhitsu*

For the branch, use the medium sumi **(1)** first, then the dark sumi **(2)**, which you must apply while the medium sumi is still wet. To shape the branch correctly, apply the ink with an undulating movement.

When brushing the dark over the medium sumi, add knots at some points of the branch to make it look more realistic **(3)**.

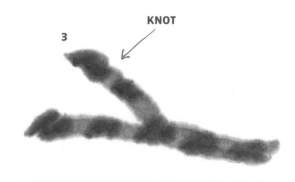

KNOT

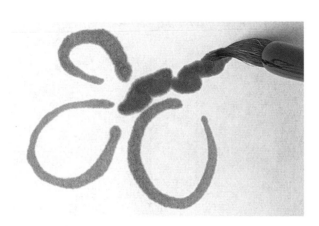

The online video tutorial for this page may be viewed on our website:
www.tuttlepublishing.com/beginners-guide-to-sumie

LEAF 葉 *HA*

- Large brush
- Medium sumi
- *Junpitsu + Mokkotsu*
- *Sokuhitsu*

⚙ **In addition to being dark green, thick and shiny, the leaves of the loquat tree are notably long, with serrated edges. In the finished painting, the leaf should look hard and strong.**

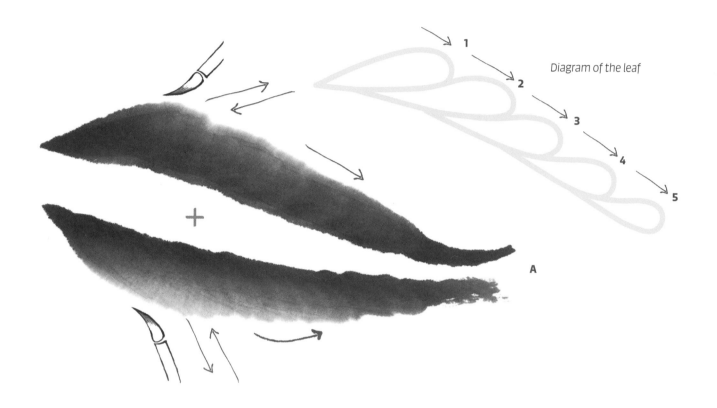

Diagram of the leaf

1
2
3
4
5

A

+

Start with the tip of the brush pointing towards the leaf's center and move it up and down, pulling towards the leaf tip (A) in order to create a serrated effect. Repeat this brushstroke about five times on each side to obtain the desired effect.

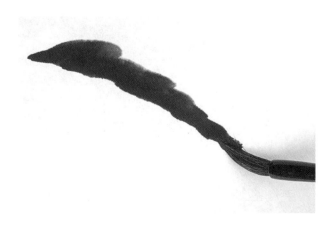

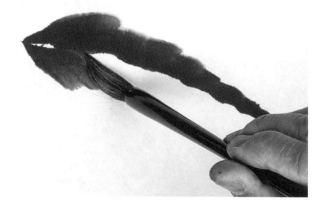

Continue painting the leaf's bottom half by holding the brush with its tip pointing towards the center, as in the following photo sequence.

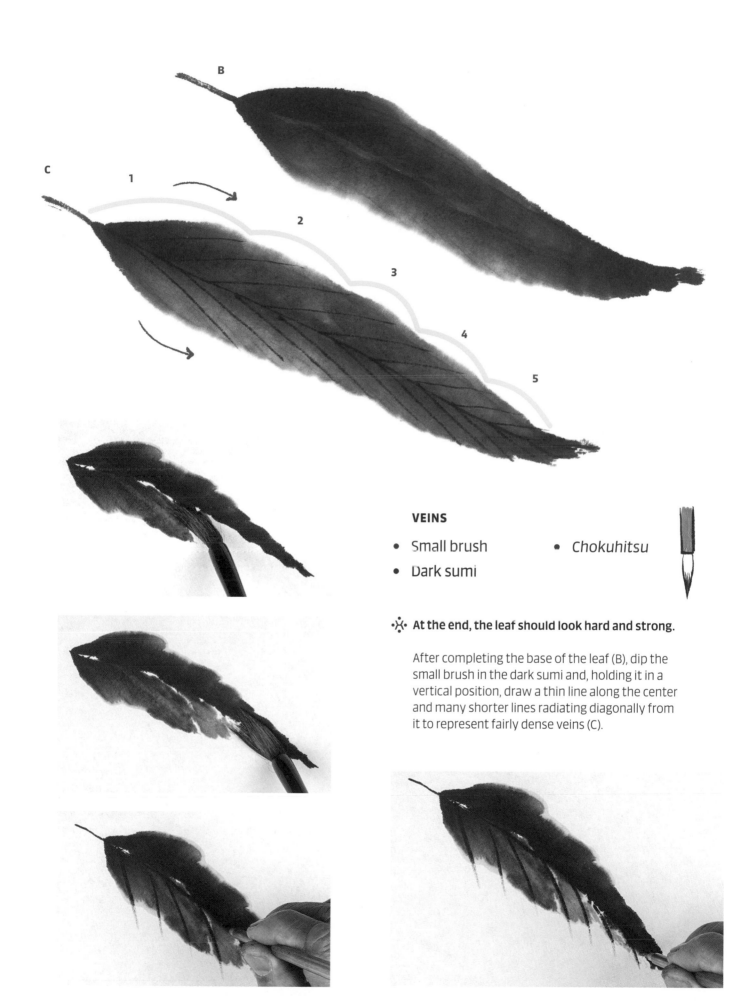

VEINS

- Small brush
- Dark sumi
- *Chokuhitsu*

✧ **At the end, the leaf should look hard and strong.**

After completing the base of the leaf (B), dip the small brush in the dark sumi and, holding it in a vertical position, draw a thin line along the center and many shorter lines radiating diagonally from it to represent fairly dense veins (C).

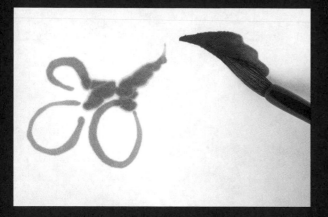

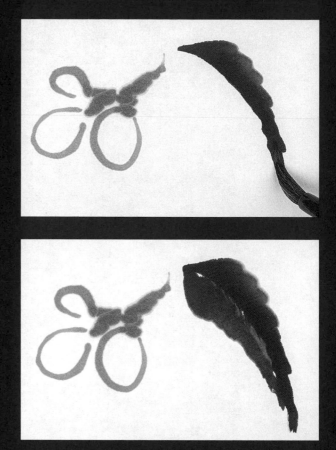

After painting the fruits and the branch, add the leaves. Balance the composition carefully, maintaining harmony between all the elements. To finish, brush some dark sumi at certain points of the branch to create the impression of knots, and use the small brush to sketch in the veins of the leaves.

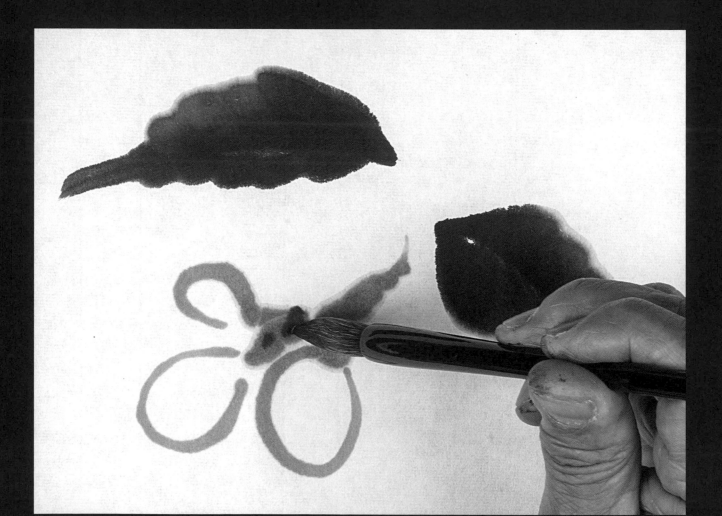

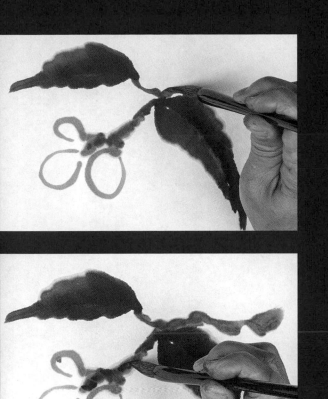

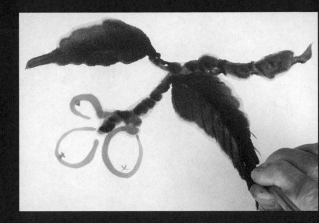

To make the fruits look more realistic, as in the painting featured on page 138, fill in the outlines with light *sumi*.

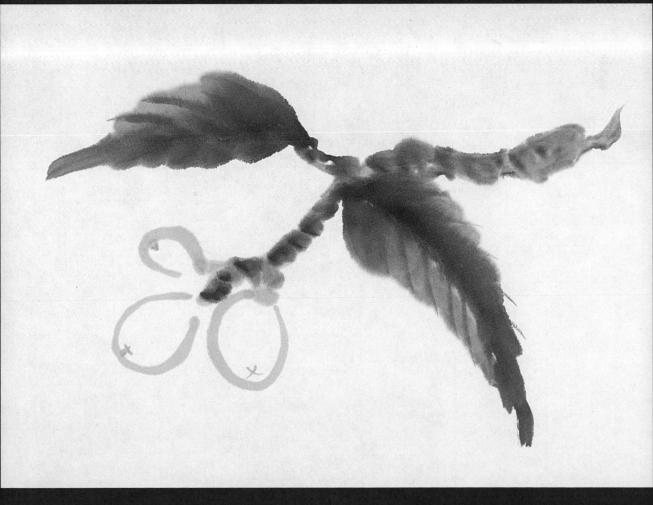

143

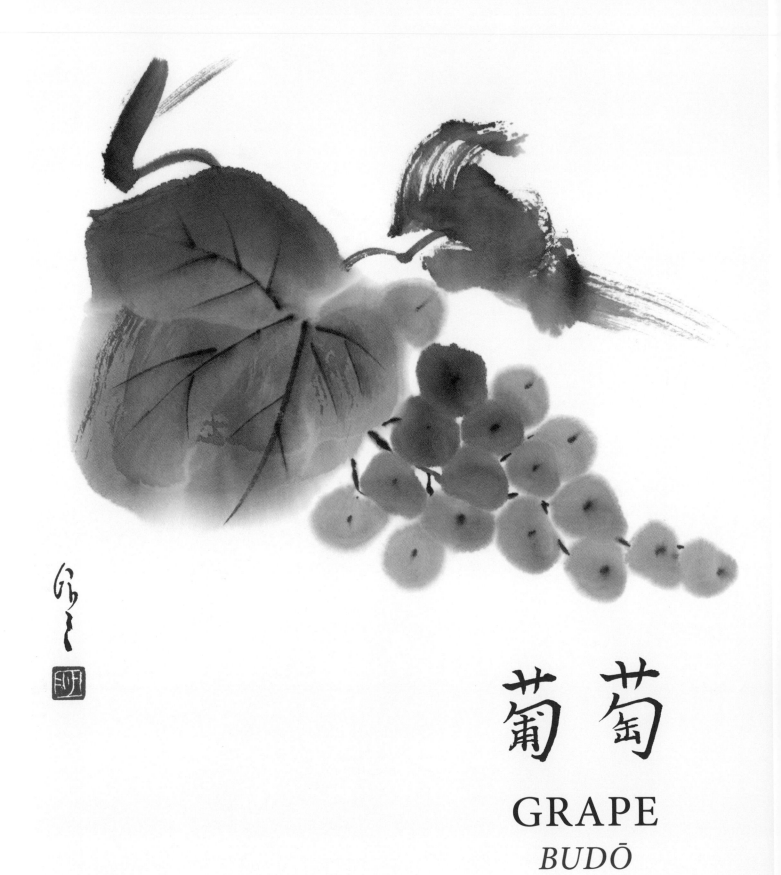

葡萄

GRAPE

BUDŌ

FRUIT 果実 *KAJITSU*

- Large brush
- Light + medium sumi
- *Mokkotsu*
- *Chokuhitsu*

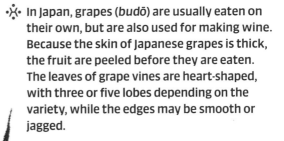

☸ In Japan, grapes (*budō*) are usually eaten on their own, but are also used for making wine. Because the skin of Japanese grapes is thick, the fruit are peeled before they are eaten. The leaves of grape vines are heart-shaped, with three or five lobes depending on the variety, while the edges may be smooth or jagged.

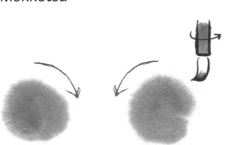

The brush is rotated clockwise or anticlockwise.

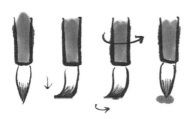

Lay the brush down nearly up to its belly and rotate it 360 degrees clockwise or counter-clockwise. The movement must capture the grape's typical roundness. Obtain variations in the shading by rotating the brush in different directions.

BUNCH 房 *FUSA*

To compose the bunch, begin with the grapes at the center, then slowly add more on the right and left.

SPECKS ON THE GRAPE

- Small brush
- Dark sumi
- *Senbyō*
- *Chokuhitsu*

Wait until the light sumi used to paint the grapes is nearly dry. Then, using the small brush and dark sumi, paint a dot at the center of each grape. Finally, draw small lines in the spaces between the grapes to join them together.

The online video tutorial for this page may be viewed on our website:
www.tuttlepublishing.com/beginners-guide-to-sumie

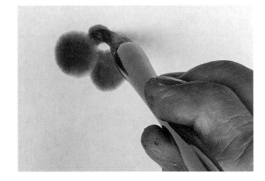

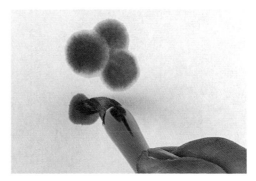

LEAF 葉 *HA*

- Large brush
- Medium sumi
- *Junpitsu + Mokkotsu*

- *Sokuhitsu*

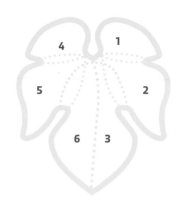

The basic leaf shape consists of six elements.

LEAF A (BASIC FORM)

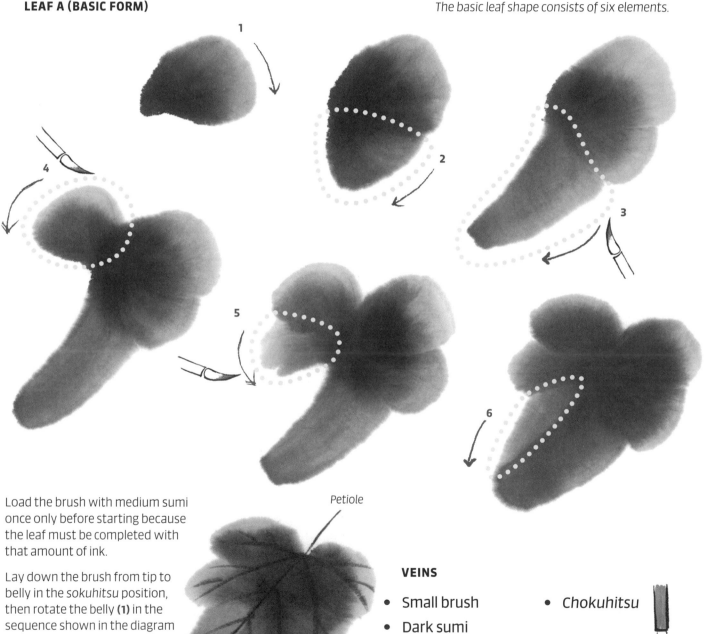

Load the brush with medium sumi once only before starting because the leaf must be completed with that amount of ink.

Lay down the brush from tip to belly in the *sokuhitsu* position, then rotate the belly **(1)** in the sequence shown in the diagram **(2–6)**.

Petiole

VEINS

- Small brush
- Dark sumi
- *Senbyō*

- *Chokuhitsu*

Using the small brush and dark sumi, draw a line for the petiole, then a central rib, then the principal veins and finally the smaller ones covering the leaf.

LEAF B (WITHERED OR INSECT-EATEN LEAF)

- Large brush
- Medium sumi
- *Kappitsu*
- *Sokuhitsu*

Form of the withered ot insect-eaten leaf.

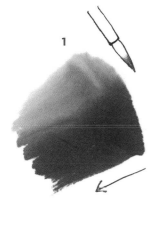

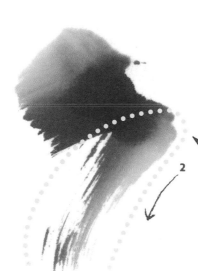

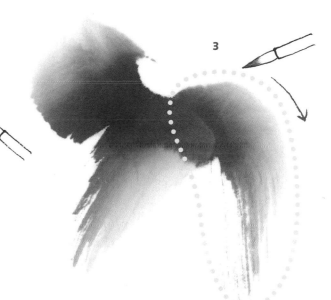

After preparing the medium sumi, squeeze out any excess liquid. Use the *kappitsu* technique with a slightly dry brush. Complete all the steps with one load of ink. The brush will gradually become drier, as will each brushstroke as you proceed.

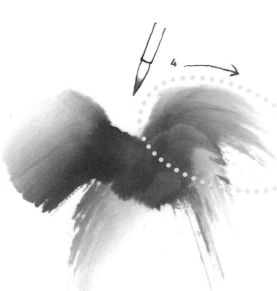

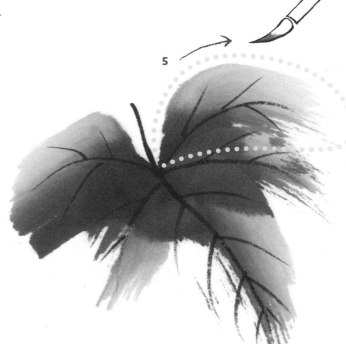

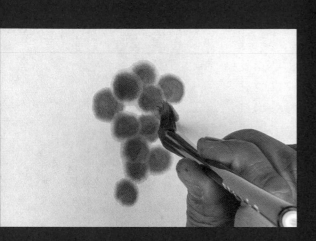

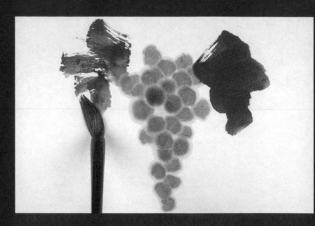

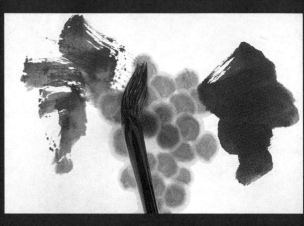

This photo sequence shows the composition of the grapes after the addition of leaves and a branch. Begin with the fruit, which should be painted in different shades. Paint the two leaves using the *kappitsu* technique after dipping the brush into the medium sumi only once. As you proceed, the sumi will lighten and the brush will dry out and create the "withered leaf" effect.

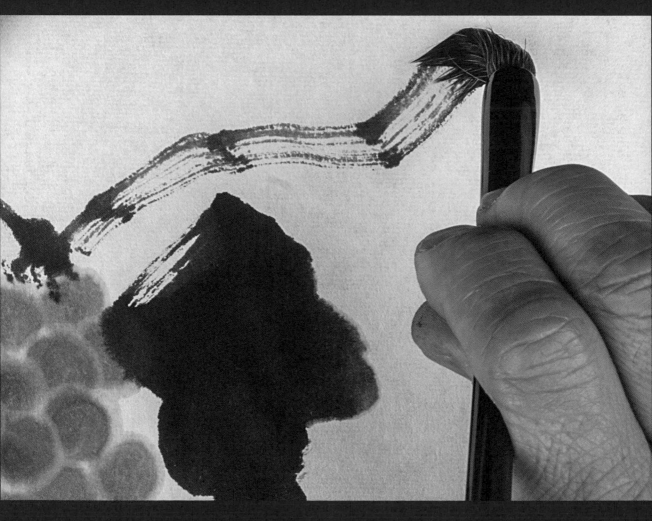

Use the *kappitsu* technique also for the branches connecting the cluster, the leaves and the main branch. Finally, using the small brush and dark sumi, add specks to the fruits, veins to the leaves and all the other details.

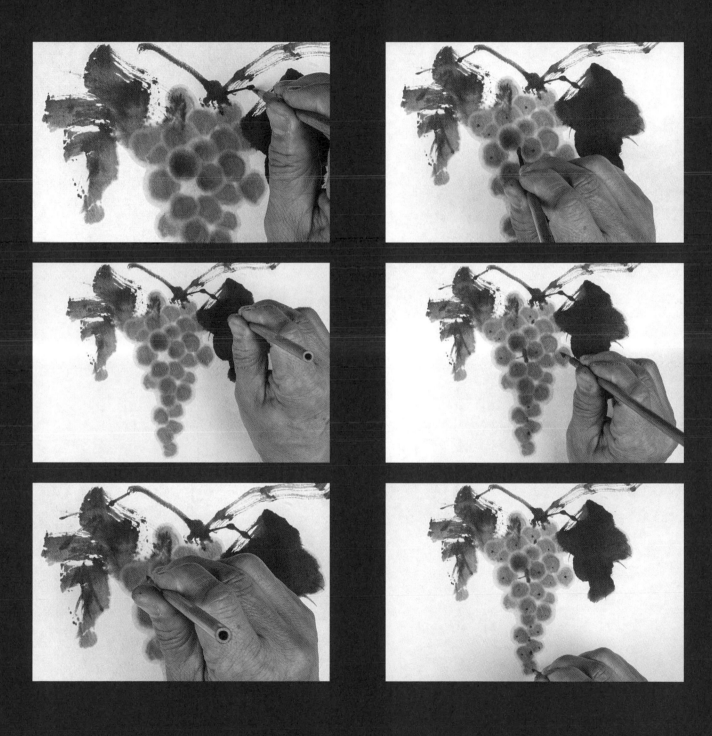

CHESTNUT
KURI

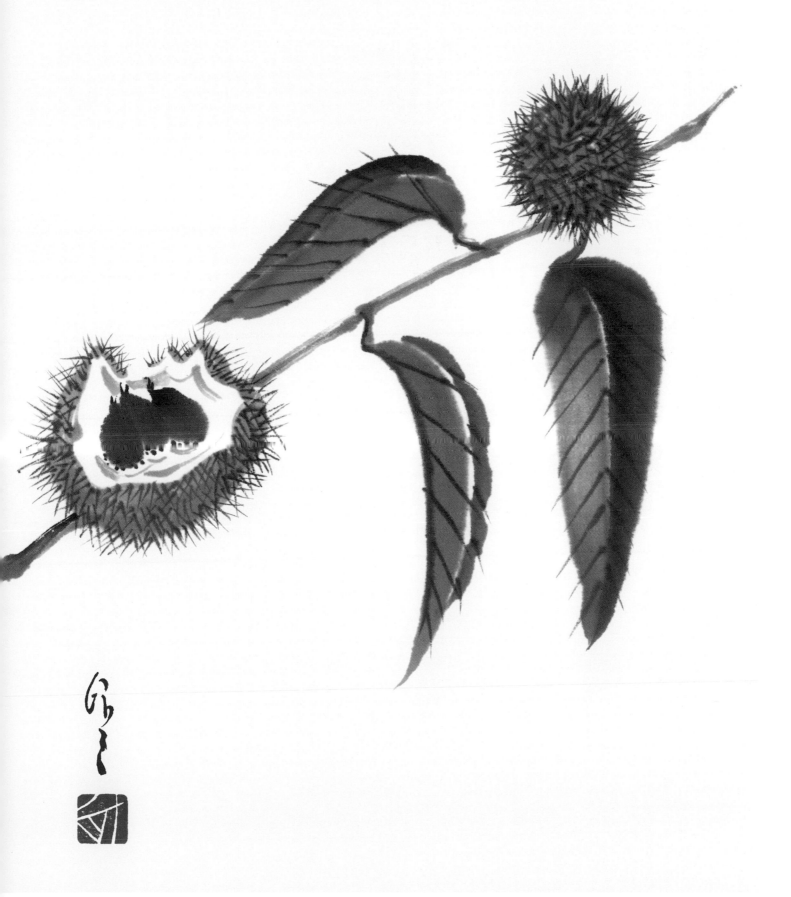

NUT 果実 *KAJITSU*

- Large brush
- Medium sumi
- Junpitsu + Mokkotsu

- Sokuhitsu

·※· The sweet, crunchy nuts of the Japanese chestnut grow in pairs or clusters on the branches of a tall tree. Encased in a thorny green-brown husk called a "burr," the nuts fall to the ground when they ripen and the husks split open.

Prepare the brush with medium sumi. Holding it in the *sokuhitsu* position with the tip firmly in place, drag its belly from right to left **(1)**.

With another stroke from left to right, outline the final shape of the chestnut while keeping the tip in place **(2)**.

The chestnut is painted with no contours. But the gradation of the sumi must be visible.

SPRIG AND SPOTS

- Small brush
- Dark sumi

- Chokuhitsu

Using the small brush, draw the details—the sprig at the top, a gently curved line towards the bottom, and the specks.

When depicting a chestnut inside an open burr, use the technique for the basic chestnut, but paint each one with a single brushstroke—first the one at the center, then the two on either side—very close to each other but not overlapping.

The online video tutorial for this page may be viewed on our website:
www.tuttlepublishing.com/beginners-guide-to-sumie

BURR 毬 IGA

WITHOUT THE CHESTNUT

- Large brush
- Light sumi
- Junpitsu + Mokkotsu

- *Sokuhitsu*

To draw the closed chestnut with its husk and thorns, use the large brush loaded with light sumi in the *sokuhitsu* position.

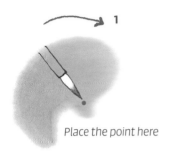

1

Place the point here

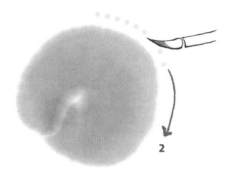

2

3

With the tip down and never lifting the brush from the paper, rotate its belly in a full circle. Compete the movement in a single stroke **(1–2)**.

THORNS

- Small brush
- Dark sumi
- *Senbyō*

- *Chokuhitsu*

4

5

6

Once the ink is dry, add the thorns with the small brush and dark sumi **(3–6)**. Begin at the outer edge and slowly fill the entire form. The lines can be different in size and angle so that "V" shapes are formed between them, as in the diagram.

OPEN BURR WITH CHESTNUTS

- Large brush
- Light sumi
- Junpitsu + Mokkotsu
- *Sokuhitsu*

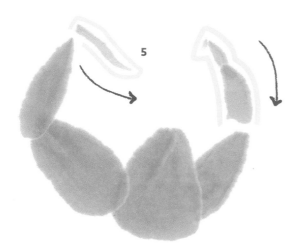

When painting the open burr, first build up the form of the casing with the light sumi. Then add the chestnuts to the interior and the thorns to the exterior. Keep some areas inside blank.

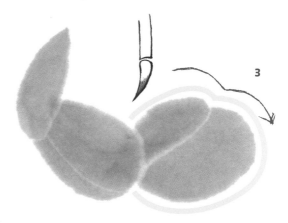

Starting from the left, place the brush in the *sokuhitsu* position with the tip pointing upwards. Press down on it to make a teardrop-like shape **(1)**. Maintaining the *sokuhitsu* position and using a broader stroke, paint a similar shape below but slightly overlapping it **(2)**.

Continue making strokes in the *sokuhitsu* position, moving and pressing down on the brush until you get a shape similar to the one in the diagram **(3)**.

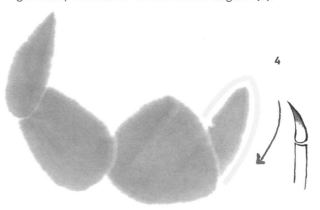

When painting the right side, change the position of the brush so that the tip is pointing upwards. Use a movement similar to the one for the first teardrop **(6)**.

Add some short, thin brushstrokes as in the diagram **(4)**. Finally, add the chestnuts at the center, then the thorns, as in the instructions. Always remember to leave blank spaces inside **(5)**.

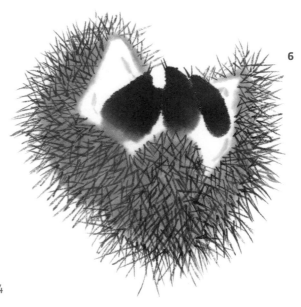

❖ Paint at least three chestnuts inside the burr using the same technique as for the single one, but make them smaller.

LEAF 葉 *HA*

- Large brush
- Medium sumi
- Junpitsu + Mokkotsu
- *Sokuhitsu*

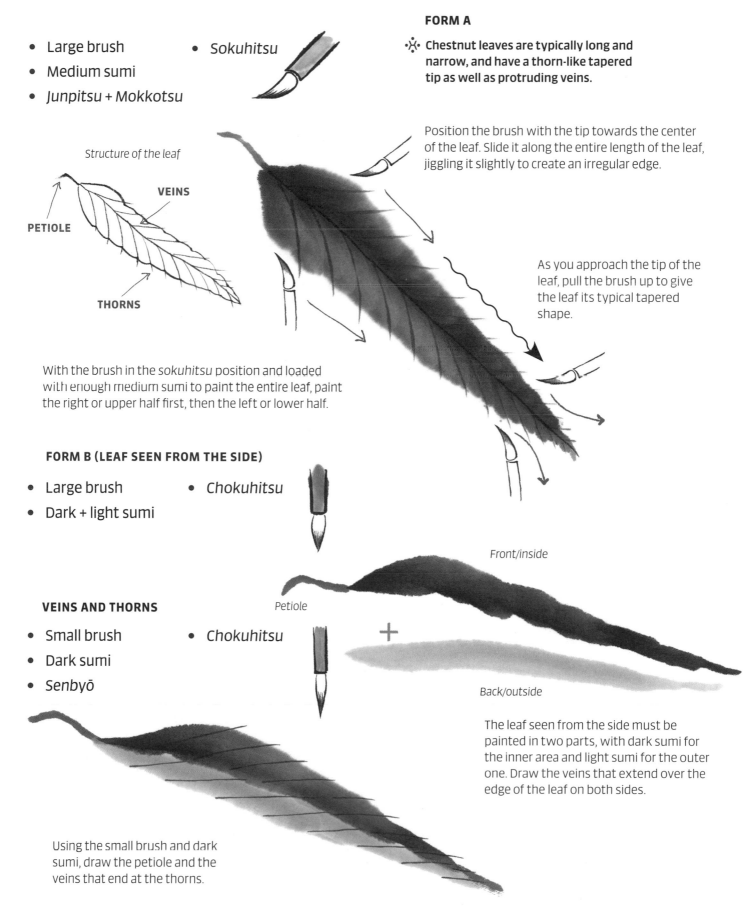

FORM A

❋ Chestnut leaves are typically long and narrow, and have a thorn-like tapered tip as well as protruding veins.

Position the brush with the tip towards the center of the leaf. Slide it along the entire length of the leaf, jiggling it slightly to create an irregular edge.

Structure of the leaf

PETIOLE

VEINS

THORNS

As you approach the tip of the leaf, pull the brush up to give the leaf its typical tapered shape.

With the brush in the *sokuhitsu* position and loaded with enough medium sumi to paint the entire leaf, paint the right or upper half first, then the left or lower half.

FORM B (LEAF SEEN FROM THE SIDE)

- Large brush
- Dark + light sumi
- *Chokuhitsu*

Petiole

Front/inside

Back/outside

VEINS AND THORNS

- Small brush
- Dark sumi
- *Senbyō*
- *Chokuhitsu*

The leaf seen from the side must be painted in two parts, with dark sumi for the inner area and light sumi for the outer one. Draw the veins that extend over the edge of the leaf on both sides.

Using the small brush and dark sumi, draw the petiole and the veins that end at the thorns.

155

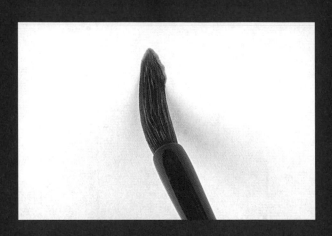

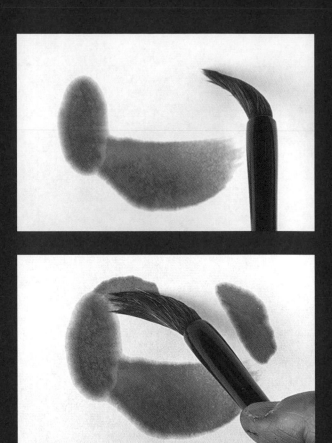

This photo sequence shows the basic composition of a chestnut branch on which closed and open burrs alternate. After adding some leaves, add touches of dark sumi to "strengthen" the appearance of the branch.

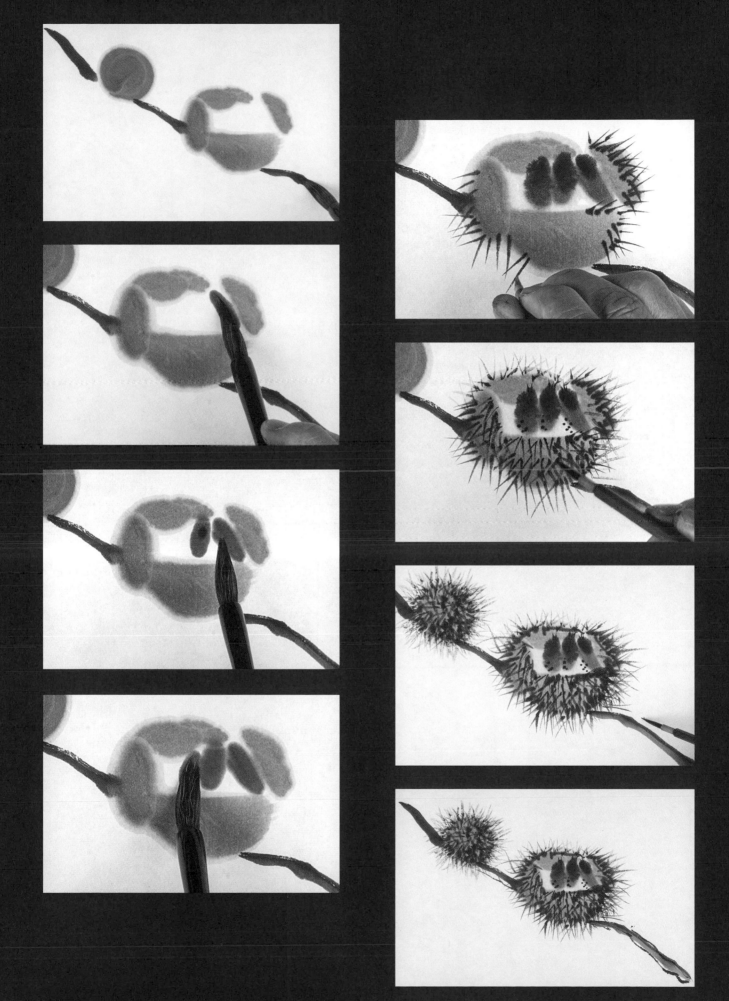

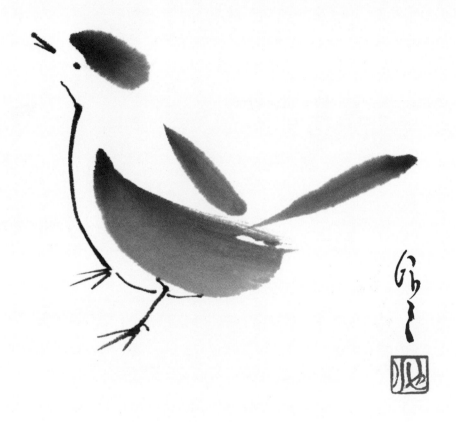

小鳥

LITTLE BIRD

KOTORI

LITTLE BIRD: VERSION A 小鳥 *KOTORI*

- Large brush
- Medium sumi
- *Mokkotsu + Senbyō*
- *Chokuhitsu*

☼ **Little birds have long been a favorite motif in Japanese art. They are associated with specific seasons and are auspicious symbols of longevity, prosperity, wisdom, luck, love and much more.**

Load the brush with medium sumi once, then paint the head, wings and tail of the bird.

To paint the head, place the brush in the *chokuhitsu* position up to its belly, then quickly lift it **(1)**. The tip of the brush will mark the direction of the bird's head. In the example here, it looks up at a 45-degree angle.

To make the first wing, place the tip of the brush slightly below the head, then slide it, keeping the tip upwards and applying increasing pressure to give the right wing sufficient breadth **(2)**.

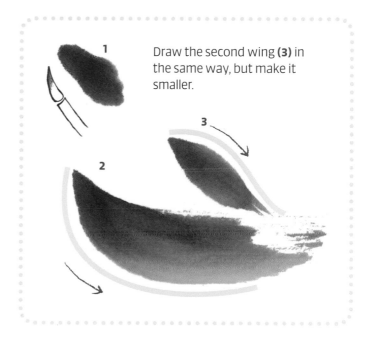

Draw the second wing **(3)** in the same way, but make it smaller.

The online video tutorial for this page may be viewed on our website:
www.tuttlepublishing.com/beginners-guide-to-sumie

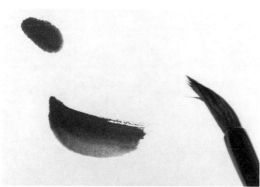

TAIL

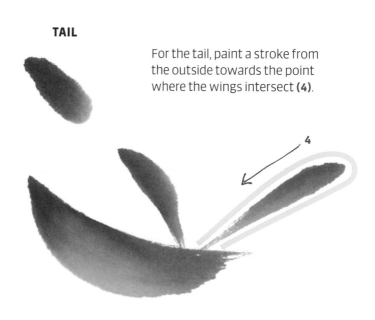

For the tail, paint a stroke from the outside towards the point where the wings intersect **(4)**.

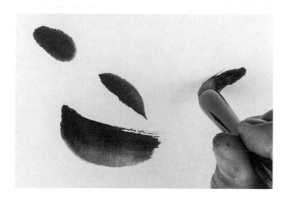

The photo sequence on the left shows the composition of the bird.

BEAK, EYE, BELLY

- Large + small brush
- Dark sumi
- *Senbyō*

- *Chokuhitsu*

Using dark sumi on the large brush, paint the beak from the outside inwards, at the same angle as the head **(1)**.

Mark the eye with a speck of dark sumi **(2)**.

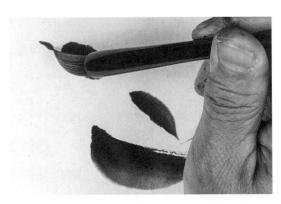

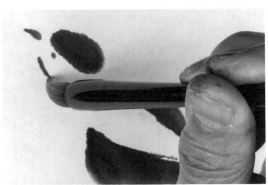

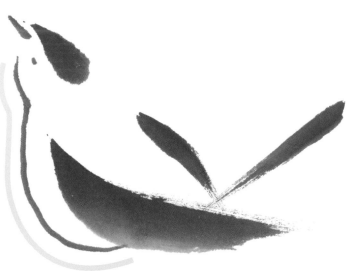

Starting just below the base of the beak, use the small brush to draw a curved line for the head, then continue with the curved line of the belly, which should sweep up towards the tail **(3)**.

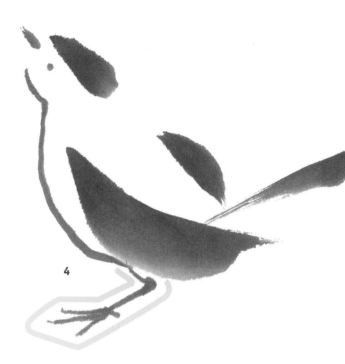

LEGS

- Small brush
- Dark sumi
- *Senbyō*
- *Chokuhitsu*

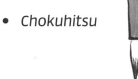

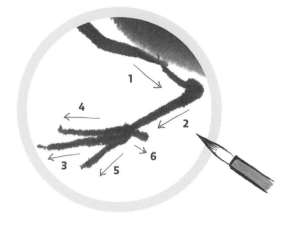

Using the small brush, draw the legs of the bird in the sequence and direction of the strokes shown in the diagram above **(4)**.

Be careful with the perspective. The foot closest to the viewer should be fully visible whereas the other should be only partly visible, as shown below **(5)**.

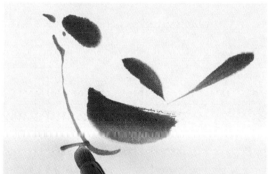

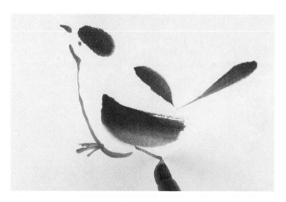

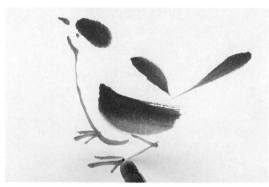

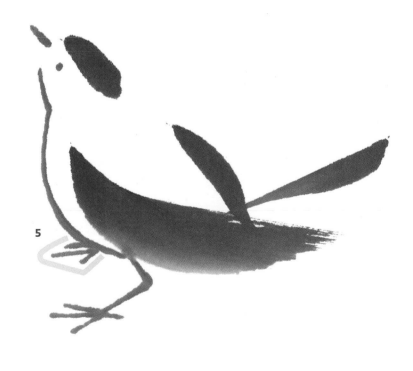

LITTLE BIRD: VERSION B 小鳥 *KOTORI*

- Large brush
- Light + medium sumi
- *Mokkotsu*

- *Chokuhitsu*

❖ In Japanese art, birds are usually perched on a branch, either singly or in pairs, and painted from the front or the back, as shown here, or from the side.

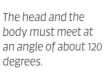

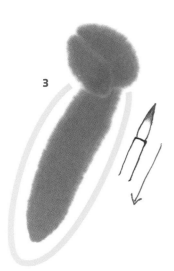

Load the brush with medium sumi. Holding it in the *chokuhitsu* position, paint the head in two brushstrokes **(1, 2)**, then the body with the first brushstroke starting at the base of the head **(3)**, and a second one, slightly longer, overlapping it **(4)**.

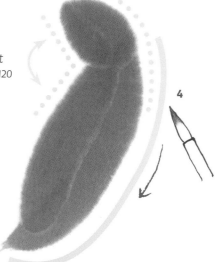

The head and the body must meet at an angle of about 120 degrees.

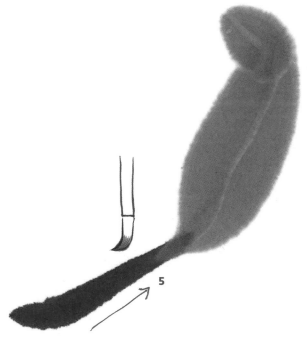

TAIL

- Small brush
- Dark sumi
- *Senbyō*

- *Chokuhitsu*

Paint the tail with one stroke of dark sumi from the outside towards the body, letting it fade as you do so **(5)**.

WINGS

- Large brush
- Dark sumi
- Senbyō

- *Chokuhitsu*

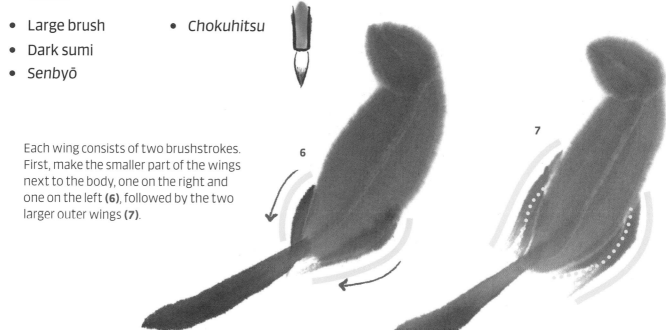

Each wing consists of two brushstrokes. First, make the smaller part of the wings next to the body, one on the right and one on the left **(6)**, followed by the two larger outer wings **(7)**.

BEAK AND EYES

- Small brush
- Dark sumi
- Senbyō
- *Chokuhitsu*

Draw a line for the beak and a dot for the eye **(8)**.

If using Japanese paper and a brush that is not too wet, wait a short while between one brushstroke and the next in order to obtain a clear line (water mark) at the intersection of the inner and outer wing brushstrokes.

FEET

- Small brush
- Medium sumi
- Senbyō
- *Chokuhitsu*

Only one foot should be visible. Paint it according to the diagram **(9)**. Lines 2 and 3 end with a slight curve as the bird's legs are perched on a branch.

163

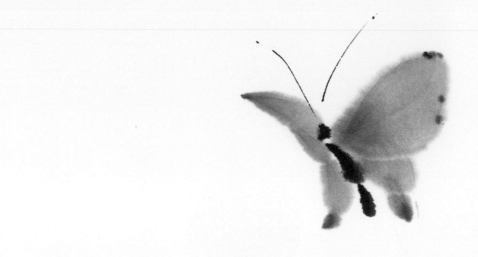

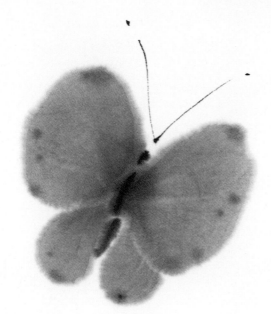

BUTTERFLY

CHŌ

BUTTERFLY: VERSION A 蝶 *CHŌ*

WINGS

- Large brush
- Medium sumi
- Mokkotsu

- *Sokuhitsu*

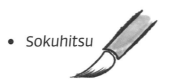

✤ Butterflies carry many meanings in Japanese culture but most often are a symbol of metamorphosis and transformation. They also symbolize joy and longevity. The butterfly can be painted in different positions.

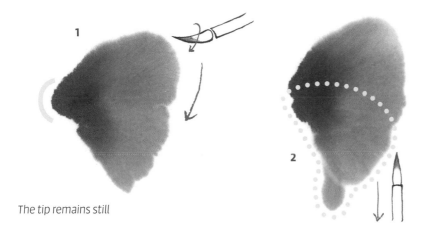

The tip remains still

Composition A

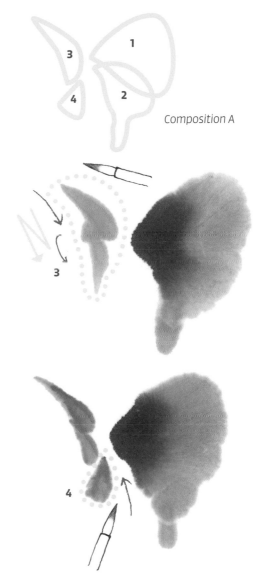

Version A shows the butterfly viewed from the side and bottom.

Load the large brush with enough medium sumi to paint both wings. Lay the brush down, and holding the tip steady, rotate the belly **(1)**. Brush the second stroke over the previous one with a similar movement, but end by dragging the brush downwards to create the wing's lower tip **(2)**.

The second wing must be smaller to achieve the correct perspective. It is painted with two strokes, the first semicircular, the second shorter and straighter immediately below. The end shape should resemble the letter "Z," as in the diagram **(3)**. Complete the second wing with one final stroke **(4)**.

BODY

- Small brush
- Dark sumi
- Senbyō

- *Chokuhitsu*

Head

Thorax

Abdomen

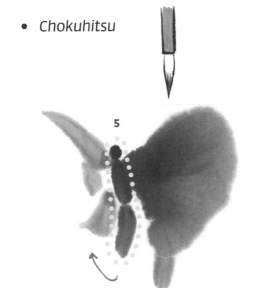

Draw the body after making the wings. Using the tip of the small brush and the dark sumi, press down lightly to paint the head. For the thorax, lay the brush down and drag it downwards while exerting light pressure. To paint the abdomen, execute the movement in the opposite direction **(5)**.

The online video tutorial for this page may be viewed on our website:
www.tuttlepublishing.com/beginners-guide-to-sumie

ANTENNA AND WING MARKINGS

- Small brush
- Dark sumi
- *Senbyō*

- *Chokuhitsu*

To complete the butterfly, paint the antenna and the markings on the wings.

Using the small brush and the dark sumi, draw the antenna from the outside towards the inside, not forgetting the dots at the ends **(6)**.

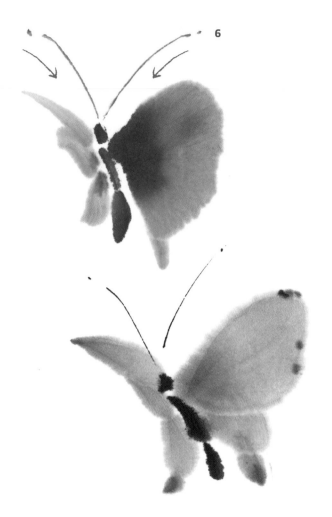

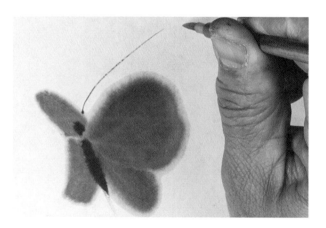

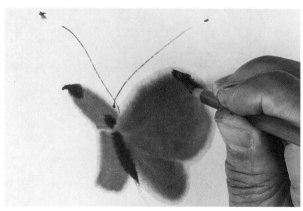

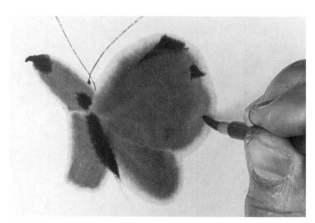

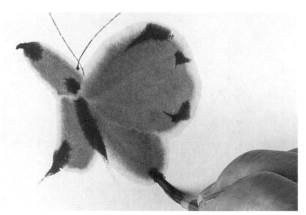

The diagrams or the photographs can be followed. You can customize the butterfly any way you wish.

BUTTERFLY: VERSION B 蝶 *CHŌ*

WINGS

- Large brush
- Medium sumi
- *Mokkotsu + Junpitsu*
- *Sokuhitsu*

Composition B

Load enough medium sumi on the brush to paint both wings. The wings of version B are painted in the same way as the larger wings of version A.

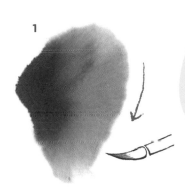

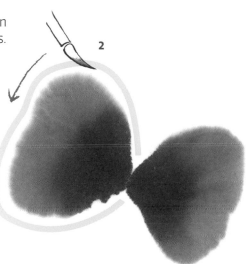

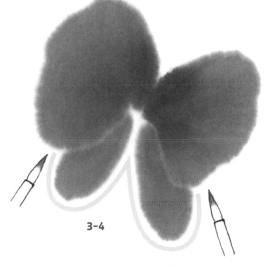

Keep the tip of the brush still and facing inwards while rotating the belly to shape the entire wing. Make the wing on the right first **(1)**, then the one on the left **(2)**.

To paint the lower section, lay the brush down from tip to belly with the tip oriented towards the interior of the first part of the wings, as in the diagram **(3-4)**.

BODY AND ANTENNA

- Small brush
- Dark sumi
- *Senbyō*
- *Chokuhitsu*

Head

Thorax

Abdomen

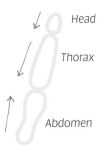

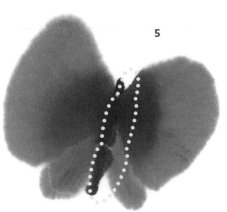

Paint the body according to the steps illustrated for butterfly version A **(5)**. The only change is the shape, which should now be straight instead of curved.

Add the antenna as in butterfly A **(6)**.

雛

CHICK
HINA

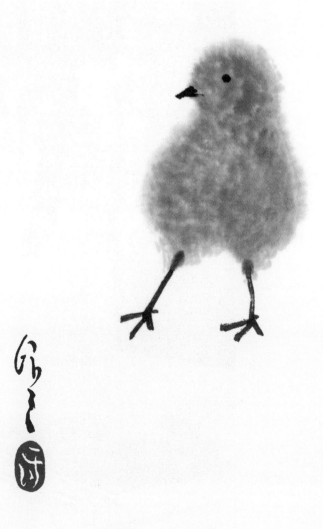

BODY 胴部 *DOBU*

- Large + small brush
- Light sumi
- Nijimi + Junpitsu
- *Chokuhitsu*

❊ The chick (*hina*, which also means "cub") is a simple subject but is useful for practicing the technique known as *nijimi*, which is used widely to depict animal fur.

HEAD, BODY

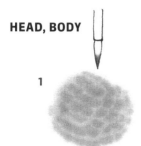

1

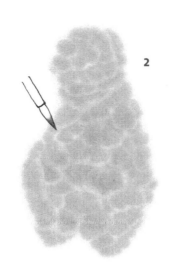

2

3

❊ The effect of the bleeding ink, a distinct feature of the *nijimi* technique, creates the sense of the chick's soft plumage.

Start by moistening the paper with clean water where you want to paint the chick. Load the large brush with light sumi and tap the tip of the brush repeatedly on the dampened areas of the paper to form a roundish head **(1)**. The sumi will bleed into the damp paper. The dots made by the taps should be very dense or even overlap.

Once the head is the right shape, paint the body in the same way in the shape shown in the diagram **(2)**.

Elaborate on the texture of the chick's plumage by adding gradations of light and shadow using the *junpitsu* technique **(3)**. Once the painting dries, you will not see any water marks around the chick.

> The online video tutorial for this page may be viewed on our website:
> **www.tuttlepublishing.com/beginners-guide-to-sumie**

BEAK, EYES AND LEGS

- Small brush
- Dark sumi
- Senbyō
- *Chokuhitsu*

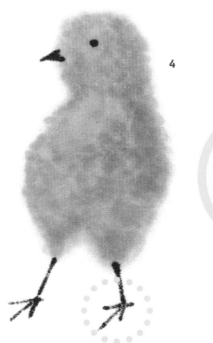

4

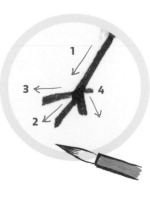

Using the small brush and the dark sumi, complete the chick by drawing a triangle for the beak, a dot for the eye and thin lines for the legs, as shown in the diagram far right **(1–4)**.

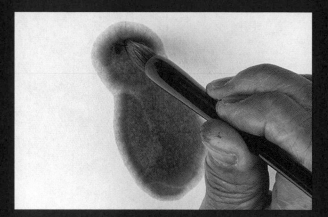

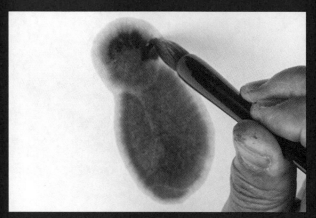

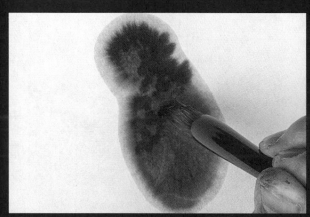

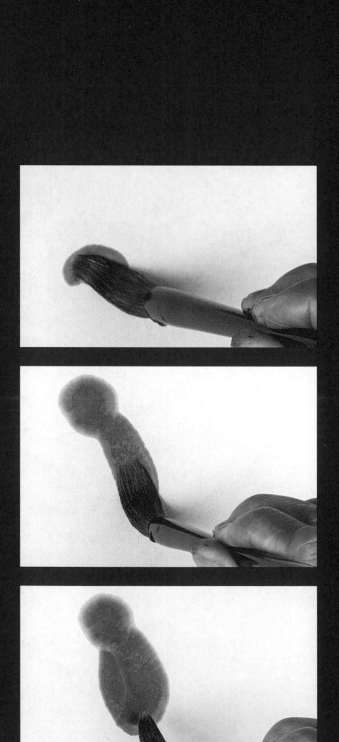

This sequence of photos shows the steps in painting the chick. Paint the head and body with the light sumi, and while still wet add the dots as per the *nijimi* technique. These will bleed and create the effect of soft plumage. Then add more texture using the *junpitsu* technique. All traces of water will disappear around the edges of the chick once the painting dries.

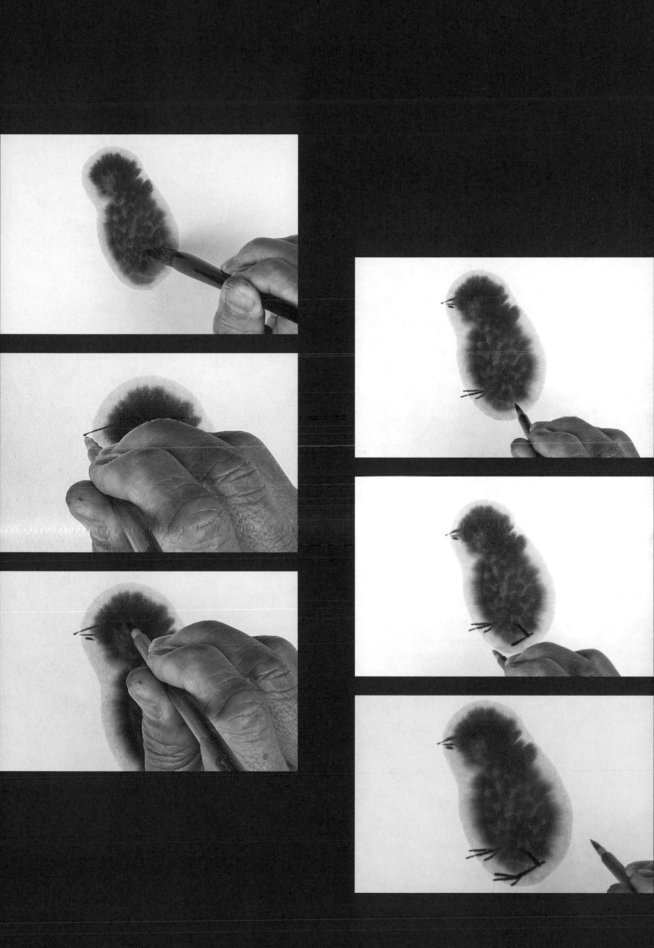

CRAB

KANI

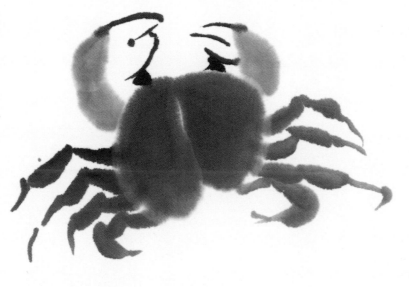

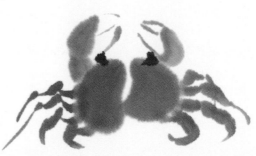

SHELL 甲羅 *KORA*

- Large brush
- Medium sumi
- Mokkotsu

- *Sokuhitsu*

❖ The crab is a popular image in Japanese art, often used to illustrate the meaning of "harmony." Ink stones and water dishes are sometimes decorated with small crabs harmoniously coupled with either lotuses or stalks of rice.

Wide part

Narrow part

The crab typically has a wide upper body and a narrow lower body.

Lay the brush down and pull it down a little to form the first part of the shell **(1)**.

Position the brush at the top and drag it down in a circular motion **(2)**. The play of light and dark must be visible in order to give a sense of volume.

CLAWS 鋏 *HASAMI*

- Large brush
- Medium sumi
- Mokkotsu

- *Sokuhitsu*

To make the first claw on the left (A), lay down the brush, then lift it **(1)**. Make a second stroke in the same way to complete the claw and connect it to the body.

The claw on the right (B) should be smaller and made with a single stroke **(2)**.

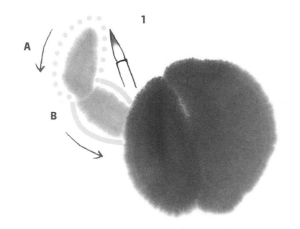

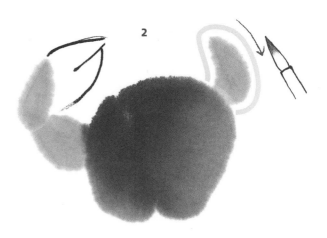

The online video tutorial for this page may be viewed on our website:
www.tuttlepublishing.com/beginners-guide-to-sumie

PINCERS

- Small brush
- Dark sumi
- Senbyō
- *Chokuhitsu*

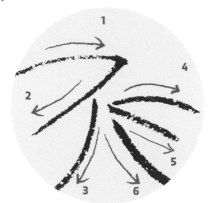

To make the pincers, paint thin lines in dark sumi following the diagram **(1–6)**.

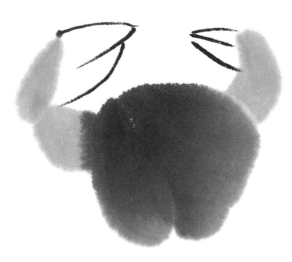

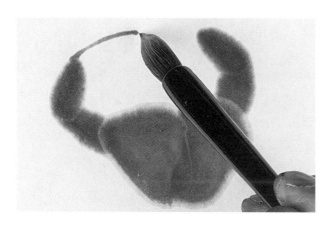

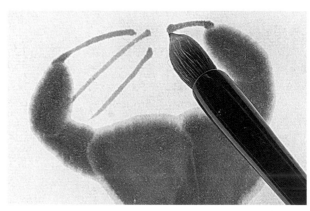

EYES

- Small brush
- Dark sumi
- Senbyō
- *Chokuhitsu*

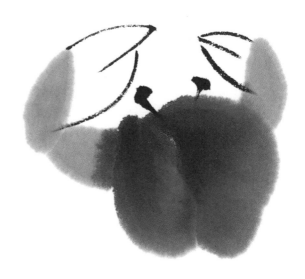

Pressing down lightly on the small brush, draw a short line to the shell in black sumi. Repeat for the other eye.

❋ **The eyes are comma-shaped.**

LEGS 脚 ASHI

- Small brush
- Medium sumi
- Senbyō

- Chokuhitsu

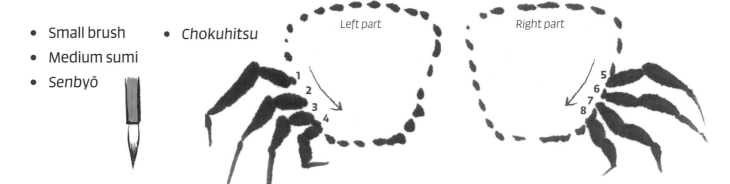

Paint the legs on both sides of the shell, each in a slightly different position so that they look as realistic as possible.

Each leg is composed of three elements. Follow the steps in the diagrams below for painting the various shapes.

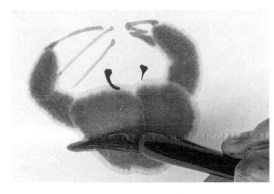

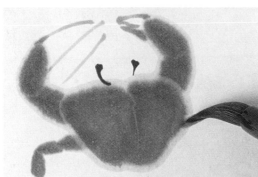

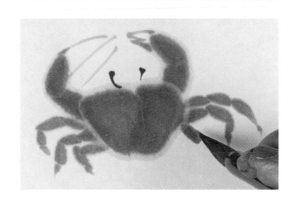

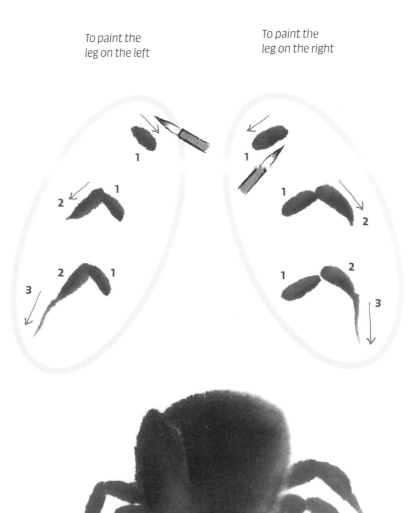

To paint the leg on the left

To paint the leg on the right

GOLDFISH

KINGYO

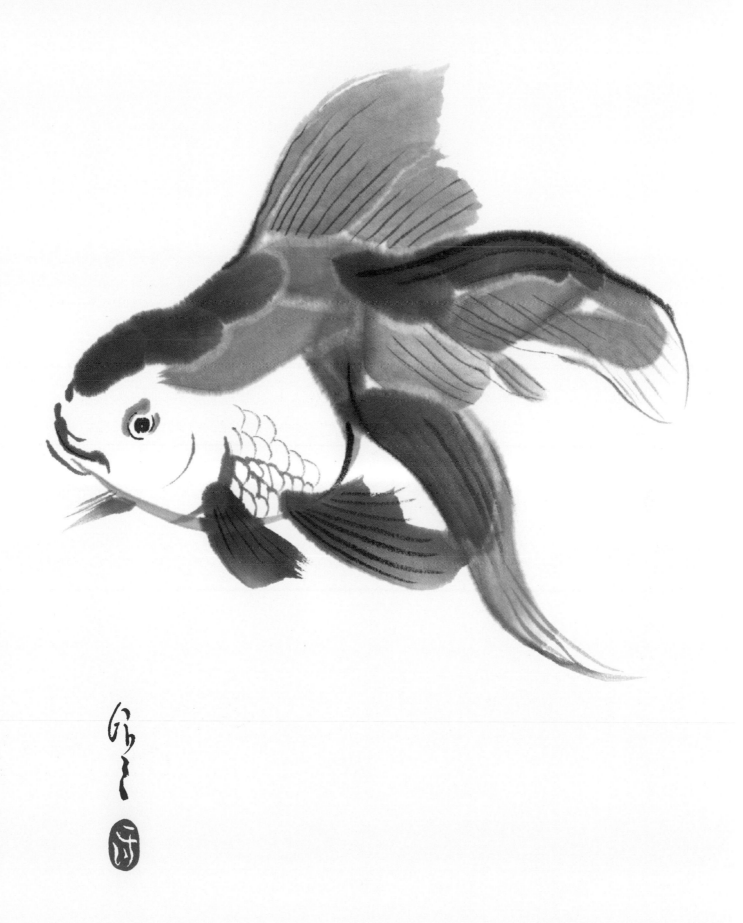

BODY 胴部 *DŌBU*

HEAD

- Large brush
- Medium sumi
- Junpitsu
- *Chokuhitsu*

·※· The goldfish, much loved in Japan, has been considered a symbol of beauty in Japanese art for hundreds of years, especially for its long, undulating fins. The goldfish is also believed to bring good luck and wealth.

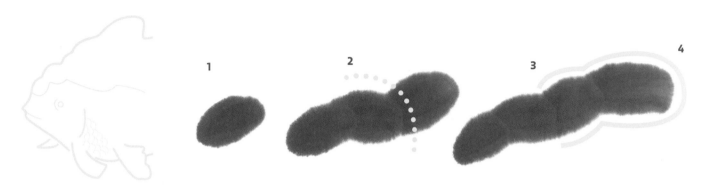

Using a large brush loaded with medium sumi, start with the top of the head. Keeping the brush in the *chokuhitsu* position, press down, then lift **(1)**. Repeat this movement three or four times, letting the brushstrokes overlap slightly as shown in the diagram **(2–4)**. The size and number of strokes will determine the size of the fish's head.

DORSAL FIN

- Large brush
- Light sumi
- Junpitsu
- *Sokuhitsu*

·※· The dorsal fin is the largest one and is attached to the upper body.

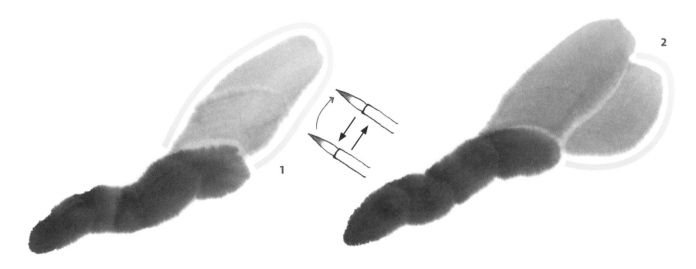

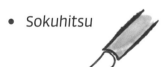

The online video tutorial for this page may be viewed on our website:
www.tuttlepublishing.com/beginners-guide-to-sumie

Load the brush with enough light sumi to paint the entire dorsal fin. Holding the brush in the *sokuhitsu* position, draw part of the fin with a sweeping movement **(1)**. Repeat this step at least one more time, superimposing the lines slightly to obtain the right size **(2)**.

CAUDAL FIN

- Large brush
- Light + dark sumi
- *Junpitsu* + *Mokkotsu*

- *Sokuhitsu*

Load the brush with enough light sumi to paint parts A, B and C of the caudal fin **(1)**.

Starting at the end of the dorsal fin, place the brush in the *sokuhitsu* position and drag it from left to right to create the fin's first section (A). Repeat the movement for sections B and C.

Part D is painted in light sumi, with dark sumi on the tip, in various lengths, as in the diagram **(2)**.

ABDOMINAL FIN

- Large brush
- Medium sumi
- *Junpitsu + Mokkotsu*
- *Chokuhitsu*

Paint a curved line to depict the belly of the fish, leaving enough space for the mouth **(1)**. The line should end at the base of the caudal fin.

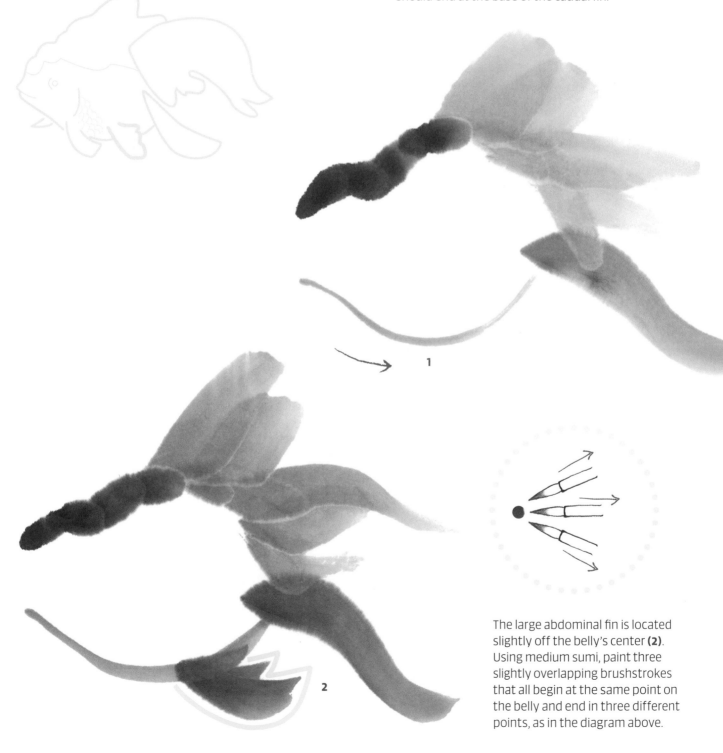

The large abdominal fin is located slightly off the belly's center **(2)**. Using medium sumi, paint three slightly overlapping brushstrokes that all begin at the same point on the belly and end in three different points, as in the diagram above.

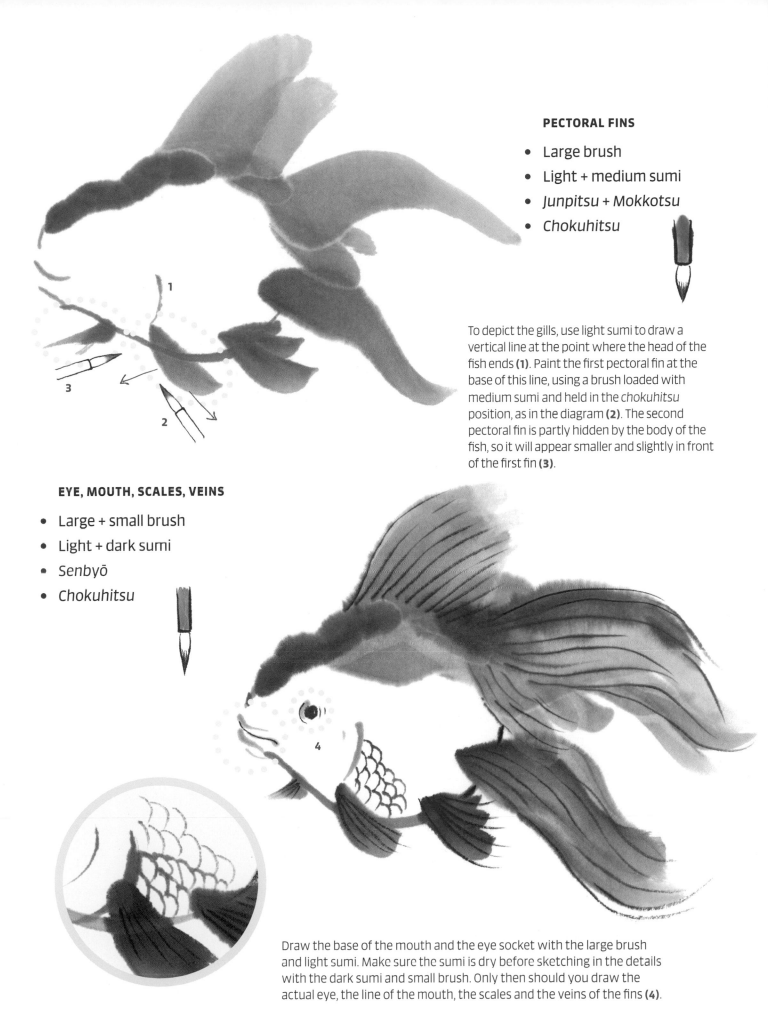

PECTORAL FINS

- Large brush
- Light + medium sumi
- *Junpitsu + Mokkotsu*
- *Chokuhitsu*

To depict the gills, use light sumi to draw a vertical line at the point where the head of the fish ends **(1)**. Paint the first pectoral fin at the base of this line, using a brush loaded with medium sumi and held in the *chokuhitsu* position, as in the diagram **(2)**. The second pectoral fin is partly hidden by the body of the fish, so it will appear smaller and slightly in front of the first fin **(3)**.

EYE, MOUTH, SCALES, VEINS

- Large + small brush
- Light + dark sumi
- *Senbyō*
- *Chokuhitsu*

Draw the base of the mouth and the eye socket with the large brush and light sumi. Make sure the sumi is dry before sketching in the details with the dark sumi and small brush. Only then should you draw the actual eye, the line of the mouth, the scales and the veins of the fins **(4)**.

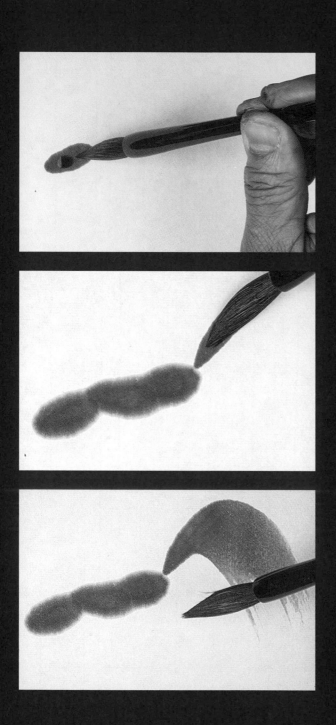

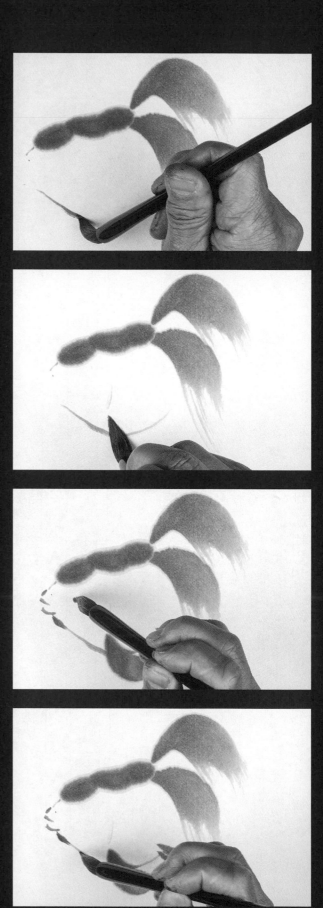

In this photo sequence, the steps in drawing the goldfish are illustrated with one variant: the dorsal fins are made with a single stroke instead of two.

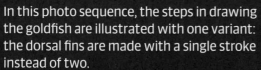

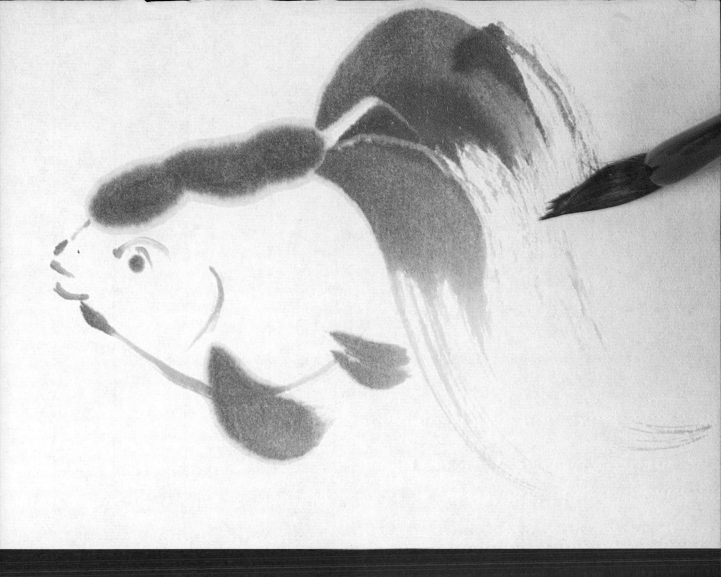

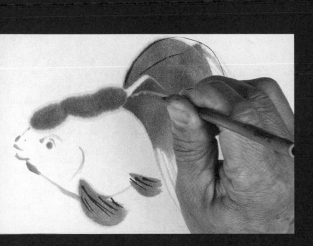

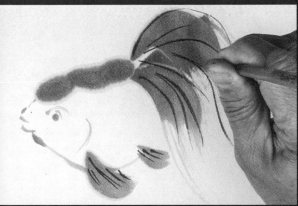

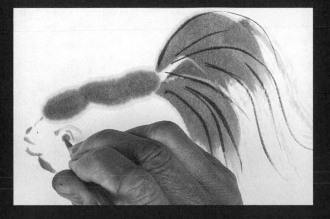

Once you master the basic techniques, you will be able to customize your goldfish creations but still respect the rules regarding the position of the fins, the roundness of the body, and the sense of movement and weightlessness of the fish.

Published by Tuttle Publishing, an imprint of Periplus Editions (HK) Ltd

www.tuttlepublishing.com

Original edition:
Sumie. L'arte giapponese della pittura a inchiostro by Shozo Koike,
© Snake Sa 2019
Graphic Design and Production: Clara Zanotti
Editorial Director: Federica Romagnoli
Translated from Italian to English: Irina Oryshkevich
Photography: Dario Canova
Video and multimedia content: Paolo Biano

ISBN 978-4-8053-1630-6

English Translation © 2021 Periplus Editions (HK) Ltd

Distributed by
North America, Latin America & Europe
Tuttle Publishing
364 Innovation Drive, North Clarendon
VT 05759-9436 U.S.A.
Tel: 1 (802) 773-8930; Fax: 1 (802) 773-6993
info@tuttlepublishing.com
www.tuttlepublishing.com

Japan
Tuttle Publishing
Yaekari Building 3rd Floor
5-4-12 Osaki, Shinagawa-ku, Tokyo 141-0032
Tel: (81) 3 5437-0171; Fax: (81) 3 5437-0755
sales@tuttle.co.jp; www.tuttle.co.jp

Asia Pacific
Berkeley Books Pte. Ltd.
3 Kallang Sector, #04-01, Singapore 349278
Tel: (65) 67412178; Fax: (65) 67412179
inquiries@periplus.com.sg
www.tuttlepublishing.com

Printed in Singapore 2106TP
24 23 22 21 10 9 8 7 6 5 4 3 2 1

"Books to Span the East and West"

Tuttle Publishing was founded in 1832 in the small
New England town of Rutland, Vermont [USA]. Our
core values remain as strong today as they were
then—to publish best-in-class books which bring
people together one page at a time. In 1948, we
established a publishing office in Japan—and Tuttle
is now a leader in publishing English-language
books about the arts, languages and cultures of
Asia. The world has become a much smaller place
today and Asia's economic and cultural influence
has grown. Yet the need for meaningful dialogue
and information about this diverse region has never
been greater. Over the past seven decades, Tuttle
has published thousands of books on subjects
ranging from martial arts and paper crafts to
language learning and literature—and our talented
authors, illustrators, designers and photographers
have won many prestigious awards. We welcome
you to explore the wealth of information available
on Asia at **www.tuttlepublishing.com.**

The online video tutorials may be viewed on our
website, type the following URL into your web browser
www.tuttlepublishing.com/beginners-guide-to-sumie
For support, email us at info@tuttlepublishing.com